Digital Photography

for dummies®
A Wiley Brand

8th edition

by Julie Adair King

for dummies®
A Wiley Brand

Digital Photography For Dummies®, 8th Edition

Published by: **John Wiley & Sons, Inc.**, 111 River Street, Hoboken, NJ 07030-5774, www.wiley.com

Copyright © 2016 by John Wiley & Sons, Inc., Hoboken, New Jersey

Published simultaneously in Canada

For general information on our other products and services, please contact our Customer Care Department within the U.S. at 877-762-2974, outside the U.S. at 317-572-3993, or fax 317-572-4002. For technical support, please visit www.wiley.com/techsupport.

Wiley publishes in a variety of print and electronic formats and by print-on-demand. Some material included with standard print versions of this book may not be included in e-books or in print-on-demand. If this book refers to media such as a CD or DVD that is not included in the version you purchased, you may download this material at http://booksupport.wiley.com. For more information about Wiley products, visit www.wiley.com.

Library of Congress Control Number: 2016939093

ISBN 978-1-119-23560-6 (pbk); ISBN 978-1-119-23563-7 (ebk); ISBN 978-1-119-23564-4 (ebk)

Manufactured in the United States of America

10 9 8 7 6 5 4 3 2 1

Contents at a Glance

Table of Contents

Introduction

A few months ago, while cleaning my office in an attempt to put off sitting down to write, I came across the first edition of *Digital Photography For Dummies*, published in 1997. Flipping through the pages, I was struck by how much digital photography has changed in the intervening years. Consider these snippets from that first edition:

> "For $800 to $1,000, you get a pixel count in the 1280 x 960 range." Pixel count refers to resolution, which determines how large you can print a digital image. With a resolution of 1280 x 960 pixels — about 1 million pixels altogether, or 1 *megapixel* in today's terminology — the maximum print size is 4 x 6 inches. If you needed more resolution back then, a Kodak/Canon hybrid model offered a 6-megapixel resolution for $29,000. (No, that figure is not a typo.) Today, even sub-$100 cameras offer resolutions of 6 megapixels or more.

> "Some cameras suck the life out of a set of batteries in just a few hours." This issue was a huge problem, and one that manufacturers have done a good job of resolving. Today, you can shoot for an entire day, or even days, without needing a recharge.

> "On cameras that have LCD screens, battery consumption is even higher." Wait — what? Digital cameras didn't have monitors back then? Well, some higher-priced cameras did, but the monitors then were nowhere near as large or as crisp as the stunning displays we now enjoy.

I could go on, but I think you get the point: Digital photography has come a long way since its early years. What remains the same, however, is that figuring out how to use all the features on your camera can be intimidating, to say the least. How many megapixels do you really need, for example? What's ISO? And are your pro photographer friends right when they insist that you shoot in the Raw format (whatever that means)?

The other thing that hasn't changed is that *Digital Photography For Dummies* has the answers to these questions and more. Completely updated to cover the latest tools, tricks, and techniques, this eighth edition spells out everything you need to know to make the most of your digital camera. Whether you're taking pictures for fun, for work, or for both, you'll find answers, ideas, and solutions in the pages to come.

About This Book

Digital Photography For Dummies, 8th Edition, covers all aspects of digital photography. It helps you assess your current digital photography needs, determine the best gear and products to suit your style, and combine the newest digital innovations with tried-and-true photography techniques. In addition, this book explains what happens after you get the shot, detailing the steps you need to take to download your picture files, produce great-looking prints to hang on the living room wall, and share your favorite images online.

Unlike other books on the topic, this one does not assume that you have any pre-existing knowledge about photography, whether digital or film. Everything is explained in easy-to-understand language, with a little humor thrown in to make learning a bit more enjoyable.

I do assume, though, that if you're into photography enough to pick up this book, you probably own a "regular" camera — that is, one designed solely to take pictures, as opposed to a cellphone or tablet with a built-in camera. Keep in mind, though, that a digital photo is a digital photo, no matter how you capture it. So, many of the tips and technical details I provide apply as much to shooting with a cellphone as they do to taking pictures with an expensive, pro-level camera.

How This Book Is Organized

As much as possible, this book is put together in a way that doesn't require you to read it in the traditional order, from front to back, in order to make sense of things. Instead, you can dip in and out of various chapters to get help with a specific topic. However, if you're brand-new to photography (or to digital photography), you may find it easier to explore the first part of the book, which explains fundamentals, before moving onto the advanced topics I cover later in the book.

The next five sections offer a brief preview of the information you can find in each of the book's four parts, plus the appendix.

Part 1: Exploring Digital Photography Basics

As the part name implies, chapters in Part 1 are designed to make it as easy as possible for you to get better results from your camera — even if you're a complete novice:

>> Chapter 1 helps you assess your current camera and decide whether it has the features you need to shoot the kinds of pictures you want to take. If the answer is no, I offer some advice on finding the right new camera in the seemingly endless array of models.

>> Chapter 2 kick-starts the creative side of your brain, providing an introduction to photographic composition and explaining which camera features affect picture characteristics such as how much of a scene is in sharp focus.

>> Chapter 3 offers tips for getting the best results when you shoot in your camera's fully automatic exposure modes, including scene modes such as Portrait mode and Sports mode. In addition to explaining when to use these automatic modes , I walk you through the steps of framing and focusing your first shots.

>> Chapter 4 explains some critical camera options, including shooting mode, shutter-release mode, resolution, and file type. Although the default settings for these options work well in most cases, you may need to adjust them for some shots, and this chapter explains the whys and wherefores.

Part 2: Taking Your Photography to the Next Level

When you're ready to take the next step in your photography journey, Part 2 helps you take more control over your pictures by taking advantage of your camera's more advanced options:

>> Chapter 5 covers exposure, explaining fundamentals such as f-stops, shutter speeds, and ISO, and offering tips on related subjects such as using flash to light your subject.

>> Chapter 6 introduces focus techniques that can help you add drama to your pictures and also looks at options that enable you to manipulate color.

>> Chapter 7 wraps up all the previous chapters with a summary of the best settings and techniques to use for specific types of pictures, from portraits to landscapes to action shots.

Part 3: After the Shot

After you fill up your camera with photos, you need to get them off the camera and out into the world. Chapters in Part 3 show you how:

>> Chapter 8 introduces you to some common picture-playback options and then explains the process of transferring pictures to your computer.

>> Chapter 9 reviews your printing options and provides advice to help you get the best prints from your digital originals. This chapter also helps you prepare your photos for online sharing, whether you want to post them on a social media site or send them via email. Additionally, look here if you shoot your photos in the Raw file format and need help converting them to a standard format for printing or online use.

Part 4: The Part of Tens

In the time-honored *For Dummies* tradition, information in this part is presented in easily digestible, bite-size nuggets:

>> Chapter 10 shows you ten accessories that can make your photography life easier, more fun, or both.

>> Chapter 11 provides a photography troubleshooting guide, discussing ten common picture problems and how to avoid or repair them.

>> Chapter 12 describes ten critical steps you should take to protect and maintain your gear — and offers advice about what to do if disaster strikes.

Appendix

As you probably have already discovered, the digital photography world is fond of jargon. Terms and acronyms you need to know are explained throughout the book, but if you need a quick reminder of what a certain word means, head for the appendix, where you'll find a glossary that translates geekspeak into everyday language.

Beyond the Book

When you have a minute or two to go online, visit www.dummies.com and enter the text *Digital Photography For Dummies Cheat Sheet* in the search box. The search should point you to a handy reference guide to the most important camera settings and terms. You can print the Cheat Sheet and carry it in your camera bag or download it so that you can read it even if you don't have Internet access.

Icons Used in This Book

Like other books in the *For Dummies* series, this book uses icons to flag especially important information. Here's a quick guide to the icons used in *Digital Photography For Dummies*, 8th Edition:

REMEMBER

This icon represents information that you should commit to memory. Doing so can make your life easier and less stressful.

TECHNICAL STUFF

Text marked with this icon breaks technical gobbledygook into plain English. In many cases, you don't need to know this stuff, but boy, will you sound impressive if you repeat it at a party.

TIP

The Tip icon points you to shortcuts that help you avoid doing more work than necessary. This icon also highlights ideas for creating better pictures and working around common digital photography problems.

WARNING

When you see this icon, pay attention — danger is on the horizon. Read the text next to a Warning icon to keep yourself out of trouble and to find out how to fix things if you leaped before you looked.

Where to Go From Here

The answer depends on you. You can start with Chapter 1 and read straight through to the index, if you like. Or you can flip to whatever section of the book interests you most and start there.

The one thing this book isn't designed to do, however, is insert its contents magically into your head. You can't just put the book on your desk or under your pillow and expect to acquire the information by osmosis — you have to put eyes to page and do some actual reading.

With our hectic lives, finding the time and energy to read is always easier said than done, but if you spend just a few minutes a day with this book, you can increase your digital photography skills tenfold — heck, maybe even elevenfold or twelvefold. Suffice it to say that you'll soon be able to capture any subject, from a newborn baby to an urban landscape, like a pro — and have a lot of fun along the way.

1

Exploring Digital Photography Basics

Discover which camera features make it easier to take different types of photos. If you're ready for a new camera, get the information you need to find just the right model.

Explore the art of composition so that you can capture more compelling photographs with any camera.

Find out how to get the best results when you rely on your camera's fully automatic shooting mode. Also take a look at scene modes, which automatically select settings considered best for specific categories of pictures, such as portraits and action shots.

Get the scoop on essential (and sometimes confusing) camera settings, including the shooting mode, shutter-release mode, resolution, and file type (JPEG or Raw).

Chapter 1

Choosing the Right Camera

You've probably heard the saying "It's a poor carpenter who blames his tools." Well, the same is true for photography: A knowledgeable photographer can produce a masterful image from even the most basic camera. That said, certain camera features make photographing some subjects easier: A fast autofocusing system improves your odds of snapping a sharp shot of a polo player, for example, and a lens that can capture subjects from a great distance enables you to photograph wildlife without the risk of becoming dinner.

This chapter helps you figure out whether your current camera offers the features you need for the type of photography you want to do, and, if not, guides you toward more suitable gear. At the end of the chapter, I provide some tips for getting the biggest bang for your buck if you go camera shopping.

Thinking About Your Artistic Goals (Or Lack Thereof)

When people come to me for camera recommendations, the first question I ask — and the one I suggest that you consider now — is "How much creative control do you want to have?" The answer determines whether you need a bare-bones, point-and-shoot camera, a high-end model with expert-level features, or something in between.

If you're new to photography, you may not understand how the camera you choose affects your creative options. Here are some of the picture qualities you can manipulate if you have the right camera features on board:

>> **Exposure:** In Figure 1-1, the left image shows the picture produced when I used my camera's full-auto shooting mode. It's fine, but it wasn't what I had in mind, which was the darker, and more dramatic, shot on the right. To make that change, I had to step out of auto mode, which doesn't let you adjust exposure. Several camera settings affect exposure, and I explain them all in Chapter 5. For this shot, I used a feature called Exposure Compensation.

>> **Motion blur:** You can determine whether moving subjects appear frozen in place or blurry. Figure 1-2 offers an example. Notice that the fountain water in the right image appears somewhat soft and misty compared with the water in the left image. To alter this characteristic, I adjusted *shutter speed,* another exposure setting covered in Chapter 5.

>> **Depth of field:** This term refers to how much of a photo stays in sharp focus. To put it another way, do objects in front of and behind your subject appear sharp, as in the left example in Figure 1-3, or blurry, as in the right image.

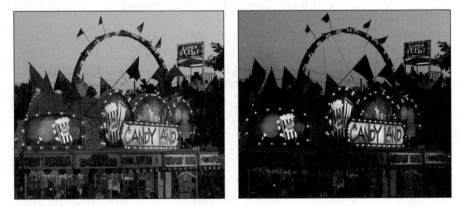

FIGURE 1-1: The shot produced in automatic shooting mode (left) lacked drama, so I took control over exposure to produce the darker version (right).

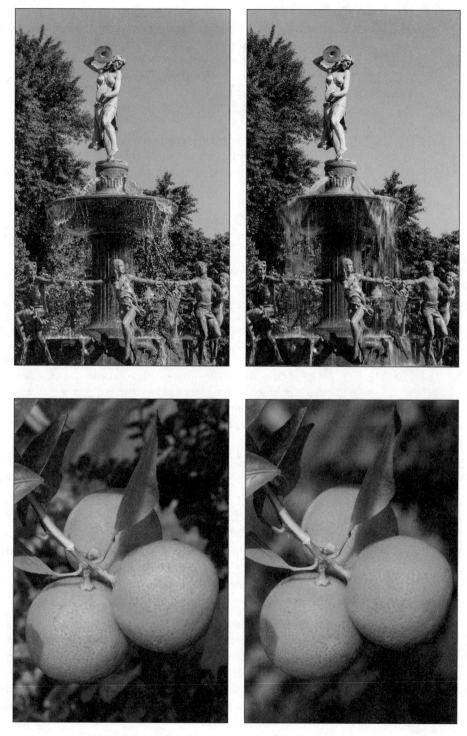

FIGURE 1-2: In these images, I varied the amount of motion blur, which affected the appearance of the fountain water.

FIGURE 1-3: Here, I adjusted settings that affect the extent to which objects in front of and behind the subject appear sharp (left) or blurry (right).

Neither version of these photos is right or wrong, by the way; beauty, as they say, is in the eye of the beholder. And please don't freak out about the photography lingo I just flung your way — I cover it in detail later in this book. The important point of this discussion is that if you care about these kinds of artistic decisions, you need a camera that lets you take charge of the aforementioned settings as well as others that control focusing, color, and image quality.

Of course, cameras that offer those features typically cost more than basic models and are more complicated to use. So if you're not interested in delving deeply into photography, there's no point in wasting time and money on features you'll never use.

The first step in finding a suitable camera, therefore, is to decide which of the following categories of cameras matches your photography interests:

>> **Basic models:** I use this term to describe entry-level cameras that offer few (or no) manual controls over exposure, focus, and so on. Cellphone cameras also fall into this category, as do cameras on iPads and other tablets.

A basic model is perfect if you're a casual photographer. That is, you enjoy taking selfies, shooting pictures of the gang at special occasions, and sharing photos of your kids or pets online. Or perhaps your work requires photo documentation of some sort — for example, an insurance adjuster needs to include photographic evidence of hail damage in order to process a claim. Either way, you want your pictures to be as good as possible — you just aren't interested in taking classes or otherwise learning advanced photography techniques.

>> **Intermediate models:** By *intermediate,* I mean a camera that offers both automatic and manual picture-taking controls. Go this route if you want to explore photography but don't know much about the topic yet. That way, you can rely on automatic shooting modes while you're learning, and gradually step up to manual options.

You can find a wide range of models in this category, some of which offer just a handful of advanced picture options and others which nearly reach the pro level of control. Later sections in this chapter help you decide which options you need and which you can do without.

>> **Advanced models:** Cameras in this category are designed for knowledgeable photographers, whether pro or *prosumer* (advanced amateur), who need certain features that intermediate cameras don't provide. For example, with some cameras in this range, you can use the built-in flash to trigger off-camera flash units, providing lighting flexibility that's often required for professional portraits and product photography. You also get substantially more ways to customize your camera, from tweaking autofocus performance to changing the function of some camera buttons.

WARNING

Usually *not* included at the pro level are automatic shooting modes or other make-it-easy features that you find on basic and intermediate cameras. This leads me to offer the following caution: No matter how much the camera salesperson (or your professional photographer friend) tries to convince you to "start at the top," don't buy an advanced camera until you master an intermediate model. The added complexity will only overwhelm you, not to mention make a larger dent in your bank account. Step up to this level only if you start doing projects that require features not found on your intermediate-level model.

Of course, you may have multiple-photography personality, as I do. Some shoots demand the capabilities of my pro model, but because it's too large to fit in my purse, it's not something I carry with me all the time. For casual shots on the go, I use my cellphone — it's great for snapping scenes that catch my eye while I'm walking the dog, for example. If I want more features than my cellphone provides but don't need all the capabilities of my advanced model, I have a compact camera that splits the difference. In other words, it's okay to put more than one camera on your next birthday wish list. In fact, I highly recommend it.

As for picture quality, you can find cameras that deliver excellent images in all three camera categories. However, it's unrealistic to expect a cellphone or tablet camera to match what you can get from a "real" camera — that is, a camera designed just to take pictures. The later section "Understanding Photo Quality Factors" explains camera specs that will help you find the best performer in the category that suits your style.

Reviewing Basic Camera Designs

Digital cameras fall into one of two categories: *interchangeable-lens cameras* and *fixed-lens cameras.* As the names imply, cameras in the first category enable you to shoot with a variety of lenses, and models in the second category come with a single, permanently attached lens.

You can find cameras designed for different levels of photography within each category, by the way. So consider this discussion one of simply form; for details on function, check out the rest of the chapter.

Interchangeable-lens cameras

Cameras in this category consist of two components: a camera *body,* which contains the guts of the picture-taking system, and a lens, which you attach to a mount on the front of the body.

What does this flexibility give you? Well, as of yet, no one has invented a single lens that's perfectly suited to capturing the entire range of subjects photographers may want to shoot. A lens designed to produce an extreme close-up, for example, has different optical qualities than one engineered to capture a faraway subject. Ergo ipso facto, we have the interchangeable-lens camera, which enables you to use whatever lens your subject demands.

Within this category, you find the following types of cameras:

>> **dSLR (digital single-lens reflex):** The top two cameras in Figure 1-4 are dSLRs. (More about the name momentarily.) Although dSLRs were once large, heavy, and complicated, manufacturers now also offer models geared to novice photographers as well as advanced shooters. High-end dSLRs still remain fairly large, but entry-level and intermediate models are available in significantly reduced sizes. The smaller of the two dSLRs in Figure 1-4, for example, isn't much wider than the iPhone 6 that I included in the foreground to give you some frame of reference.

dSLRs

Mirrorless

FIGURE 1-4:
Interchangeable-lens cameras vary in size; some aren't much bigger than the iPhone 6, included in the foreground for comparison.

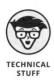

Okay, about the name: The *d* in *dSLR* represents *digital,* distinguishing a digital SLR from film models, which have been around for a long time. SLR stands for *single-lens reflex* and refers to the viewfinder technology used in this type of camera. The name stems from the fact that the SLR viewfinder involves a series of mirrors that reflect (reflex) the light coming through the lens to the viewfinder display.

>> **Mirrorless cameras:** With this type of camera, the mirror-based viewfinder system is gone — thus, it's *mirrorless.* Taking out that mirror assembly enables mirrorless models to be much smaller and lighter than dSLRs, which is why you sometimes hear them referred to as *compact system cameras.* The bottom-left camera in Figure 1-4 is a mirrorless model.

Some mirrorless models do away with the viewfinder entirely; you compose the image using the monitor on the camera back. Others incorporate or enable you to attach an *electronic viewfinder,* which provides the convenience of a viewfinder without taking up as much space as an *optical viewfinder*, which is the type used in a dSLR viewfinder. The section "Viewfinder: Optical or electronic," later in this chapter, has more details.

>> **Rangefinders:** Figure 1-5 gives you a look at this less-common variety of interchangeable-lens camera. At first glance, rangefinders look a lot like compact system cameras, but they work quite differently. Traditional rangefinders use a different focusing system than other cameras. The viewfinder displays two views of your subject, and you determine the focusing distance, or range, by turning a ring on the lens until the two images align. However, some rangefinder models also offer other, more standard autofocusing options.

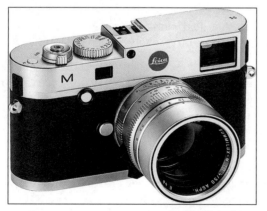

FIGURE 1-5: Leica is the best-known manufacturer of digital rangefinder cameras.

Courtesy of Leica Camera

Fixed-lens cameras

Again, by *fixed lens*, I mean a lens that's permanently paired with the camera body. Cameras in this category fall into two camps:

> **"Real" cameras:** That is, a camera whose sole purpose is photography, as opposed to a computer device or phone that sports a camera.
>
> Most people refer to these cameras as *point-and-shoot* models because they offer automatic settings that enable the novice photographer to, well, point and shoot. Yet I hesitate to use the term, because higher-end fixed-lens models do enable you to control exposure, focus, and other picture settings. And although you can't swap out lenses on these cameras, some models have zoom lenses that reach from wide-angle to telephoto views, so you still enjoy lots of picture-taking flexibility.
>
> Whatever you want to call them, these cameras come in a variety of sizes, shapes, and colors, ranging from models that look like a small dSLR or mirror-less camera to pocket-size wonders that make the latest smartphones look huge. You also can find models specifically designed for rugged use, offering features such as shockproof and water-resistant cases. These models are great not only for outdoor adventurers, but also for young photographers who may not always be as careful with their devices as the adults in their life would like them to be. Heck, I certainly don't qualify as a young photographer (although 56 *is* the new 55), and I can't be counted on to always retain a firm grip on my equipment, either.
>
> **Cellphone and tablet cameras:** Of course, no book on digital photography today would be complete without mentioning the cameras built into these multipurpose devices. But let's be honest: Taking a photo with a tablet — even a small one such as the iPad mini — is cumbersome at best. For the purposes of this book, I concentrate on cellphone cameras.
>
> Providing many specifics, though, is difficult because the capabilities of cellphone cameras vary so widely. On some phones, you can do things such as tap the screen to indicate the focus point or adjust exposure slightly. Other phones give you no control at all. Suffice it to say that if you're going to use a phone as your main camera, do your research.

TIP

Also note that even though you can't swap out lenses on these types of cameras, you can often attach lens modifiers that provide a different angle of view than the built-in lens. Companies such as Moment (`www.momentlens.co`) sell telephoto and macro (close-up) add-on lenses for smartphones, for example.

SO HOW MUCH IS THIS GOING TO COST?

Camera prices are constantly on the move, so any dollar amount I mention today will likely be out of date even before this book makes its way from the printing press to you. But as a general guideline, basic cameras range from about $75 to $150, and intermediate-level models sell in the neighborhood of $300 to $700. Advanced models typically set you back around $800 to $2,000, and that price may or may not include a lens.

Pro models carry price tags of $2,000 and up, not including the lens. Lenses, too, vary widely in price, starting at around $150 and reaching into the thousands. As for cell-phone cameras, you can pay anything from nothing to $600 and up, depending on what service agreement you sign with the cell carrier.

Remember, too, to include a few necessary accessories in your budget, such as memory cards (the little cards that store your pictures) and a good camera bag. Chapter 10 covers additional accessories to consider.

Understanding Photo Quality Factors

Often overlooked amidst the more glitzy, whiz-bang options touted in camera magazine and television ads are the ones that affect the quality of the pictures the camera can produce. After all, if a camera doesn't live up to your expectations for its main purpose — producing sharp, clear, colorful photographs — nothing else matters.

The next sections explain technical specs that affect picture quality. Be sure to also check out the section on lenses, later in this chapter, because they also con-tribute to photo quality.

REMEMBER

One note before you dig in: Although it's important to understand these specs, don't consider them the final word on image quality. Photos from two cameras that have the same specs may differ greatly because of the performance built into various camera components and the internal software used to turn image data into photographs. For the full story, check out magazine and online reviews done by pros who have the equipment and expertise to make accurate quality assessments.

Resolution: How many megapixels?

Digital images are made of colored tiles know as *pixels*. The magnified portion of Figure 1-6 gives you a look at these image building blocks. Camera *resolution*, stated in *megapixels* (1 million pixels), indicates the maximum number of pixels that it can use to create a photo.

Chapter 4 discusses resolution in detail, but in terms of evaluating a camera, you need to know these key points:

>> **Image resolution determines the size at which you can produce high-quality prints.** A general guideline is to aim for 300 pixels per linear inch (ppi). Table 1-1 does the math for you, listing the number of megapixels required for traditional print sizes.

>> **For onscreen photos, you need very few pixels.** Resolution affects the display size of digital photos, but does *not* affect picture quality. And because most screen devices are limited in the number of pixels they can display, a 1 mp image is usually more than adequate. On Facebook, for example, the area allotted for a cover photo (the wide image that runs across the top of the page) is 851 x 315 pixels (about .2 mp).

>> **High-resolution pictures create larger data files.** The more pixels, the faster you fill a camera memory card (the removable storage used by most cameras), a cellphone's onboard storage space, and your computer's hard drive or any online storage closet you may use.

TABLE 1-1

Resolution Requirements for Printing at 300 ppi

For This Print Size . . .	You Need This Many Megapixels
4 x 6 inches	2 mp
5 x 7 inches	3 mp
8 x 10 inches	7 mp
11 x 14 inches	14 mp

Image sensor: Full frame or smaller?

A photograph is formed when light passes through a lens and strikes a light-sensitive recording medium. In a film camera, the film negative performs the light-recording function. In a digital camera, the *image sensor* handles the task. The sensor is covered with *photosites,* which are electronic doodads (that's the technical term) that collect the light data needed to create the image pixels.

TECHNICAL STUFF

Digital-camera image sensors come in two flavors: CCD (charge-coupled device) and CMOS (complementary metal-oxide semiconductor). In the past, each had a reputation for offering different advantages, but today, both are capable of producing excellent images (although techno-geeks still love to argue about which technology is best).

TIP

Sensor *size,* however, is a different story: A smaller sensor usually produces lower image quality than a large sensor. Why? Because when you cram tons of photosites onto a small sensor, you increase the chances of electronic noise that can degrade the picture.

The three largest sensors commonly used in digital cameras have been assigned these monikers:

>> **Full frame:** The sensor is the same size as a 35mm film negative (36 x 24mm). Why *full frame?* The term is related to camera lenses, which are still manufactured using the 35mm film negative as a standard. That means that a full-frame sensor is large enough to capture the entire angle of view that a lens produces on a 35mm film camera. Smaller sensors can capture only a portion of that angle of view. For more on this issue, check out the upcoming section related to lens focal length.

>> **APS-C (advanced photo system-type C):** This is a smaller-than-full frame sensor but with the same 3:2 proportions as a 35mm negative. Within this category, the specific dimensions of the sensor vary from camera to camera. Nikon APS-C sensors measure about 24 x 16mm, for example, whereas Canon's are approximately 22 x 15mm.

Some people use the term *crop* sensor to refer to this category because it's a trimmed-down version of a full-frame sensor. Technically, the *C* in APS-C stands for *classic,* but *crop* is more helpful in remembering how these sensors vary from full-frame versions. Also, Nikon coined the term *DX* to refer to its APS-C sensors, using *FX* to indicate full-frame sensors.

>> **Micro Four Thirds:** These sensors are slightly smaller than APS-C sensors, and as the name implies, they have a 4:3 aspect ratio as opposed to the 3:2 ratio of full-frame and APS-C sensors. Note that the term Four Thirds is used for any sensor that has a 4:3 aspect ratio, even for those much smaller than a Micro Four Thirds sensor.

Which is best — 4:3 or 3:2? Well, there's no magic to either aspect ratio. But 3:2 originals translate perfectly to a 4 x 6 print, and a 4:3 image must be cropped to fit. Mind you, you also need to crop 3:2 originals to print them at other frame sizes — 5 x 7, 8 x 10, and so on. And many cameras enable you to choose from several aspect ratios for your pictures or to crop them to a certain proportion using in-camera editing tools.

If you don't see one of these terms, you can find the sensor's dimensions in the camera's spec sheet. But sometimes, size is presented as a single number, such as 1". In this case, that number reflects the diagonal measure of the sensor, which is the same way that TV sizes are presented.

Image file format: JPEG versus Raw

File format refers to the type of file used to record picture data. The standard format is JPEG ("jay-pegg"), but cameras aimed at intermediate and advanced photographers usually offer a second format called Camera Raw, or just Raw, for short.

When it comes to image quality, Raw outperforms JPEG for reasons you can explore in Chapter 4, if you're interested. (*Spoiler:* The difference has to do with the fact that JPEG files are compressed to shrink file size, resulting in some data loss.)

Pro shooters also prefer Raw to JPEG because Raw can record a greater *dynamic range* (spectrum of brightness values, from shadows to highlights). Additionally, JPEG files are "processed" in the camera, with characteristics such as contrast, sharpness, and color saturation tweaked to provide what the manufacturer thinks its clients like. Raw files are just that: uncooked data straight from the image sensor. The photographer then does the work of turning that data into a photo using a software tool known as a Raw converter. This gives the photographer control over the final look of a photo.

This is not to say that you should bypass cameras that offer only JPEG, however. Today's digital cameras produce excellent-quality JPEG images, unlike some of the JPEG-only models of past years. But obviously, a camera that offers both

formats beats one that doesn't provide the Raw option. You may not be interested in Raw now, but as your skills grow, it may become more appealing to you.

See Chapter 4 for more details on this important camera setting.

High ISO performance (noise levels)

TECHNICAL
STUFF

A digital camera's sensitivity to light is measured in terms of *ISO*, named for the group that developed the standards for this attribute (International Organization for Standards). Most cameras offer a choice of *ISO* settings so that you can increase or decrease light sensitivity as needed. In dim lighting, for example, you may need to raise the ISO in order to expose the image.

Being able to increase light sensitivity is great in terms of exposure needs, but there's a tradeoff: As you increase sensitivity, you increase the chances of introducing a defect known as *noise*, which gives your photo a speckled look. Figure 1-7 offers an example, with the noise most evident in the dark background of the picture. Noise is also easier to spot when you enlarge the image, as illustrated by the magnified view shown on the right in the figure.

FIGURE 1-7:
Using a high ISO setting can produce noise, the speckly defect that mars this image.

Today's cameras are much less noisy than in years past. In fact, if you're using a camera that's more than a couple of years old, better low-light pictures is a perfectly valid reason to justify the purchase of a new model. But because noise levels vary from camera to camera, this is an important characteristic to study when reading camera reviews. Note, however, that a high ISO isn't the only cause of noise; long exposure times also produce noisy images, no matter what ISO setting you use.

Looking at Lenses

As your camera's eye, the lens plays a huge part in what types of photos your camera can produce. A few lens features are easy to understand:

>> **Camera compatibility:** Interchangeable-lens cameras require specific lens types. If you have a Nikon camera body, for example, the lens must have a Nikon mount. That *doesn't* mean that you have to stick with the manufacturer's lenses; you can get great lenses from third-party makers such as Tamron and Sigma. Again, just make sure that the lens offers the correct mount for your camera (or that you can make it work with an adapter).

WARNING

Just because you can put a lens on a camera doesn't ensure that it can take advantage of all camera features, however. Autofocusing may not be possible, for example. Check your camera manual for details on what types of lenses support which camera features.

>> **Optical quality:** Just as with eyeglasses, having a carefully crafted lens — "good glass," in photo lingo — is critical to image quality. Unfortunately, it's not practical for most of us to test lenses to find the best performer. The good news is that lens reviews are readily available in photography magazines and at online photography sites.

>> **Weight and size:** Today's lenses are significantly lighter and smaller than those from even a decade ago. So if you're shooting with an older lens that's weighing you down — literally — check out the newer options. Some lenses retract into a more compact form when you're not using them, as shown in Figure 1-8.

>> **Minimum focusing distance:** This number is especially important if you enjoy shooting close-ups. The shorter the minimum focusing distance, the closer you can get to your subject, enabling you to fill the frame with small details.

TIP

If you're really into close-up photography, you may want a *macro* lens, which permits especially close focusing. Technically, the term *macro* means that the lens can record an object at its actual size or larger, but sometimes the label is used to refer to closer-than-normal focusing in general. Check out Chapter 7 for more tips on close-up photography.

FIGURE 1-8:
Some lenses collapse when not in use, taking up less room in your camera bag.

Two additional lens specs, focal length and aperture range, are a little more complicated; the next sections explain how both affect your photography.

Lens focal length

TECHNICAL STUFF

Focal length, stated in millimeters, refers to the distance from the center of the lens to the image sensor. Focal length is measured when the lens is set to focus at the farthest possible distance.

Having done my due diligence in providing the technical definition of focal length — which, by the way, isn't really important to remember unless you want to impress a roomful of optical engineers — I am now free to explain focal length in real-world photographic terms:

REMEMBER

>> **Focal length determines the angle of view.** The shorter the focal length, the more subject area fits in the frame. Increasing focal length narrows the angle of view and makes your subject appear closer and larger. Figure 1-9 illustrates this fact, showing the same scene captured at four focal lengths. (A lower number indicates a shorter focal length.)

Some focal length recommendations:

- *Landscape photography:* Look for a *wide-angle lens,* characterized by a focal length of 35mm or shorter.

- *Nature and sports photography:* Assuming that you'll be shooting at a fair distance from your subject, you need a *telephoto lens,* which has a focal length of 70mm or longer.

18mm 60mm

100mm 170mm

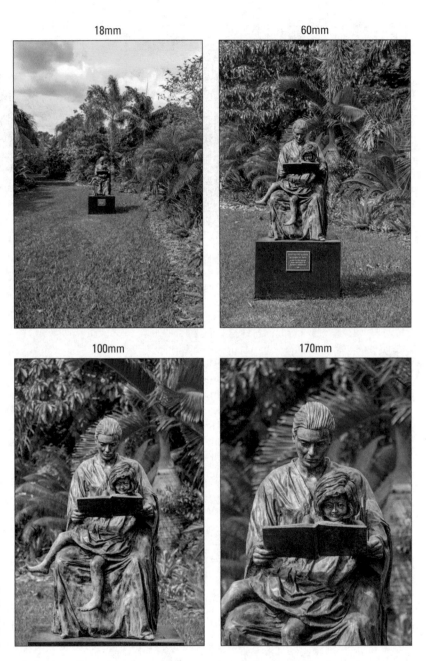

FIGURE 1-9:
The shorter the
focal length,
the wider the
angle of view.

- *Portrait photography:* Aim for a focal length in the range of 70-135mm. At
 other focal lengths, facial features can be distorted. A wide-angle lens, for
 example, can make your subjects appear sort of like how they look when
 you view them through a security peephole in a door. And a very long lens
 can flatten and widen a face.

» The angle of view produced by any focal length depends on the size of the image sensor. You get the stated focal length only on a camera that has a full-frame sensor — that is, one that's the same size as a 35mm film negative. With smaller sensors, the angle of view is reduced because the sensor is no longer large enough to capture the entire area that the lens can see. The resulting picture is what you would get if you took a picture with a full-frame camera and then cropped the picture. The measurement of how much frame area you lose is known as the *crop factor*.

Because sensor sizes vary, the crop factor depends on the camera model. Most dSLR and mirrorless image sensors have a crop factor ranging from 1.5 to 2. Figure 1-10 illustrates the image area at these crop factors when compared to the full-frame view.

To figure out what angle of view a lens will provide, just multiply the camera's crop factor (which should be stated in the camera specs) by the lens focal length. For example, if the camera has a crop factor of 1.5, a 50mm lens gives you the same angle of view as a 75mm lens on a full-frame digital or 35mm-film camera.

» Focal length affects depth of field. As focal length goes up, depth of field — the distance over which focus appears sharp — goes down. As an example, compare the backgrounds in Figure 1-9. Notice how much blurrier the trunk of the palm tree behind the monument appears in the 100mm image than in the versions shot at the shorter focal lengths.

1.5x crop 1.6x crop 2.0 crop

FIGURE 1-10:
On a digital camera, the angle of view that can be recorded at any focal length depends on the camera's crop factor.

What about the crop factor and depth of field? They're unrelated; you get the same depth of field from a particular focal length no matter what the size of the sensor. The image produced by a camera with a smaller sensor may *appear* to have a different depth of field than one from a camera with a full-frame sensor, but that's only because you're looking at different portions of the scene.

>> **A prime lens offers a single focal length; a zoom lens, a range of focal lengths.** For example, a lens might zoom from 18 to 55mm.

In camera or lens advertisements, the zoom range is sometimes described in terms of an "x" factor, as in a *3x zoom*. Here, the *x* means *times,* with the value indicating the difference between the shortest and longest focal length of the lens. So an 18–55mm lens boasts a 3x zoom, for example (18 x 3 = 54).

TIP

As a general rule, prime lenses equate to better-quality photos because a lens can be engineered to optimal performance at only a single focal length. That said, one of my favorite lenses is the *super zoom;* it has a monster focal length range — 18 to 270mm. Newer lenses perform better in this regard than those manufactured in the past.

>> **Don't bother with digital zoom.** For fixed-lens cameras, note whether the lens offers an *optical* or *digital* zoom. *Optical zoom* is a true zoom lens and produces the best picture quality. *Digital zoom* is a software feature that crops away the outside of the image and enlarges the remaining area, a process that lowers image quality.

In most cases, the focal length is printed on the lens, but for some models, you may need to check the user manual or lens spec sheet. Often, the manufacturer gives both the actual focal length of the lens (that's the measurement mentioned in the opening to this section) as well as the 35mm equivalent.

As for cellphone cameras, finding the focal length usually requires inspecting the image *metadata* (hidden data stored with the digital photo file). You may be able to view this data in a photo program; visit Chapter 9 for a list of some programs to consider. For the time being, just know that cellphone cameras typically have wide-angle lenses.

Lens aperture range

The *aperture* is an adjustable hole through which light must pass to reach the image sensor. Aperture size is stated in *f-numbers,* more commonly referred to as *f-stops.* A higher number indicates a narrower aperture size. So f/11, for example, results in a smaller aperture opening than f/8.

Changing the aperture size is one way to manipulate exposure. But the f-stop setting also contributes to *depth of field,* or the distance over which focus appears sharp. The smaller the aperture, the greater the depth of field, as illustrated in Figure 1-11.

If you're keeping track, you now know that the lens gives you two points of control over depth of field: the focal length and the aperture setting. In Figure 1-11, I used the same focal length for each shot, so the aperture setting is the sole reason for the shift in depth of field.

f/22 f/5.3

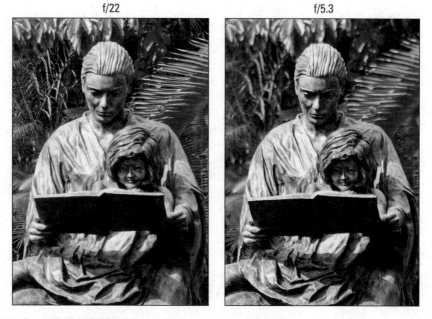

FIGURE 1-11: For these variations, I used the same focal length and instead adjusted the aperture size (f-stop) to manipulate background sharpness.

And why, you're probably wondering, is the exposure of both images in Figure 1-11 the same, given what I just said about the f-stop affecting image brightness? This is why: When I opened the aperture, I also reduced the exposure time, so the light was able to strike the image sensor for a shorter period. I kept the light sensitivity (ISO setting) the same for both photos.

You can explore f-stops, exposure, and depth of field further in Part 2 of the book. For the purpose of comparing lenses, you need just a few more bits of aperture information:

>> **Every lens has a specific range of aperture settings.** Obviously, the larger that range, the more control you have as a photographer.

>> **The larger the maximum aperture, the "faster" the lens.** Again, the more open the aperture becomes, the less time is needed to expose the image. So if one lens can open to a maximum setting of f/4 and another lens has a maximum aperture of f/2, the f/2 version is said to be faster.

TIP

A fast lens is especially beneficial when photographing action, because a moving subject blurs at long exposure times. But it also helps when you shoot in dim lighting, because you can get the shot at a lower ISO setting, reducing the chances of image noise.

>> **On a zoom lens, the aperture range may change as you zoom in or out.** For example, on an 18–140mm lens, you may be able to open the aperture to f/2 when the lens is at the 18mm position but only to f/5.6 at 140mm.

TIP

You can buy zoom lenses that maintain the same minimum and maximum apertures throughout the zoom range, but be prepared to part with more money than for a lens that doesn't offer this feature.

» **Depth of field at any aperture varies depending on the size of the image sensor and lens.** Cameras with small sensors and lenses produce a much greater depth of field at any f-stop than cameras with larger sensors and lenses. The result is that it can be difficult to achieve much background blurring even if you open the aperture all the way. That's an important consideration if you're interested in the type of photography that benefits from a short depth of field, such as portraiture. On the other hand, if you're a landscape photographer, you may love the extended depth of field those smaller cameras produce.

Checking Out Shooting Modes

How much artistic control a camera offers is closely tied to its choice of *shooting modes*, sometimes called *exposure modes*. Usually, shooting modes are represented by letters and symbols like the ones you see on the camera dial in Figure 1-12.

If you fall into the "not that into photography" category, you'd be happy with a basic camera that offers only automatic shooting modes. Along with standard Auto mode, this level of camera typically also offers *scene modes*, which automatically dial in settings deemed most appropriate for specific types of photos, such as portraits and sports shots.

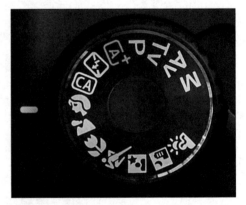

FIGURE 1-12:
The various symbols on this camera dial represent shooting modes.

The problem with scene modes is that they're geared to producing a certain effect, and you can't deviate from that result. For example, in Sports scene mode, the camera can only freeze action; you don't have the option of blurring motion. And in Portrait mode, the camera blurs the background as much as it can. That's fine for most portraits, but you may have times when you want the background to be as sharp as your portrait subject.

For more photographic control, I suggest a camera that offers these three shooting modes: shutter-priority autoexposure, aperture-priority autoexposure, and manual exposure. These modes enable you to precisely control not only exposure, but also all the other characteristics I discuss at the start of this chapter and more.

Check out the first part of Chapter 4 for specifics on these and other common shooting modes.

Considering Focusing Options

Digital camera focusing systems range from incredibly simple to amazingly complex. In my experience, few people need all the focus-related settings found on pro cameras. (Even fewer people understand how to adjust those settings in a way that makes sense for their subject.) But neither do I recommend a camera that offers you no control over focusing, which is the case with some cellphones and basic point-and-shoot cameras.

To help you find the right balance, here's an introduction to focusing features:

>> **Focusing method (automatic and manual):** Even the best AF (autofocus) systems have trouble with some subjects, such as highly reflective objects. So the option to switch to manual focusing is a plus.

How manual focusing is implemented is also important. In most cases, you adjust focus by turning a ring on the lens — easy peasy. But some cameras instead require you to select a menu option and then enter a focusing distance, which is not only time-consuming but also requires an accurate sense of how far your subject is from the camera. Still, this form of manual focusing is better than none.

>> **Focus point selection:** Most cameras are set by default to focus on the closest object, which causes problems if that object is not your subject. Chapter 6 shows you a trick you can use to lock focus on a specific area, though a better solution is a camera that enables you to select from several focus points located throughout the frame. Some cameras (and lenses) also offer an infinity setting, which sets focus at the farthest point possible.

>> **Face/eye/smile/blink detection:** These features are designed to simplify portrait photography. *Face detection* searches the frame for a face, and if it finds one, automatically sets focus on that person, as shown in Figure 1-13. Sometimes you can choose which face in a group portrait to use

as the focusing target. Models that offer *eye detection* narrow their search to specifically target the subject's eyes, which are of primary importance in most portraits. Taking these features one step further, some cameras offer *smile-and-blink* detection. In this mode, the camera tracks a subject's face and then snaps the photo automatically when the person's eyes are open and smile is widest.

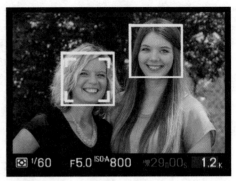

FIGURE 1-13:
Face detection is a feature that automatically looks for and sets focus on a face.

TIP

These features aren't foolproof; most face-recognition systems don't work unless your subject is facing forward, for example. And as for smile-and-blink technology, it does the trick only if everyone in the portrait displays wide smiles and bright eyes at the exact same moment. So the best way to ensure that you get a great-looking portrait is to snap many different images of your subject.

>> **Single and continuous autofocusing:** Single autofocusing refers to the standard autofocusing method used on most cameras: Focus is locked when you press the shutter button halfway (or tap the touchscreen). This system works fine for still subjects, but for moving subjects, you're better off with *continuous autofocusing*. When you use this feature, you select an initial focus point, and then if the subject moves, the camera tracks that movement, adjusting focus as necessary until you take the picture.

>> **Number of autofocus points:** Generally speaking, higher-end cameras have more focusing points than lower-priced models. The difference is most important when you shoot rapidly moving subjects and rely on continuous autofocusing: In this mode, your subject will stay in focus as long as it remains under one of the active focusing points. The more focus points, the better the chances of that happening.

However, because analyzing all the focusing data can slow the system somewhat, a good camera will enable you to choose how many of the available points you want to activate.

>> **Type of focusing points:** If a camera offers *cross-type* autofocus points, it gets extra credit. Cross-type points improve autofocusing performance because they look for focusing information in four directions: up, down, left, and right. Normal focusing points work only in the vertical direction.

IMAGE STABILIZATION: ANOTHER KEY TO SHARP SHOTS

TIP

One cause of blurry pictures has nothing to do with focusing, but with *camera shake.* If the camera moves when the shutter is open, the entire image may be blurry even when focus is perfectly set. The longer the exposure time, the longer you have to hold the camera still to avoid this type of blur. Shooting with a telephoto lens makes things even more difficult, especially if that lens is long and heavy.

You can avoid camera shake by mounting the camera on a tripod. But a feature called *image stabilization* can enable you to get sharper shots when you need to handhold the camera. The feature may go by different names depending on the manufacturer: *vibration reduction, antishake, vibration compensation,* and the like. Whatever the name, the feature is implemented in one of two ways:

- **Hardware-based stabilization:** With this method, sometimes called *optical image stabilization,* the antishake benefit is produced by a mechanism built into the camera or the lens. This type of image stabilization is best.

- **Software-based stabilization:** This type of stabilization, sometimes known as *electronic image stabilization,* or EIS, is applied by the camera's operating software rather than a hardware mechanism. It works differently depending on the camera. In some cases, the camera applies some complex correction filters to the image when motion is detected. Other cameras address camera shake by automatically increasing the ISO setting, which makes the camera more sensitive to light. When the camera is at a higher ISO, you can use a faster shutter speed, which means that the length of time you need to hold the camera still is reduced. Unfortunately, a higher ISO often brings the unwanted side effect of image noise, as discussed earlier, in the section "High ISO Performance (noise levels)."

Even the best possible stabilization system can't work miracles; you still need a tripod for very long exposures. But you can expect to get a steady shot at shutter speeds slower than what you can enjoy without stabilization. How much slower depends on the capabilities of the camera or lens.

Long story short (too late, you say?): This is one camera feature that I highly recommend to photographers of any level.

Taking the Exposure Reins

Learning to control exposure is one of the most important things you can do to improve your photographs. If you're ready to take this step, you first need a camera that offers the advanced shooting modes I discuss earlier (aperture–priority and

shutter-priority autoexposure and manual exposure). In addition, I recommend the following exposure-related features:

>> **EV (exposure value) compensation:** This feature enables you to tell the camera that you want a darker or lighter picture than its autoexposure system thinks is appropriate. It's a must-have item for intermediate and advanced shooters who want to take advantage of autoexposure but still retain control over the final exposure result. (On some cameras, you can access this feature even when shooting in fully automatic modes.)

TIP

Exposure compensation is also now provided on many basic cameras, although it may not announce itself formally. On some cellphones, for example, a little sun icon appears when you tap the screen, and you can then drag the icon up or down to adjust exposure before the shot.

>> **Metering mode options:** The *metering mode* tells the camera which part of the frame to consider when calculating exposure. Basic cameras use whole-frame metering, often called *pattern, matrix,* or *evaluative* metering. At times, you may want to base exposure on just one part of the frame, however. So it's important to also have *spot metering,* which bases exposure on a small, selected area of the frame, and *center-weighted metering,* which considers the whole frame but puts more emphasis on the center.

>> **Automatic exposure bracketing:** This feature automates the process of capturing the same scene at multiple exposure settings, which increases the odds that you'll get at least one exposure that you love.

Note that this trio of exposure controls is just the start of the multitude of exposure-related features found on high-end cameras. You can read about additional features and get the complete story on exposure in Chapter 5.

Understanding Advanced Flash Options

Basic cameras — even most cellphone cameras — usually offer built-in flash and *red-eye reduction,* a feature that's designed to lessen the chances of red-eye in flash photos. But that's about it in terms of flash features.

Higher-end cameras offer options that enable you to control flash behavior, which is a critical part of getting the best results when photographing scenes that require artificial light. Here are the most common flash-related features, listed in what I consider the order of importance:

>> **Control over whether the flash fires:** On some point-and-shoot models, you can use flash only when the camera thinks additional light is needed. At

first blush, that restriction sounds sensible: Flash on when needed and flash off when the ambient light is sufficient. But when you're outdoors on a sunny day, you often can get a better picture by using flash, especially when shooting portraits. On the flip side, when you want to emphasize the natural light hitting your subject, as I did in Figure 1-14, you don't want flash, because it would eliminate the shadows that enhance the scene. So being able to say yea or nay to flash is essential.

>> **Flash exposure compensation (Flash EV):** This feature adjusts the output of the flash, which is otherwise controlled by the camera's autoexposure system.

>> **Connection for external flash:** The built-in flash on most cameras produces harsh, direct lighting that often overpowers a subject. Especially for portrait work, you can get much better results by connecting a separate flash head to the camera. The most common method is via *hot shoe,* which is a connection on top of a camera. As an alternative, some models can connect to a flash via a cable known as *flash sync cord*. You can then attach the flash head to a bracket that positions the flash to the side of the camera or simply hold up the flash by hand, depending on how you want to angle the light. (You often see wedding photographers using this type of setup.)

FIGURE 1-14:
If you want to be able to capture interesting patterns of light, as here, make sure the camera allows you to disable flash.

>> **High-speed flash:** This feature enables you to use a faster shutter speed than is normally possible for flash photos, which is the key to outdoor portraits that feature a soft, dreamy background. To achieve that blurry background, you need a wide aperture, which lets in too much light to permit a slow shutter speed in bright sun. Part 2 of the book provides more details on this topic, but for now, just know that if your goal is outdoor portrait work, high-speed flash is essential. You also need a flash unit that supports the feature.

>> **Commander mode:** Some flash units can be set to *commander mode,* which lets you use them to wirelessly trigger off-camera flashes. If your camera's flash can't perform this function, you can buy a separate commander unit that you attach to the camera's hot shoe. The benefit is that you can light your subject from any angle and with as many lights as you think necessary — you're no longer restricted to aiming a single flash directly at your subject.

Investigating Color Controls

For input over photo colors, look for the following features, usually found on intermediate and advanced cameras:

>> **White-balance adjustments.** Digital cameras use a feature called *white balancing* to ensure accurate colors. In most cases, the default white balance setting, auto white balance (AWB), works fine. But problems can occur when a scene is lit by multiple light sources, so being able to manually control the setting is important.

The option to choose from a menu of specific light sources — cloudy daylight, sunshine, fluorescent bulbs, and so on — is standard on intermediate and advanced cameras and even available on many basic models. But those settings often don't get you where you need to be, color-wise, so many cameras offer ways to fine-tune white balance. Chapter 6 explains these features.

>> **Color space:** The *color space* determines the range of colors a digital device can capture. The standard digital camera space is sRGB (*standard RGB*), which is fine for 99.9 percent of users. But for photographers who demand a little larger color spectrum, intermediate and advanced cameras usually offer a second color space: Adobe RGB. See Chapter 6 to find out why I recommend sRGB unless you have a specific use for Adobe RGB.

>> **Picture Styles:** This feature, which goes by different names depending on the camera, enables you to choose from several different recipes that determine how the camera "processes" your digital originals. Common styles include Landscape, which amps up blues and greens; Portrait, which warms skin tones; and Monochrome, which creates a black-and-white image. This feature affects only pictures that you shoot in the JPEG file format, and it also tweaks other picture characteristics, such as sharpness and contrast.

Oh, and don't confuse the Landscape and Portrait Picture Styles with the Scene modes that have the same names. Yeah, I know. But if manufacturers weren't so good about confusing you, I wouldn't be able to earn a living and might wind up sleeping on your couch, so. . . .

>> **Raw file capture:** Okay, so this feature isn't a color control, strictly speaking. But the Raw file format, discussed earlier in this chapter, makes all the other color controls somewhat moot because you determine how raw pixel data is translated to photo colors when you process Raw files. As long as you use a capable Raw converter, you can play with color in endless ways, from choosing a white-balance setting to altering the saturation and hue of specific colors. You might make all your reds more intense, for example, or turn navy blue into medium blue.

DO YOU HAVE THE NEED FOR SPEED?

If action photography is your passion, look for a camera that offers these features, all designed to make capturing moving subjects easier:

- **Burst mode:** Records a continuous series of frames as long as you hold down the shutter button. How many frames per second (fps) you can capture depends on the camera; typically, the fastest frame rates are found on the most expensive models. Don't despair if you're on a budget, however. I find that 3 fps is more than enough for all but the speediest subjects. (Think about it: How much actually changes in a single second?)

- **Shutter-priority autoexposure:** In order to freeze action, you need to select a fast shutter speed, which you can do either in shutter-priority autoexposure mode or manual exposure mode. Shutter-priority autoexposure is my go-to mode because it lets me set the shutter speed while the camera chooses the aperture setting needed for a good exposure. In manual exposure mode, you have to take care of both the shutter speed and the aperture setting. And when action is happening very quickly, the extra time needed to take care of the aperture setting may cause you to miss an important shot.

- **Continuous autofocus:** This autofocus mode, which may go by different names depending on the model, adjusts focus as needed right up to the time you take the shot to keep moving subjects in focus.

- **High ISO performance:** To use a fast shutter speed in dim lighting, you often need to use a high ISO setting, which increases the camera's sensitivity to light. But raising ISO can introduce noise, giving your picture a grainy look. How high you can set ISO before noise is apparent varies from camera to camera; check reviews to find a model that enables you to amp up the ISO to a fairly high level (ISO 800 or more).

- **Compatibility with high-speed memory cards:** Camera *memory cards* — the little removable cards that store your pictures — are rated in terms of how fast they can read and write data. With a faster card, the camera needs less time to store the image data after you shoot the picture. Although older cameras often can't take advantage of the speed increases, some newer models work with the fastest cards.

Reviewing Other Important Features

I could write an entire book decoding all the other specifications that affect the type and quality of the pictures your camera can produce. But we'd both be bored to tears after the first few pages. Instead, the rest of this chapter lists only the options that I think make a real difference. Some are designed just to make things easier for beginners, some are geared to advanced photographers, and some can improve your time behind the lens no matter what your experience or interest level.

Viewfinder: Optical or electronic?

TIP

Cellphones and cameras that lack a viewfinder force you to frame your shots using the monitor. That causes two problems: You have to hold the camera a few inches away to see the monitor, and unless you keep your hands very steady, camera shake can cause a blurry picture. Additionally, monitors wash out in bright light, making it hard to see what you're shooting. For these reasons, I consider a viewfinder an important bonus. But not all viewfinders work the same way, and because this component plays a critical role in your camera use, it's worth understanding the differences.

Here's a look at your options:

>> **Optical viewfinders:** This term is used to describe a standard viewfinder — the kind that's been used for a long time in both film and digital cameras. Made from glass, optical viewfinders come in two forms:

- *Mirror-and-pentaprism (dSLR) viewfinders:* In a dSLR, a tiny mirror sits in front of the *shutter,* the barrier that prevents light from hitting the image sensor until you press the shutter button. The mirror reflects the light coming through the lens onto a *pentaprism,* which is a multi-angled mirror that flips the reflected image to its proper orientation and then bounces it to the viewfinder. When you press the shutter button, the mirror flips up, the shutter opens, and the light passes through the lens to the film or sensor. The mirror flips down after the shutter closes.

 This type of viewfinder is categorized as a *through-the-lens,* or TTL, viewfinder because the display is created by light coming directly through the lens.

- *Non-TTL (through-the-lens) viewfinders:* The problem with the mirror-and-pentaprism approach used by dSLR cameras is that the assembly that makes it possible adds to the size and weight of the camera. Rangefinders and most point-and-shoot cameras instead use a different setup: The viewfinder is set above and to the side of the lens.

 The disadvantage to this viewfinder setup is that it results in *parallax error.* Because the viewfinder and lens have slightly different angles on the world, the viewfinder doesn't show exactly what the lens will capture, making it difficult to precisely frame a photo. To help solve the problem, most cameras include framing marks in the viewfinder to guide you; when camera shopping, be sure the framing marks are easily visible. And note that not all viewfinders of this type are created equal — the amount of parallax error varies from camera to camera, so do your research.

>> **Electronic viewfinder (EVF):** In the past few years, manufacturers found another way around both the parallax problem and the bulky design of

the dSLR-style viewfinder by developing *electronic viewfinders.* Mirrorless interchangeable-lens cameras and some point-and-shoot compacts use this type of viewfinder.

With an electronic viewfinder (EVF), the camera sends the live feed that's normally displayed on the camera monitor to the viewfinder, and because the monitor shows the same area as the lens, this viewfinder option offers the same improvement in accuracy that you get with the dSLR system. But this system has two other benefits: First, you can not only use the viewfinder to compose your subject, but you can also see *everything* normally displayed on the camera monitor. You can review your photos through the viewfinder, for example, and see camera menus. I love these features when I'm shooting in bright sunlight — instead of having to look for a shady spot where I can clearly see what the monitor is displaying, I simply look at the viewfinder display.

However, EVF displays vary in quality, so this is one component you should test in person. Some are amazingly crisp, looking like a high-def TV display, and others are grainy and blurry, making it difficult to compose your pictures precisely. Also, keep in mind that you usually can't see anything through the viewfinder until you turn on the camera, which means that you can't set up your shots without using up battery life. More importantly, most electronic viewfinders go dark for a split second between shots, which makes it difficult to follow the action when you're shooting a burst of continuous frames.

While we're on the subject of viewfinders, make sure that you can easily make out the data displayed in the viewfinder. Especially for people who wear glasses, the readouts in some viewfinder displays are too small and dim to be easily read. You also want a viewfinder that can be adjusted to your eyesight; the control in question is called a *diopter adjustment.*

Video-recording capabilities

Most digital cameras can record video as well as still pictures. In this book, I don't provide much video-recording information, for a few reasons: First, if all you're after is basic recording, there's not much to it: You press the Record button to start recording and press it again to stop. On the other hand, if you want to get serious about digital cinematography, you're probably after a lot more information than I have room to offer in this book.

That said, I realize that you may want a little guidance as far as knowing which video-related specs are most important, so the following sections provide a quick rundown. You can find lots of information online; one site to get you started is www.dslrvideoshooter.com. Also check your camera manufacturer's website; many offer whole sections devoted to video recording.

Video-recording specs

First up are three specs that are commonly presented together, as in "Video recording: 1080p at 30 fps." Collectively, they tell you the resolution (frame size), frame-recording format, and number of frames per second, all of which contribute to the quality of your video. Here's the scoop:

TECHNICAL STUFF

>> **Video resolution (frame size):** Just like photos, digital videos are created out of pixels, and the resolution, or *frame size,* indicates how many pixels are used to produce each frame of video. The highest resolution found on most cameras is 1920 x 1080, known as *Full HD* (*high definition,* as in HDTV); the second highest, 1280 x 720 pixels, which is *Standard HD.*

Some high-end cameras, however, offer 4K video, which delivers *approximately* 4000 horizontal pixels and is designed for the hot (for now) new 4K displays. I say *approximately* because the exact number hasn't been standardized yet, so it varies from camera to camera.

Some cameras also offer a low-resolution setting of 640 x 480 pixels, which is old-school television resolution and has a screen format of 4:3, versus the 16:9 of HDTV. This setting can be useful if you want to post videos online and you need a small file size (every pixel increases that size).

>> **Progressive (p) versus interlaced (i):** This spec has to do with the way that the video frames are created. Progressive is the more current technology and is considered better for most video-recording purposes.

>> **Frame rate:** This value indicates how many frames the camera records per second, which affects the look of your movies:

- *24 fps*: The standard for motion pictures; gives videos a soft, movie-like look.

- *25 fps:* The standard for television broadcast in countries that follow the PAL video-signal standard, such as some European countries. It gives videos a slightly more "real-life" look.

- *30 fps*: Resulting in even crisper video, 30 fps is the broadcast standard for the United States and other countries that use the NTSC signal standard. It's the default setting for cameras bought in those countries, too.

- *50 and 60 fps:* These super-high frame rates are designed for capturing very fast action as well as for shooting footage that you want to play in slow motion. (More original frames delivers smoother slo-mo playback.)

 How about 50 versus 60? You're back to the PAL versus NTSC question: 50 fps is a PAL standard, and 60 is an NTSC standard.

- *120 fps:* A few cameras raise the frames per second bar even higher. Again, the purpose of this high frame rate is for creating slow-motion footage.

Most cameras offer at least two or three combinations of frame size and frame rate, but newer models often don't offer interlaced recording. That may be a problem if you want to shoot new footage and edit into existing interlaced footage; otherwise, don't sweat it.

Other recording features

Also take note of these other video-recording options:

- » **Audio features:** Built-in microphones on most cameras produce so-so audio quality. For better audio, some cameras allow you to attach an external, higher-quality microphone.

- » **Continuous autofocusing:** Most new cameras can track focus during recording, a capability that was missing until a couple years ago. However, one issue still exists on most cameras: If you use the camera's internal microphone to record sound, you may be able to hear the sound of the autofocus motor doing its thing when you play the movie. If the camera offers a jack to attach an external mic, problem solved: You can position the mic far enough from the camera to avoid picking up the focusing sounds. Of course, on interchangeable-lens cameras, you can forego autofocus and focus manually, but it takes practice to be able to adjust focus manually without creating noticeable camera movement.

- » **Movie length:** Digital cameras typically limit you to fairly short video clips — anywhere from 4 to 30 minutes — even if the memory card in the camera isn't full. You can start a new recording when one ends, but you then have to stitch them together in a video-editing program. Check the camera manual to find out the maximum movie length you can record; the answer changes depending on what resolution and frame rate you use to record the movie.

Memory-card features

Instead of recording images on film, digital cameras store picture data on removable *memory cards.* Most cameras can hold only one card at a time, but a few, like the model shown in Figure 1-15, have two card slots. This feature is great because you can configure the two cards to perform different storage functions. You can put all your Raw files on one card, for example, and JPEG files on the other. Or you can send all files to both cards so that if one fails, the other provides a safety net.

As for card type, most cameras use either SD (Secure Digital) or CF (CompactFlash) cards, which you can see peeking out of the front and back card slots in Figure 1-15. Some high-end pro cameras accept new card types, XQD and CFast, both of which are designed for high-resolution, high-speed shooters. Some cellphones and tablets enable you to store files on a Micro SD card, which is a miniature version of an SD card.

FIGURE 1-15:
Having two
card slots
provides
more storage
capacity and
flexibility.

Secure Digital card CompactFlash card

Although I would never choose a camera based on what *type* of card it uses, it is important to know what card *speed* the camera supports. A model that supports high-speed cards can write picture data to the card more quickly, enabling you to capture more frames per second and record smoother videos. Also note that some features provided on the latest cameras aren't compatible with old, slow cards.

Manufacturers use a variety of terms to specify card speed, and those terms vary depending on the type of card. Rather than bore you with an explanation of all the various speed specs, I'll keep it simple: A higher number means faster performance. Check your camera manual to find out which speeds it supports, and then buy the fastest card your budget allows. (Yes, prices go up along with speed.) Memory cards also vary in capacity; again, check your camera manual to find out how large of a card it can accept. If you're using an older camera, it may not be able to use today's super-capacity cards.

Convenience features

No matter what category of photographer you consider yourself, I rank the following features as not critical, but nice to have:

>> **Articulating (adjustable) monitor:** Some cameras, such as the Canon model shown in Figure 1-16, feature fold-out screens that can be rotated to a variety of angles. The benefit is that you can position the camera at nearly any angle while still being able to see the monitor. When not using the monitor, you can rotate it so that the screen faces the back of the camera, providing an extra degree of monitor protection.

>> **Touchscreen operation:** Of course, all smartphone cameras can be operated by touch, as can the phone's picture-playback tools. But touchscreens are being included on many other types of digital cameras as well. I originally thought touchscreens were a gimmick not worth the additional cost they add to a camera, but having used them for a while, I've changed my tune. They do make many camera operations easier, especially scrolling through pictures in playback mode and selecting options from menus.

>> **Remote control shutter release:** Being able to trigger your camera's shutter release with either a wired or wireless remote control comes in handy for a couple reasons. You can secure a camera on a tripod near your hummingbird feeder, for example, and then step away to avoid spooking any birds that come by, triggering the shutter release from afar. Remote control functionality also is great for long-exposure shots because you don't have to physically press the camera's shutter button, which can jog the camera just enough to introduce a slight blur.

Some cameras enable you to use a smartphone or tablet to trigger the shutter release. For more about remote controls, visit Chapter 10.

TIP

FIGURE 1-16: Some monitors can be adjusted to different viewing angles.

- » **Wireless connectivity:** If you buy a camera that offers wireless connectivity, you can enjoy the cable-free life when it's time to download pictures or share them online. Some models are designed to connect to a standard wireless network (such as one you may have set up to allow everyone in the house to access your Internet connection). Others offer NFC (Near Field Communication), which means that you can set the camera next to another NFC-enabled device, such as a tablet, and the two can connect on their own independent wireless channel. For more about this feature, see Chapter 9.

- » **In-camera editing tools:** Many cameras offer built-in retouching filters that can fix minor picture flaws, such as red-eye or exposure problems. For easier online sharing, you also may find in-camera options that create low-resolution copies of high-res originals and convert Raw files into the JPEG format. (You have to convert Raw files to JPEG in order to share them online.) These tools are especially helpful for times when you need to print or share a photo before you can get to your computer to fix the image in your photo software or create an online version.

- » **GPS tagging:** Have a hard time remembering — or proving — where you've been? Some cameras offer built-in GPS (global positioning satellite) technology that can tag your pictures with the location where you shot them.

- » **Video-out capabilities:** If the camera has a video-out port, you can connect the camera to a television and view your pictures on a TV screen. Some cameras offer both standard-definition and high-definition (HDTV) output; you may need to buy the necessary cables, however.

So . . . Is It Time for a New Camera?

Summing up all the details in the preceding sections, the answer is "Maybe." Consider investing in a new model if any of the following statements apply:

- » You're not happy with the quality of your printed photos.

- » You have trouble capturing action shots because your camera is a slow performer.

- » Your pictures appear noisy (speckly) when you shoot in dim lighting.

- » You're a serious photographer (or want to be) and your camera doesn't offer exposure control, Raw image capture, a flash hot shoe, or other advanced features.

- » Your current camera is so big and heavy that you often leave it behind — and when you do take it along, your neck and back start to hurt in no time.

Of course, some cameras address these issues better than others, so again, be sure that you read reviews on any new model you consider. Also consult with the salespeople at your local camera store, who can point you toward cameras that best solve the picture–taking problems you're experiencing.

WARNING

AVOIDING SHOPPING PITFALLS

Whatever type of camera you decide to buy, remember these shopping tips:

- **Be suspicious of unusually low prices.** If you see new camera equipment offered for significantly less than it's priced at major retailers, you can be pretty sure you're buying *gray market goods.* These are goods manufactured for sale in other countries, where the market may require lower prices than in your neck of the woods. Gray-market sellers snap up those bargain-priced models, import them, and then offer them to you at "bargain" prices. Usually, your purchase turns out to be anything but a good deal, however. You may find that the camera warranty is no good in your country, the user manual is written in a foreign language, or you have to pay extra for components that usually are included in the camera box, such as the battery charger.

- **Remember that a higher price tag doesn't necessarily translate to better pictures.** Yes, you typically pay more for cameras that offer the features that deliver higher photo quality, such as larger image sensors. But just as with any other product, you can also pay a premium for vanity features, such as a limited-edition model that bears a celebrity's name or has a case made out of leather. Go for it if those things make you happy; just don't expect them to improve your photos. Nor does paying through the nose for the latest and greatest smartphone promise of superb image quality; as detailed elsewhere in this chapter, the smaller sensors and lenses used for cellphones simply can't produce the ultimate in image quality.

- **Check the return policy:** Find out about the camera's warranty and the return policy of the store where you plan to buy. Many retailers charge a *restocking fee,* which means that unless the camera is defective, you're charged a fee for the privilege of returning or exchanging the camera. Some sellers charge restocking fees of 10 to 20 percent of the camera's price. You might also consider renting the camera you're considering for a day or two so that you can be sure it's the right choice. Some camera stores offer this service, and you also can rent from online companies such as BorrowLenses.com and LensRentals.com.

Chapter 2

Starting to See Like a Photographer

When I started mingling with professional photographers, I noticed that they often used the term "making a photograph" instead of "taking a photograph." At first, I assumed this was just a bit of artistic posturing — after all, isn't producing a photograph simply a matter of pressing a shutter button?

But as I learned more about photography, I realized that pressing the shutter button is actually the last in a series of steps a good photographer takes to create an image. Before that moment, you need to consider several creative issues, such as composition, *depth of field* (how much of the surrounding area should be as sharply focused as your subject), whether you want to blur or freeze action, and lighting. For the most part, you can control these aspects of your photograph even when shooting with basic cameras, although advanced models give you a few additional tools for varying depth of field, motion blur, and lighting.

This chapter helps you understand these creative choices so that you can start creating stronger images. Also check out Chapter 7 for additional tips specific to shooting better portraits, landscapes, close-ups, and action photos.

Exploring Composition Basics

Not everyone agrees on the best ways to compose an image — art being in the eye of the beholder and all that. But the tips laid out in this section are generally accepted as tried-and-true ways to give your photos more visual appeal. For every "rule," however, you can find great-looking images that prove the exception, so don't be afraid to experiment with other artistic ideas.

Positioning elements in the frame

When framing a scene, try positioning your subject and other elements according to one of these three guidelines:

>> **Rule of Thirds:** Perhaps the best-known composition strategy is to divide the frame into horizontal and vertical thirds and position your subject at a spot where two lines intersect. Notice the placement of the bee in Figure 2-1, for example.

FIGURE 2-1: One rule of composition is to divide the frame into thirds and position the main point of interest at the spot where two lines intersect.

>> **Golden Ratio:** This concept follows the same idea as the rule of thirds, but the framing lines are spaced a little differently, as shown in Figure 2-2.

>> **Golden Triangle:** Yet another variation on the theme, this arrangement divides the frame into triangles, as shown on the left in Figure 2-3. The sweet spots for your subject are, again, at the points where those lines intersect.

REMEMBER

Notice the one characteristic all three framing guides have in common: None puts the center of interest smack-dab in the middle of the frame. If you take away only one lesson from this section, remember that moving your subject off center can greatly improve the composition. In the first image in Figure 2-4, for example, I positioned the horizon line halfway down the frame. Most people would be happy with that shot, especially given the stunning shades of the sunset. But compare that photo with the one on the right, and you can see that reframing to shift the horizon line down creates a more dynamic composition.

What about portraits, where the goal is to fill the frame with your subject — such as in a senior portrait? The same concept applies: Assuming that you're shooting the person's face (or full body, with face visible), the eyes are the most important component of the image, so place them at one of the intersecting lines suggested by the framing guidelines you choose to follow.

You can find other proven compositional guides if you do an online search for the term *image composition.* Don't worry about whether you land on a page devoted to paintings or drawings instead of photography — the principles are the same no matter what your creative medium.

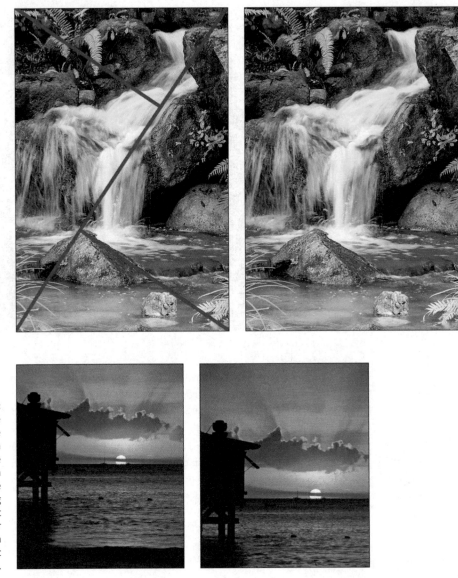

FIGURE 2-3:
A third
compositional
concept divides
the frame into
triangles.

FIGURE 2-4:
Positioning the
horizon line
halfway down
the frame
makes for a
dull image
(left); reframing
to move that
line off center
leads to a
more dynamic
shot (right).

Creating movement through the frame

To add life to your images, compose the scene so that the viewer's eye is led naturally from one edge of the frame to the other or even entirely around the frame. You can create these *leading lines* with shapes, patterns of color, or variations of light and shadow.

Figure 2-5, which I captured after climbing at least a million steps to the top of a lighthouse, shows an obvious example of this concept. The strong curve of the railing on the left leads the eye into the frame, and the spiral formed by the stairs carries the movement to the bottom of the lighthouse. Light plays a role, too: Notice that the areas of sunlight and shadow create additional paths for the eye to follow.

FIGURE 2-5: The spiraling stairs, along with the patterns of light and dark, lead the eye from the top of the stairs to the bottom.

In Figure 2-6, the diagonal lines created by the oars and the blue and white areas of the boats lead the eye from left to right. In the left image in Figure 2-7, the winding canal takes the eye from the boat in the foreground to the back of the frame. In the right image, color and form create the movement. The eye is drawn from the bright pink tail feathers of the right flamingo, around the curves of the second bird, down to the reflections in the water, and then up again to those first tail feathers.

FIGURE 2-6: You also can use strong diagonal lines to create movement.

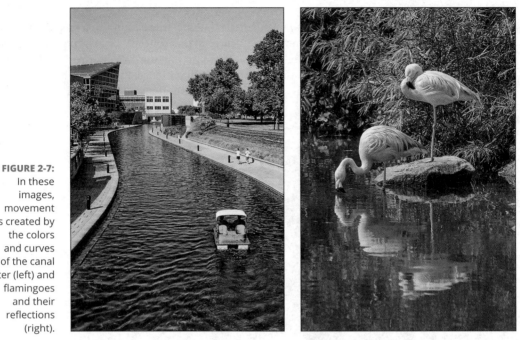

FIGURE 2-7: In these images, movement is created by the colors and curves of the canal water (left) and flamingoes and their reflections (right).

Eliminating clutter

Do you know that claustrophobic feeling you get when you walk in a store that is jam-packed to the rafters with goods — so cluttered that you can't even move down the aisles? That's the same reaction most people have when looking at a photo like the one in Figure 2-8: There's simply too much going on. The eye doesn't know where to look, except away.

As a photographer, you must decide what you want your main subject to be and then try to frame the shot so that distracting elements aren't visible. For example, in Figure 2-9, reframing the shot to include just a portion of the ride creates a much better image. All the energy of the fair is captured in the whirling chairs, and the composition is such that the eye moves around the curve of the frame to take it all in.

WARNING

Being aware of the subject's surroundings is especially critical in portraits. If you're not paying attention, you can wind up with plant-on-the-head syndrome, as illustrated in Figure 2-10. The window blinds and computer monitor further distract from the subject's beautiful face in this picture.

FIGURE 2-8:
This shot looks chaotic because there's too much going on for the eye to land on any single subject.

FIGURE 2-9:
Concentrating on just a small portion of the ride captures its energy without all the distracting background.

Leaving some head room

When shooting a portrait — or any subject, for that matter — don't frame your images so tightly that your subject looks cramped. Instead, allow what photographers refer to as *head room*, which means leaving a small margin of empty background at the top of the frame. When shooting a subject in profile, also leave extra padding in the direction that the subject's eyes are focused, as shown in Figure 2-11. This helps the eye follow the focus of the subjects across the frame and then causes the viewer to imagine what is just out of sight.

For action shots, you may need to increase the amount of background margin on the side of the frame where the subject is headed. As an example, see Figure 2-12. I left plenty of empty space on the right, according to the direction the biker is riding. Otherwise, it appears that there's nowhere for the subject to go.

FIGURE 2-10:
Scan the background for distracting objects to avoid plant-on-the-head syndrome in portraits.

FIGURE 2-11:
Leaving extra space on the right causes the viewer to follow the subject's glance across the frame.

FIGURE 2-12:
Give moving subjects somewhere to go in the frame.

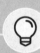

TIP

REFINING COMPOSITION WITH A CROP TOOL

In the interest of full disclosure, I need to tell you that very few images you see in this chapter appear exactly as I originally shot them. Most contained at least some additional margin of background that I cropped away to arrive at the compositions shown in the figures. "Wait," you say. "Isn't that cheating?" If you're a photojournalist and the cropped photo creates a false impression of the event you're documenting, then yes, cropping is verboten. But for the rest of us, I believe that cropping after the shot is an absolutely acceptable way to arrive at the best composition. In fact, it's often a necessity.

When you're shooting a still life, such as a product advertisement shot or a studio portrait, you have time to perfectly arrange the elements in a scene. But when you're photographing a moving target — especially one that stings (see the bee in Figure 2-1) — you don't have that luxury. Framing your shots a little loosely gives you the flexibility to crop the image to the composition you had in mind. It also enables you to crop to different aspect ratios, which is important for images you want to print. Keep in mind that most cameras capture an image that has a 3:2 aspect ratio, which translates perfectly to a 4 x 6 print but needs cropping to fit a frame size with a different aspect ratio. In the two

images below, you see how much of a 3:2 original fits inside a 5 x 7-inch frame (left) and 8 x 10-inch frame (right). If your camera captures 4:3 originals, you need to crop even to create a 4 x 6-inch print.

The good news is that you don't need a high-powered photo-editing program to trim away the parts of the image you don't want. You can find a crop tool in nearly every program that enables you to view a digital image, including cellphone photo apps. (See Chapter 11 for a look at the process of using a crop tool.) Some digital cameras even have built-in crop tools that enable you to create a cropped copy of an image before you even download files to your computer; check your camera manual to find out if your model offers that flexibility.

Using Depth of Field to Artistic Advantage

When you set focus on your subject, you establish the distance at which the image appears sharpest. *Depth of field* refers to how far that sharp focus zone extends in front of and behind that point.

Figure 2-13 shows examples of both treatments. In the left image, the sharp focus region extends only a few inches in front of and behind my subject, the butterfly. Notice that the leaf in front of the butterfly appears just slightly blurry, and

the background objects become progressively blurrier as the distance from the butterfly — the focus point — increases. The right image features a landscape that has a very large depth of field. I set focus on the hut on the left side of the walkway, but everything in front of and behind that structure remains sharp for quite a distance.

FIGURE 2-13: A short depth of field causes foreground and background objects to blur (left); a long depth of field extends the range of focus over a greater distance (right).

Skilled photographers vary depth of field for two main reasons:

>> **Assign visual weight to the various elements of a scene.** Viewers typically look first at the parts of a photo that are in sharpest focus. So a short depth of field draws the eye to a specific portion of the frame, and a long depth of field prompts the eye to consider all objects in the scene together.

Consider the photos in Figure 2-14, for example. In both cases, I set focus on the gecko. In the left image, the depth of field is large enough that the pink flower behind the gecko subject is sharp, giving it and the gecko equal visual weight. In the right image, a shallow depth of field blurs the flower, which in turn emphasizes the gecko. Neither treatment is right or wrong; this use of depth of field is completely up to your artistic discretion.

>> **Diminish the impact of distracting background and foreground objects by using a short depth of field.** In my butterfly image, for example, blurring the foreground and background greenery prevents them from grabbing attention from the butterfly.

FIGURE 2-14:
With a long depth of field, the flower and gecko have equal visual weight (left); shortening the depth of field makes the gecko the star of the shot (right).

» **Visually separate your subject from a similarly colored background.** I used this tactic for the photo shown in Figure 2-15, which features a caterpillar munching away on my milkweed plant (a trade I offer willingly in exchange for photo ops and, eventually, butterflies). The only angle I could get for this shot was against a background that was very similar in color to the white and yellows of the caterpillar. So that those areas didn't make it difficult to distinguish the caterpillar, I shortened depth of field as much as possible. The difference in focus between background and subject creates a distinct boundary between the two.

FIGURE 2-15:
A short depth of field helps a subject stand out from a similarly colored background.

Enough theory; I think you get the idea. The question now is, how do you control this important aspect of your photos? Depending on your camera, you can use some or all of the following techniques:

>> **Change the distance between your subject and the objects in the background or foreground.** Remember that depth of field determines how far the sharp focus zone stretches in front of or behind your subject. So if you want more blurring of the background, for example, move your subject farther in front of it.

>> **Move the camera closer to or farther from your subject.** For less depth of field, move closer to the subject; for greater depth of field, back up. Of course, moving the camera also changes the angle of view of the photo. The farther you are from the subject, the more of the surrounding area you include in the scene.

>> **Vary the lens focal length.** If your camera has a zoom lens, you can increase depth of field by zooming out to the shortest focal length. Go the other direction to reduce depth of field. For example, if you're shooting with an 18–55mm lens, you get more depth of field at 18mm than at 55mm.

With an interchangeable lens camera, you can also just swap out lenses according to whether you're after a short or long depth of field. But again, keep in mind that changing the focal length also changes the angle of view; a shorter focal length delivers a wider view than a longer focal length. (The Chapter 1 section related to lenses talks more about focal length.)

>> **Adjust the aperture (f-stop) or use an automatic Scene mode designed to produce the depth of field you want.** If your camera enables you to specify the aperture setting, dial in a low f-stop number for shallow depth of field; raise the f-stop number to increase depth of field. Before you go this route, though, explore Chapter 5, which explains how adjusting aperture also affects image exposure.

If you don't have the option to set the f-stop or you don't want to get involved with exposure settings, you may be able to manipulate depth of field by using certain common Scene modes:

- *Use Portrait mode for shallow depth of field.* Because the traditional portrait look is a sharp subject against a blurred background, this shooting mode automatically uses a low f-stop setting to achieve that effect.

- *Try Landscape mode for long depth of field.* This mode takes the aperture setting in the other direction, using a high f-stop number to extend the zone of sharp focus over a large area.

Be aware, though, that Portrait mode also warms colors (emphasizes reds and yellows) and softens contrast in order to produce a more flattering portrait. And Landscape mode boosts cools tones (blues and greens) and typically increases contrast, producing the traditional bold, crisp look popular among

landscape photographers. In addition, whether the camera can use the f-stop setting that creates the intended depth of field depends on the available light: The correct exposure is given more weight than depth of field in the camera's f-stop decision, so in very bright or very dim lighting, you may not enjoy short depth of field in Portrait mode or long depth of field in Landscape mode. See Chapter 3 for more about using these Scene modes.

>> **Look for other automated shooting modes that enable you to adjust depth of field.** Cameras that offer a guided shooting mode, which takes you step by step through setting up the shot, usually ask you to specify the type of subject you want to shoot and then ask whether you want a blurred or sharp background.

REMEMBER

Keep in mind that the camera-to-subject distance, subject-to-background (or foreground) distance, focal length, and f-stop setting combine to determine the final depth of field. So for maximum depth of field, use the shortest focal length and highest f-stop setting possible, move farther from your subject, and, if possible, position your subject closer to foreground and background objects. For minimum depth of field, do the opposite.

Capturing Motion: To Blur or Not to Blur?

Any time you're photographing a moving subject, whether it's an athlete on the field, a toddler taking those first steps, or a flower blowing in the wind, you have two choices:

>> **Freeze time.** In other words, capture a split second in time, such as the moment a tennis racquet hits the ball, or, as is the case in Figure 2-16, the moment a drop of water falls from an icicle. This image, by the way, is not a black-and-white photo; the day I shot the melting ice was simply devoid of color. You should also know that it took many, many frames to get the timing of the shot just right, capturing the drop of water at the position you see it in the figure. On a personal note, it was this ice storm, which kept me housebound for four days, that convinced me to relocate from Indiana to south Florida. I do miss my friends in the Midwest, but at my age, photographing palm trees and sunny beaches is a little more appealing than standing in the bitter cold and snapping images of icicles.

FIGURE 2-16: I used a fast shutter speed to capture a melting drop of water in midair.

» **Allow the moving object to appear blurry.** A little blur can emphasize movement, as shown in Figure 2-17. Notice that the iguana's raised arm is just a tad out of focus, and that blur helps tell the viewer that the iguana was moving toward the camera. You also can blur the object so much that you create an abstract field of color, as I did in Figure 2-18. The subject for this picture was a whirling carnival ride.

FIGURE 2-17:
The slight blur of the iguana's arm emphasizes that the creature is in midstride.

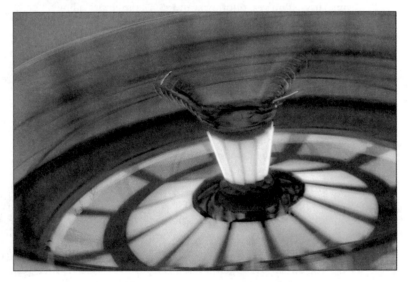

FIGURE 2-18:
Allowing a colorful moving object to blur completely produces a fun abstract image.

Here's what you need to know to take control over this aspect of your photos:

» **Shutter speed determines whether a moving object appears blurry.** *Shutter speed,* measured in seconds (or fractions of seconds), determines how long light is allowed to strike the image sensor, which helps determine image exposure and also affects motion blur. I explain the role of shutter speed in image exposure in Chapter 5, but for the purpose of controlling motion blur, all you need to know is that a fast shutter speed freezes motion and a slow shutter speed blurs it.

» **The shutter speed you need to blur or freeze action depends on the speed of your subject.** For my icicle image, I set the shutter speed to 1/500 second; for the iguana, 1/250 second; and for the carnival ride, 1/5 second. But don't mistake the speeds I used in my examples as one-speed-fits-all recipes; you need to experiment to find out which shutter speed works best for the amount of blur (or lack thereof) you have in mind for your subject.

To give you a general guideline, though, you can usually freeze a moderately paced subject, such as a person walking, at about 1/320 second. For faster subjects, such as birds flapping their wings or dogs bounding across a yard, go higher — about 1/640 second should get you close to where you need to be. To blur motion, I start at about 1/20 second. But again, it's important to take test shots at different shutter speeds, check the results, and then go with a higher number (faster shutter speed) or lower number (slower speed) if you're not happy with the results.

» **If your camera offers shutter-priority autoexposure mode, try using that mode when controlling motion blur is important.** In this shooting mode, you set the shutter speed, and the camera selects the f-stop (aperture size) needed to properly expose the image at the current ISO (the setting that determines the light sensitivity of the image sensor). You also can adjust shutter speed in manual exposure mode, but if you go that route, you have to adjust the f-stop setting yourself. (Again, see Chapter 5 for more about these settings and general exposure information.)

» **You also can achieve different motion effects with certain automatic scene modes.** To freeze action, try Sports mode, which tells the camera to select the fastest shutter speed possible that will produce a good exposure. Achieving intentional motion blur is a little more difficult. If your camera offers a nighttime landscape or nighttime portrait mode, give those modes a try; both typically force a slow shutter speed. Some cameras also offer a waterfall mode designed to slow the shutter enough to blur the water, producing the classic misty water effect that you can see earlier, in Figure 2-3.

WARNING

» **When using a slow shutter speed, use a tripod to avoid camera shake.** Any movement of the camera during the exposure blurs the entire image, not just the elements that are in motion.

>> **How fast or slow a shutter speed you can use depends on the light and your other exposure settings.** Specifically, you may need to adjust the f-stop (aperture setting) and ISO setting (light sensitivity) to get a good exposure at the shutter speed you have in mind.

>> **If your camera offers a continuous shutter-release setting, try using that option to capture fast action.** In this mode, the camera clicks off a continuous series of frames as long as you keep the shutter button depressed, increasing the odds that you'll capture that highlight-reel moment in time. I talk more about this setting in Chapter 4.

Becoming a Student of Light

Creating a photograph requires light — the word *photograph*, in fact, stems from the Greek words *photo* (light) and *graph* (writing.) Chapter 5 explains how to adjust your camera settings to get a proper exposure in any light — although, frankly, today's autoexposure systems handle that job fairly well with little input from you. Just as important, though, is becoming aware of the following characteristics of light and how they affect your images:

>> **Quality of light:** Is the light soft and diffuse, touching everything evenly and creating very little shadow, as you might see on an overcast day? Or is the light harsh and narrowly focused, creating what photographers call *contrasty* light — leaving some parts of the scene very bright and others very dark?

>> **Color of light:** Every light source infuses a scene with its own color cast. For example, just before sunset and just after sunrise, the sun paints the scenery with a beautiful yellow orange tint, which is why photographers refer to these times of day as the *golden hours*. And the period just after sunset and just before sunrise is called the *blue hours* because the light takes on a cool, bluish tint at that time.

TIP

Don't fret if you can't wait for golden-hour light; if you like the golden color cast, you can create it artificially via your digital camera's White Balance control, which I discuss in Chapter 6. Ditto for blue-hour light. On the flip side, if you prefer to neutralize the color of the light source, you can use the White Balance control to make that shift.

>> **Direction of light:** The angle at which the light hits a subject is also important. Most people gravitate toward front lighting because it provides the greatest degree of subject illumination. But you often can get more interesting results with side lighting, which brings out the texture in a subject, or back lighting, which you can use to either photograph your subject in silhouette or bring out details that emerge when light shines through translucent objects.

Figures 2-19 and 2-20 offer two examples to get you to start thinking more about how these attributes of light affect your images. In the first image, the sun is striking the buildings from directly overhead, telling the viewer what time of day the shot was taken. Bright daylight is nearly white, lending no additional color to the scene, and making the skies appear a brilliant blue in contrast.

FIGURE 2-19:
The midday sun strikes a New York street with bright, neutral light.

FIGURE 2-20:
The fading sunlight in this scene lends a soft, golden tone to the image; the direction of the light creates interesting reflections in the water beneath the bridge.

In Figure 2-20, the soft, warm light bathes everything in that lovely golden-hour light, telling you that the shot was taken just before sunset. Yet the direction of the light is such that the bridge reflects in the water — an important element in this scene.

TIP

A side note regarding Figure 2-19: The buildings seem to lean toward each other because of the lens phenomenon called *convergence,* which occurs any time you point your camera lens up at a building (or down, if you're standing on a nearby rooftop). You can buy a special *tilt-shift* lens to avoid this issue or correct the leaning structures in a photo editor. But in this case, I like the result because they suggest the somewhat caged-in feeling I get when I actually walk among skyscrapers.

Again, Chapter 5 explores the topic of light, including how to achieve a brighter or darker exposure than the camera's autoexposure system thinks is ideal. You also can find tips for using flash and other artificial light sources in that chapter.

Exploring New Subjects and Angles

One more piece of advice I can give to help you make the shift from picture-taker to photographer is to look for the subject or subject angle that sets your photo apart from the ones that everyone else snaps. Here are a few ideas to help you achieve this goal:

>> **Find a new perspective.** Figure 2-21 shows two views of an architectural ruin located in a park in Indianapolis. My guess is that about 90 percent of park visitors who photograph the ruin capture the wide-angle front view shown on the left. Technically, it's fine — in focus, nice colors, and so on — but there's nothing compelling about the image. Compare that photo with the one on the right side of the figure, which gives you an entirely different take on the scene. In this close-up view, you can see the details that make this structure so intriguing when you see it in person: the expression on the man's face, the rough texture of his body, and even the veins in his foot.

>> **Look for interesting reflections, patterns, and textures.** Figures 2-22 and 2-23 offer two examples. I was attracted to the first scene by the way the hard, straight edges of the lines in the side of the building emphasize the distortions of the lines in the reflected buildings. In the second photo, the rough texture and pattern of the brick walkway provides an interesting contrast to the soft petals and curving leaves of the flower.

FIGURE 2-21: The left image is a technically fine rendition of the scene, but the right image provides a more interesting angle and reveals details not visible in the wide-angle view.

» **Search beyond the usual suspects.** Most people focus their cameras on the obvious: When in Rome, for example, everyone takes a picture of Trevi Fountain, and if you go to the beach, photographing the sunset or sunrise is pretty much a requirement. I'm not saying that you should ignore those subjects, but if you want your photographs to stand out, search for scenes that most people wouldn't think of as photographic opportunities. If you keep your eyes open, subjects often present themselves when and where least expected. That was the case with the photo featured in Figure 2-24.

The story: I went to a butterfly garden with the intention of filling up my camera's memory card with images of those winged beauties. But it was summer in south Florida, and the heat and humidity got to

FIGURE 2-22: When shooting in the city, look for interesting reflections in windows.

me faster than I anticipated. I knew that I had enough butterfly pictures to have made the trip worthwhile, so I headed toward the parking lot. Luckily for me, the path to the exit leads past a large, decorative pool. As I stood for a moment debating how much trouble I would get into if I jumped into the water to cool off, I noticed the feather and the flower petals floating on the surface. Whatever part of my creative brain that wasn't shut down by the heat kicked into gear, excited by the mixture of colors and textures in the pool.

The result was the image that I considered the most successful shot of the day. Why? Because it was *different*. I'm fairly certain that almost everyone who took a picture at those gardens came home with at least one or two good butterfly images, but I suspect that I may be the only person who captured this colorful collage.

FIGURE 2-23:
Here, the softness of the flower provides interesting contrast to the rough texture of the brick.

FIGURE 2-24:
A feather, a few flower petals, and a watery background create a colorful image, enhanced by the leaf shapes visible at the bottom of the pool.

Chapter 3

Easy Does It: Using Auto and Scene Modes

Learning all there is to know about digital photography — heck, learning a hundredth of what there is to know — isn't a quick process. You have so many technical terms and camera settings to consider that it's just not possible to sort everything out in a few days or a single read of this book. The good news is that while you're getting up to speed, you can still take great-looking pictures by using your camera's automatic shooting modes, which select most exposure settings and other critical options for you.

Even when you're shooting in automatic modes, though, you can get better results by following a few guidelines, which I lay out in this chapter. After helping you set up your camera for automatic shooting, I walk you through the steps of taking pictures in Auto mode. Following that, you can get information about *scene modes,* which automatically choose settings geared to certain types of photos.

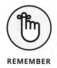

REMEMBER

Note: Most "device cameras" — that is, cameras built into cellphones, tablets, or other multipurpose devices — don't offer the range of options that I discuss in this chapter or later chapters. So from this point forward, most information assumes that you're working with a standalone camera and not a mobile-device camera.

That said, each new phone or tablet release seems to include additional picture-taking options, and new apps to help you process and shoot pictures crop up every day. I encourage you to check your device's user manual to find out what options are included and how to implement them. (In most cases, the user manual is provided in electronic form on the device itself.)

Investigating Automatic Shooting Modes

Although the number and type of automatic exposure modes vary from camera to camera, most models now offer these options:

>> **Auto mode:** This setting is designed to deliver good results no matter what your subject. Think of it as one-size-fits-all shooting. Some cameras also have an Auto Flash Off setting, which is just like Full Auto but with the flash disabled. (It's designed for shooting in places that don't permit flash, such as most museums.)

>> **Scene modes:** These modes enable you to take a little more artistic control over your images but still enjoy automatic shooting. Scene modes are designed to produce the picture characteristics traditionally found in certain types of photographs, such as portraits and action shots.

>> **Special-effects modes:** As the title implies, these modes automatically apply special effects, such as giving a photo a watercolor look or a grainy, black-and-white appearance.

I cover Auto mode and the four most common scene modes later in this chapter. I don't discuss special-effects modes because, although they're fun to play around with, they also get people into trouble. Here's the problem: If you like the composition and subject of an image that you take in effects mode but aren't keen on the effect itself, you're stuck — you can't remove the effect from the image. If you do shoot in effects mode, take a couple snaps of the subject in Auto mode or another non-effects mode as well.

You can always apply an effect to a copy of the normal photo, if you like. In fact, some cameras offer built-in editing tools that enable you to apply effects to a copy of an existing image. You also can find countless apps and photo programs that enable you to add special effects to photos after you download them to your computer or another device.

One other word of advice before you move on: Automatic exposure modes are helpful in that you don't have to know much about photography or worry about setting a bunch of controls before you shoot. But you typically lose access to features that may be helpful for capturing your subject. For example, the camera usually decides whether a flash is needed, and you can't override that decision. You also may not be able to tweak color, focus, or exposure. Sometimes, you can't even access the camera's entire cadre of menu options in automatic modes.

TIP

If your camera offers more advanced exposure modes, such as programmed auto-exposure, aperture-priority autoexposure, shutter-priority autoexposure, or manual exposure, it's worth your time to learn how to use them. They may take a while to fully grasp, but they make your life easier in the long run because you can easily tweak exposure, color, and focus settings to precisely suit your subject. See Chapters 5 and 6 for a look at the picture-taking options you can access when you shift out of fully automatic exposure modes.

Setting Up for Automatic Success

I assume that if you're starting out with a new camera, you already unpacked the box and performed such basic setup steps as attaching a lens, putting in the battery, and inserting a memory card. If you haven't, do so now, following the instructions in your camera manual. (Can't find the manual? Hop online and visit the manufacturer's website. Look in the support section of the site for a link to download the manual in electronic form.)

With those tasks out of the way, take the following additional steps to prepare the camera for shooting in automatic modes:

1. **Select the shooting mode you want to use.**

 Typically, you set the shooting mode via a dial on the top or back of the camera. For example, the left image in Figure 3-1 shows the mode-selection dial from a Nikon model; the right image shows a dial from a Canon camera.

 Auto mode, if not represented by the word *Auto* itself, is usually represented by a green camera or a green rectangle adorned with the letter *A,* as shown in Figure 3-1. On some cameras, however, the A setting brings up aperture-priority exposure mode rather than Auto mode. Your camera manual should point you to the right setting for automatic shooting.

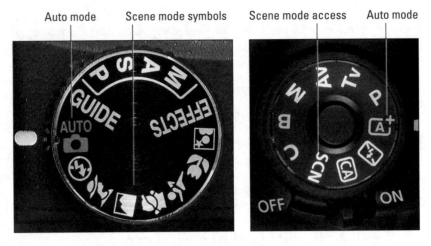

FIGURE 3-1: Here are two symbols commonly used to represent the Auto shooting mode.

Auto mode Scene mode symbols Scene mode access Auto mode

Scene modes may also be available via the mode dial; they're sometimes represented by symbols like the ones shown on the left in the figure and listed in Table 3-1. Or you may need to set the mode dial to Scene (sometimes abbreviated SCN, as in the right image in the figure), and then scroll through screens that appear on the monitor to select a specific scene type. Cameras that offer tons of scene modes sometimes take a hybrid approach: You can select a few scene modes from the dial, and to access others, you set the dial to Scene and then scroll through menus to select a mode.

2. **Restore the camera's default shooting settings.**

Your camera's default settings are designed to make it as easy as possible to get good results from the get-go. If you've played with any settings since initial setup, don't worry: Just check your camera manual to find out how to restore the defaults.

TABLE 3-1 **Common Scene Modes**

Symbol	Name	What It Does
👤	Portrait	Selects settings that produce a sharp subject set against a blurred background; also softens and warms skin tones.
⛰	Landscape	Chooses settings that keep as much of the scene in sharp focus as possible, increase contrast, and emphasize blues and greens. Flash may be disabled.
🚶	Sports	Selects a fast shutter speed to freeze motion. It also usually disables flash and uses burst-mode shooting. (The camera records a continuous series of images as long as you hold down the shutter button.)
🌷	Close-up	Blurs background and foreground objects to emphasize your subject; on some cameras, enables closer focusing than is normally possible.

TIP

When the camera is set to an automatic shooting mode, sometimes simply turning the camera on and off is enough to restore the defaults. But you also should find a menu option that resets most camera options to their original states. With some cameras, you may need to choose a reset option on more than one menu. For example, you may need to reset things on both a main shooting menu and a second menu of advanced options. You may also discover a way to reset critical shooting options by pressing a couple of buttons on the camera body.

3. **Check the battery status.**

Most cameras display a symbol like the ones shown in Figure 3-2 to indicate a fully charged battery. If the battery symbol is partially empty, take the time to charge the battery or, if that's not possible, check out Chapter 12 for tips on how to preserve the battery power that remains.

REMEMBER

As with all the camera screens shown in this book, the two in Figure 3-2 are generic mash-ups provided just to give you a look at how certain common camera settings are represented. Where you find these symbols depends on the camera, and if your model offers a viewfinder, its data readout may include certain symbols as well. To find out how information is presented on your camera, look in the first part of your camera manual, which should provide a guide to various information screens.

FIGURE 3-2: Most cameras display information about the battery status and number of shots remaining on the main data screen.

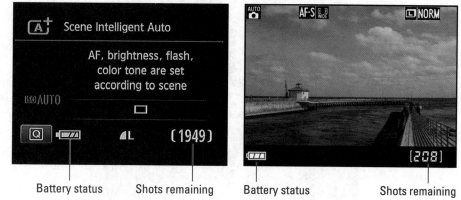

4. **Make sure that your camera memory card has plenty of free space.**

The camera display should also indicate how many new pictures the installed memory card can hold. Where you find this value varies; the values highlighted in Figure 3-2 give you just two examples.

If your card is running low on space, you can either delete unwanted images or download files to your computer to free up room for new pics. But wait until

after you take Step 7 to do it; the number of remaining shots may change depending on the decisions you make at that point.

5. **Set the focusing method to automatic.**

If your camera offers both manual and automatic focusing, choose autofocusing. Depending on your camera, you accomplish this in one of the following ways:

- *Set a switch on the lens or camera (or both).* On a removable-lens camera, you usually adjust this setting by using a lens switch, like the one shown in Figure 3-3. Look for a switch marked A or AF for autofocusing. The label AF/M indicates autofocusing with manual override, a feature that enables you to autofocus initially and then fine-tune focus manually, if needed.

 With advanced interchangeable-lens cameras, you may need to set a focus-method switch on the camera body itself, too.

- *Select the focusing method from a camera menu.* If your camera or lens doesn't offer a focus-method switch, press the Menu button and look for the option within the camera menus.

Image Stabilization switch

Auto/Manual focus switch

FIGURE 3-3: On interchangeable-lens cameras, you may find a switch to set the camera focusing method and another to enable image stabilization.

6. **Unless you're mounting the camera on a tripod, enable image stabilization, if available.**

This feature, which you may enable via a lens switch like the one shown in Figure 3-3 or from a camera menu, helps to compensate for any camera shake that can occur when you handhold the camera. That camera shake can create a blurry image. You still need to hold the camera as still as possible, however; image compensation can't correct for a large amount of camera shake.

Remember that this feature goes by various names depending on the equipment you're using. It may also be called vibration reduction, vibration compensation, or something similar.

7. **Check the file type and resolution.**

I provide full details on both options in the next chapter, but in short, they work together to determine image quality. Until you have time to digest Chapter 4, I recommend using the following settings:

- *Set the file type to high-quality JPEG.* The file-type option goes by different names depending on the camera, too — Image Quality, Image Type, and so on. Regardless of the name, the two most common file types are JPEG and Camera Raw (or Raw, for short). The latter is an advanced option that requires some after-the-shoot processing work not necessary with JPEG, so stick with JPEG for now. Usually, you can opt for a few different JPEG settings, often given vague names such as Fine, Normal, and Basic. Each of these settings results in a different level of image quality. More about that issue momentarily.

- *Select the highest resolution setting.* This option, detailed in Chapter 4, determines how many *pixels* the image contains. The more pixels, the larger you can print your photos and expect good picture quality. Common names for this setting are Image Size or just Size.

TIP

Although JPEG is typically the default file type, many cameras don't use the top JPEG quality setting or maximum resolution option by default. Why? Because those settings create larger files, which means you can fit fewer pictures on your memory card. But if your memory card has plenty of space, I say go ahead and select the top resolution setting and JPEG quality option. Just keep an eye on the shots-remaining value in the camera display; that number drops as you dial in higher-quality settings. Check your camera manual for specifics on how to adjust these settings and for the name given to the top-quality JPEG option.

That's it — you're ready to start shooting. You can find step-by-step instructions for taking pictures in Auto mode in the next section and find additional information about scene modes after that.

ADJUSTING THE VIEWFINDER TO YOUR EYESIGHT

REMEMBER

If your camera has a viewfinder, you can adjust the focus of the viewfinder to match your eyesight, just as you can adjust binocular eyepieces. Making this adjustment is critical; otherwise, subjects in the viewfinder may appear blurry when they're actually in focus, and vice versa.

Follow this process: First, turn on the camera and remove the lens cap, if your camera has one. Now look near the edge of the viewfinder for a tiny dial or switch like the one shown in the sidebar figure. You use this control, officially called a *diopter adjustment control,* to set the viewfinder focus.

With your finger on the adjustment switch or dial, look through the camera and aim the lens at a bright, plain surface, such as a white wall. Press the shutter button halfway to display data at the bottom of the viewfinder. Then move the adjustment dial or switch until the data display appears sharpest. Also notice any lines in the center of the viewfinder, which relate to autofocusing or provide picture-framing guides, depending on the camera. Those lines, too, become blurrier or sharper as you adjust the viewfinder focus.

Remember: You're adjusting only viewfinder focus, not actually focusing the camera lens when you take this step. Don't be distracted by the scene in front of the lens; it won't become any more or less sharp as you move the diopter switch or dial. Pay attention only to the appearance of the viewfinder data or focusing and/or framing marks.

Viewfinder adjustment control

Shooting in Auto Mode

In Auto mode, the camera selects exposure, color, and autofocus settings based on the scene that it detects in front of the lens. Here's how to take advantage of this mode:

1. **Set the shooting mode to Auto, as described in the preceding section.**

2. **Frame your subject in the viewfinder or monitor.**

When composing the scene, try to incorporate at least one or two of the composition ideas presented in Chapter 2.

TIP

3. **Press and hold the shutter button halfway down.**

The camera's autofocus and autoexposure meters begin to do their thing. In dim light, the flash may turn on or pop up if the camera thinks additional light is needed.

For still subjects, most cameras lock focus when you depress the shutter button halfway. But if your camera senses motion, it may continually adjust focus from the time you depress the shutter button halfway until you take the picture. Your role in this scenario is to move the camera as necessary to keep the subject in the frame, keeping the shutter button pressed halfway as you do.

When focus is established, the camera will likely beep at you and display a focus-confirmation light in the viewfinder, as shown on the left in Figure 3-4, or display a green focus frame on the monitor, as shown on the right. (These signals may not be provided when the camera is tracking a moving subject, however.)

FIGURE 3-4: Wait until you see the "focus achieved" indicator to press the shutter button all the way down.

Focus frame

Focus achieved light

4. **Press the shutter button the rest of the way and then release it to record the image.**

WARNING

While the camera sends the image data to the camera memory card, another light on your camera may illuminate. Don't turn off the camera or remove the memory card while the lamp is lit, or else you may damage both camera and card.

A few final tips to remember when using Auto mode:

>> **Solving focus problems:** If the camera has trouble focusing on your subject or the entire image is out of focus, try these remedies:

- *Move farther from your subject.* One of the most common causes of focusing issues is positioning the camera so close to the subject that you exceed the near-focusing limit of the lens. If you're shooting close-ups, take a step or two back and try again.

- *Check your camera manual for framing guidelines.* Some cameras require you to position the subject within the specific areas of the frame when using autofocusing. Look for an illustration in the "basics" section of your camera manual for help with this framing issue. You also may see markings in the viewfinder that indicate focus points, as shown in the left screen in Figure 3-4. (The tiny squares clustered in the middle of the viewfinder are the focus points in this case.)

- *Remember that most cameras focus on the closest object in Auto mode.* If that object is *not* your subject, you can use *focus lock* to establish focus where you want it to be. First, frame the scene so that your subject *is* the nearest object to the lens. Press and hold the shutter button halfway to lock focus, and then reframe to your desired composition.

- *If you're shooting a moving subject, try switching to Sports mode.* A blurry moving subject indicates a too-slow shutter speed. You can't change the shutter speed in Auto mode, but Sports mode automatically uses a fast shutter speed. I provide more specifics about this mode later in the chapter.

- *If the entire image is blurry, find a way to steady the camera.* All-over blur indicates camera shake during the exposure. If you don't have a tripod handy, look for a solid surface on which you can place the camera to take the shot. Also, press the shutter button *gently* — jabbing the button forcefully can create enough camera movement to blur the image. Or, for totally hands-free shooting, you can use a remote control, if one is available for your camera, or set the shutter release to self-timer mode, explained next.

>> **Using self-timer mode:** Most cameras enable you to switch from the regular shutter-release mode to self-timer mode, which delays the shutter release until a few seconds after you press the shutter button all the way. You can take advantage of this mode for hands-free shooting, as just described, or when you want to include yourself in the shot.

The name of the option that controls the shutter-release mode varies; it may be named something like Drive mode, Release mode, or Shooting mode, for example. The universal symbol for this mode looks like the one you see in the margin here.

>> **Fixing exposure problems:** Unfortunately, Auto mode doesn't give you many options if your subject turns out too dark or too bright. One possible solution is to add or disable flash, but many cameras don't give you flash control in Auto mode. A more surefire answer is to move your subject into brighter or dimmer light, if possible. Chapter 5 covers additional exposure-correction options, but again, you may need to move out of Auto mode to use them.

>> **Switching to playback mode:** When the recording process is finished, most cameras display the picture briefly. If you want a longer look at the image, you need to put the camera into playback mode. Look for a button marked with a triangle, as shown in the margin here, which is the standard label used for the switch that puts the camera into playback mode. To return to shooting, press that button again. Chapter 8 offers more details about playback options.

WHY WON'T MY CAMERA TAKE THE PICTURE?

TIP

If the camera doesn't release the shutter to take the picture when you press the shutter button, don't panic: This error is usually due to one of two problems:

• **Focus isn't set.** By default, most cameras insist on achieving focus before releasing the shutter to take a picture. You can press the shutter button all day and the camera just ignores you if it can't set focus. Try the focusing tips outlined at the end of the earlier section "Shooting in Auto Mode" as well as those detailed in Chapter 6 to solve this problem. With advanced cameras, you may be able to turn off this feature so that the shutter releases regardless of whether focus is achieved.

• **You don't have a memory card in the camera (or the card is full).** In this case, the camera should alert you by flashing a card symbol in the viewfinder or displaying a message in the monitor. Some advanced cameras *do* offer an option that enables you to record a temporary image when no card is installed in the camera, but the only good reason to turn on this option is to experiment with different shots while someone goes to get a memory card for you. Otherwise, it's too easy to forget that you enabled the setting and spend the whole day shooting pictures that disappear within seconds after you snap them. (As far as I can tell, this feature is provided mainly so that camera-store demo models don't need to have memory cards installed in order for customers to give them a test run.)

Stepping Up to Scene Modes

In Auto mode, the camera tries to figure out what type of picture you want to take by assessing what it sees through the lens. If you don't want to rely on the camera to make that judgment, you may be able to select from several *scene modes,* which select settings designed to capture specific scenes in ways that are traditionally considered best from a creative standpoint. For example, most people prefer portraits that have softly focused backgrounds. So in Portrait mode, the camera selects settings that can produce that type of background.

For the most part, shooting in scene modes involves the same process as using Auto mode — but there are a few variations to understand, so the next four sections outline the most common (and, in my opinion, most useful) scene modes.

REMEMBER

As outlined in the earlier section "Setting Up for Automatic Success," you select the scene mode that you want to use either from a dial on the camera or via camera menus. Table 3-1, near the beginning of this chapter, shows you generic versions of the symbols used to represent these modes. Check your camera manual to find out what the scene mode symbols look like on your camera and also to discover any other scene modes that may be available to you.

Portrait mode

Portrait mode attempts to select exposure settings that produce a blurry background, which puts the visual emphasis on your subject, as shown in Figure 3-5. In certain lighting conditions, though, the camera may not be able to choose exposure settings that produce the soft background. Additionally, the background blurring requires that your subject be at least a few feet from the background. The extent to which the background blurs also depends on the other depth-of-field factors that you can explore in Chapter 2.

Check your camera manual to find out what other image adjustments may be applied in Portrait mode. Most cameras tweak color and sharpness in a way designed to produce flattering skin tones and soften skin texture.

WARNING

If you're photographing a group and not all of your subjects are positioned near the focus point, be careful with Portrait mode. You may wind up with a depth of field that's *too* shallow, leaving some subjects slightly blurry. Your next best bet is Auto mode.

Also, if you're not sure that your subject will remain motionless, you may get better results by using Sports mode, which is designed to capture moving subjects without blur. The *background* may not blur in that mode, however.

FIGURE 3-5:
The portrait setting produces a softly focused background.

Landscape mode

Whereas Portrait mode aims for a very *shallow depth of field* (small zone of sharp focus), Landscape mode, which is designed for capturing scenic vistas, city skylines, and other large-scale subjects, produces a large depth of field. As a result, objects close to the camera *and* objects at a distance appear sharply focused. Figure 3-6 offers an example.

Like Portrait mode, Landscape mode achieves the greater depth of field by manipulating exposure settings — specifically, the aperture, or f-stop setting. So the extent to which the camera can succeed in keeping everything in sharp focus depends on the available light and the range of aperture settings provided by the lens. To fully understand this issue, see Chapters 2 and 5. In the meantime, know that you also can extend depth of field by zooming out to a wider angle of view and moving farther from your subject, too.

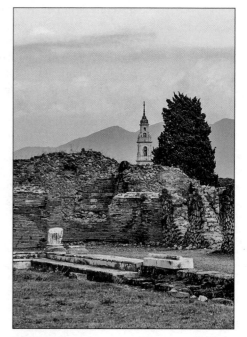

FIGURE 3-6:
Landscape mode produces a large zone of sharp focus and also boosts color intensity and contrast.

On most cameras, Landscape mode also increases contrast and adjusts colors to produce more vivid blues and greens. Additionally, flash is usually disabled in Landscape mode, which presents a problem only if you need some extra light on an object in the front of the scene.

Close-up mode

On most cameras, Close-up mode — also known as *macro* mode — is represented by a little flower icon. On some point-and-shoot cameras, selecting this mode enables you to focus at a closer distance than usual. For a dSLR, the close-focusing capabilities of your camera depend entirely on the lens you're using. But in either scenario, your camera or lens manual should spell out exactly how close you can get to your subject.

FIGURE 3-7:
Close-up mode also produces short depth of field. Notice how all objects on the background table are blurred.

Choosing this mode typically results in exposure settings designed to blur background objects so that they don't compete for attention with your main subject, as with the wedding cake in Figure 3-7. Again, notice that the background table is significantly blurry — which is a big help to this image because if all those objects were in sharp focus, they would compete with the cake for the eye's attention. As with Portrait mode, though, how much the background blurs varies depending on the capabilities of your camera, the distance between your subject and the background, and the lighting conditions. Should you prefer a greater or shorter depth of field, see Chapter 2 for other ways to adjust this aspect of your pictures.

Unlike Portrait and Landscape modes, Close-up mode generally doesn't play with colors, so they appear similar to how they look in Auto mode. You may or may not be able to use flash, and the region of the frame that's used to establish focus also varies, so check your manual to find out how this mode is implemented on your model.

Sports mode

Sports mode, sometimes also called Action mode, results in a number of settings that can help you photograph moving objects such as the soccer player in Figure 3-8. First, the camera selects a fast shutter speed, which is needed to "stop motion." *Shutter speed* is an exposure control that you can explore in Chapter 5.

With some cameras, dialing in Sports mode also selects some other settings that facilitate action shooting. For example, if your camera offers *burst mode* or *continuous capture,* in which you can record multiple images with one press of the shutter button, Sports mode may automatically shift to that gear. And flash is usually disabled, which can be a problem in low-light situations; however, it also enables you to shoot successive images more quickly because the flash needs a brief period to recycle between shots.

FIGURE 3-8:
To capture moving subjects without blur, try Sports mode.

The other critical thing to understand about Sports mode is that its ability to freeze action depends on the available light. In dim lighting, the camera may need to use a slow shutter speed to properly expose the image, in which case your chances of freezing action aren't great. On the other hand, a little blurring in an action photo can sometimes be acceptable and add to the effect of motion.

For more tips on action photography, check out Chapter 7.

Chapter 4

Understanding Basic Picture Options

C hapter 3 walks you through the steps of setting up your camera to shoot in your camera's fully automatic modes, relying on the default settings for most picture-taking options. When you're ready to take a bit more control, this chapter helps you make sense of four critical camera settings you should check before every shoot: exposure mode, shutter-release mode, image resolution, and image file type (JPEG or Raw). In addition, the end of the chapter provides advice about some common camera-customization features.

Choosing an Exposure Mode

Your selection of *exposure mode*, sometimes called *shooting mode*, determines which other camera settings you can access. Depending on your camera, you may be able to choose from the following exposure modes:

>> **Auto mode:** This mode gives almost all control to the camera. You usually can adjust picture resolution, however, and select the other basic setup options outlined at the end of this chapter. See Chapter 3 for details on how to shoot in Auto mode.

>> **Automatic scene modes:** These modes enable you to tell the camera what type of picture you want to take — portrait, landscape, sports, and so on. The camera then selects settings designed to produce the traditional characteristics for that type of image. For example, Sports mode is designed to freeze action.

Most of the picture-taking process is the same as in Auto mode; see Chapter 3 for a few details about the most common scene modes.

>> **Advanced exposure modes:** Typically not found on entry-level cameras, the following modes enable you to take control of two important exposure settings — f-stop and shutter speed — as well as all of your camera's other options:

- *Programmed autoexposure (P):* This mode selects the f-stop and shutter speed for you. On most cameras, though, you can choose different combinations of the two settings.

- *Aperture-priority autoexposure (A or Av):* You choose the aperture setting (f-stop), and the camera selects the shutter speed required for a good exposure. (*Av* stands for *aperture value.*)

- *Shutter-priority autoexposure (S or Tv):* You choose the shutter speed (length of exposure), and the camera dials in the f-stop for you. (*Tv* stands for *time value,* as in *exposure time.*)

- *Manual (M):* You set both the f-stop and shutter speed, but the camera provides an exposure meter to help you gauge whether your settings are on target.

REMEMBER

If your camera offers manual and automatic focusing, don't confuse the M exposure mode with the control that invokes manual focusing (usually marked with the letters M or MF). You usually can choose automatic or manual focusing no matter which exposure mode you select.

TIP

Although the first three advanced modes still rely on the camera to determine the "proper exposure," you can override that decision by using such options as Exposure Compensation. See Chapter 5 for details on this feature as well as an explanation of f-stops, shutter speed, and other exposure-related settings.

Some cameras also offer specialty modes that enable you to create a panoramic image (a wide-and-short or tall-and-narrow photo), create brief animated video clips out of still photos, add special effects, and get step-by-step guidance for taking a photograph. Advanced models usually enable you to store one or two groups of picture settings as custom-user modes as well. Because these features vary so much in their use from camera to camera, I can't cover them in this book, but I encourage you to investigate them nonetheless.

How you select an exposure mode also depends on your camera. You may need to choose the setting from a dial similar to the ones in Figure 4-1, which show some of the common symbols used to indicate exposure modes. On small cameras, you may instead get a simplified dial that enables you to set the camera to still-photo mode (usually a camera icon) and then select a specific mode from a menu, as shown in Figure 4-2. On advanced cameras, you may instead see a Mode button; press that button to access the available exposure modes and then use another dial or control to choose the one you want to use. (Cameras this sophisticated usually don't offer Auto or scene modes.)

Exposure mode dials

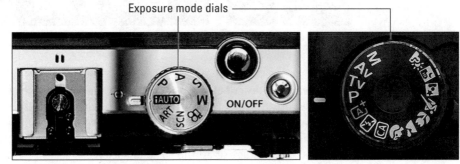

FIGURE 4-1:
Some cameras offer access to a variety of exposure modes via an external dial.

Exposure mode dial

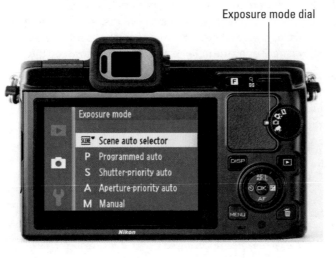

FIGURE 4-2:
In other cases, you set the camera to still photo mode (indicated here by the camera symbol) and then select an exposure mode from a menu.

Setting the Shutter-Release Mode

Many cameras offer a choice of shutter-release modes, which controls what happens when you press the shutter button. The name of the option varies, but it's typically something like Drive mode or Release mode. Check your camera manual for that information and for details on how to select the mode you want to use. You may find the settings lurking on an external dial, as shown on the left in Figure 4-3, or accessible via a button that displays a screen where you choose a release mode, as shown on the right.

FIGURE 4-3: Although the controls used to adjust the shutter-release mode vary, most cameras offer a standard batch of settings and setting icons.

Release mode dial Release mode settings Release mode button

The following list describes the most common shutter-release modes. In the margins, you see the symbols that are typically used to represent these modes in camera displays. Note that which shutter-release modes you can select depends on your chosen exposure mode. You may need to step up to an advanced exposure mode to take advantage of all the various options.

» **Single-shot mode:** The camera records one image every time you fully depress the shutter button. In other words, this is normal photography mode. It is usually represented on camera screens as a single rectangle like the one shown here or by the letter *S,* as on the dial shown on the left in Figure 4-3.

» **Continuous or burst mode:** Designed to make capturing fast action easier, this mode records a continuous series of images — a *burst* of frames — as long as you hold down the shutter button. The standard symbol used for this mode is a stack of rectangles (representing multiple frames).

A few tips to know about this mode:

- *How many frames per second you can capture depends on your camera and memory-card speed.* Advanced cameras typically offer a faster shooting rate, which is important if your primary interest is photographing sports (or other fast-moving subjects, such as hummingbirds). As for the memory

card, its read/write speed can affect whether the camera can actually achieve the fastest frame rate promised in its marketing specs. Before buying the fastest card on the market, though, be sure that your camera supports it. Some cameras can't communicate with the latest cards or may be able to store files on them but not at a faster rate than with slower cards.

- *You don't always need to max out the frame rate.* You also may be able to choose from a couple of continuous-frame rates, typically labeled Continuous High (maximum frames per second) and Continuous Low (typically around three frames per second). Although most people are tempted to always use the highest frames-per-second setting, I recommend that option only when shooting a subject that's moving at a really rapid pace. Otherwise, you wind up with lots of shots showing the exact same thing because not much actually changes between frames. And with the high resolution of today's cameras — which translates to huge files — that's a waste of valuable memory card space.

- *You probably can't use flash.* Most cameras disable flash when you select this shutter-release mode because there isn't enough time between frames for the flash to recycle. With some cameras, turning on the flash automatically changes the shutter-release mode to single-frame; with other models, the flash may fire once but then go to sleep.

» **Self-timer mode:** In this mode, you fully depress the shutter button, and the camera releases the shutter and captures the image several seconds later.

The original purpose of this mode was to give the photographer enough time to press the shutter button and then run in front of the camera and be part of the picture. But savvy photographers also take advantage of this mode to eliminate any chance of camera shake (and resulting image blur) when shooting long exposures and using a tripod. Especially if you're using a long lens (telephoto lens), even the slight action of pushing the shutter button can move the camera enough to induce blur. So you set the camera to self-timer mode, press the shutter button, and then take your hands off the camera and wait for the shutter release. Of course, if your camera offers remote-control operation, that's an easier option, but if not, self-timer mode offers a convenient workaround.

On some cameras, self-timer mode offers some bells and whistles that make it even more helpful. You may be able to choose from two delay times for the shutter release — say, two seconds or ten seconds. The two-second delay is great when you're substituting self-timer mode for remote-control operation; waiting around for ten seconds between shots gets a bit annoying. Some cameras even enable you to set up a self-timer session that records multiple frames with each push of the shutter button. This feature is known as *continuous self-timer mode.*

» **Remote-control mode:** Some cameras enable you to trigger the shutter button with a corded or wireless remote control. You may need to choose a special shutter-release mode to take advantage of that option, so consult your camera manual about this issue. The icon shown in the margin is often used to label a special mode provided for wireless remote control, for example. As with self-timer mode, you may be able to tell the camera to release the shutter as soon as you press the button on the remote or to delay the release for a couple of seconds.

Many cameras offer the option to use a smartphone instead of a dedicated camera remote to trigger the shutter release. For example, the screen shot in Figure 4-4 shows an app used to trigger the shutter on some Nikon cameras. To take advantage of this option, you need to download the proper app from the manufacturer's website.

TIP

If you're shooting with an intermediate or advanced camera, also check out these additional shutter-release options, some of which may be buried somewhere in the camera's menus instead of being grouped with the other settings:

» **Time-lapse shooting:** Sometimes called *interval* or *intervolametor* shooting mode, this feature enables you to set the camera to automatically capture one or more frames over a period of time, with a specified interval between capture sessions. You set the camera on a tripod, focus the lens on your subject, enable the feature, and then walk away and let the camera take care of the rest. You might use this option to record the gradual opening of a flower bud over a couple of days, for example.

» **Mirror-lock up:** One component of the optical system of a dSLR camera is a mirror that moves every time you press the shutter button. The small vibration caused by the action of the mirror can result in slight blurring of the image when you use a very slow shutter speed, shoot with a long telephoto lens, or take extreme close-up shots. To cope with that issue, some cameras offer mirror-lockup shooting, which delays opening the shutter until after the mirror movement is complete.

FIGURE 4-4:
With cameras that offer wireless connectivity, you may be able to use an app on your smartphone or tablet to trigger the shutter release.

Situations that call for mirror lockup also call for a tripod: Even with the mirror locked up, the slightest jostle of the camera can cause blurring. Using a remote control or self-timer mode to trigger the shutter release is also a good idea. Note, too, that on some cameras, a mirror-lockup setting is provided only for the purposes of cleaning the image sensor (you have to move the mirror out of the way to reach the sensor) and not for picture taking.

>> **Quiet mode:** This mode is another setting sometimes found on dSLR cameras and also has to do with mirror movement, which makes some noise when you take a picture. (You may hear photographers refer to this noise as *mirror slap.*) In Quiet mode, you can delay the sound by keeping the shutter button pressed down after the shutter is released. You still hear the mirror slap when you release the button — and you can't take another picture until you do. But if you're in a situation where the slightest noise is problematic, Quiet mode may be of some help. In addition to delaying mirror noise, this mode automatically silences the beep that most cameras make to let you know that autofocusing is complete.

If you need truly silent camera operation, some non-dSLR cameras provide that option. This feature is especially helpful when photographing babies and pets, who sometimes get spooked by normal camera sounds. Usually, you need to select a special setting to enjoy silent operation; by default, most cameras make some sort of noise to let you know that your picture has been recorded.

CONSIDERING PICTURE ASPECT RATIO

By default, digital cameras capture photographs using an aspect ratio of either 3:2 or 4:3. (The term *four-thirds camera* refers to models that use the 4:3 picture proportions.) But some models enable you to capture photos at proportions other than the default setting. You may be able to record a square image, for example, or, if your camera normally shoots 4:3 images, click off some 3:2 frames, or vice versa. You also may have the option to create a 16:9 image, which matches the aspect ratio of today's wide-screen, high-definition televisions and is normally used for panoramic photographs.

I don't often deviate from the camera's default aspect ratio, however. Here's why: At the default aspect ratio, the camera uses the entire image sensor to record the image, capturing the maximum subject area that my lens covers. When you choose a different aspect ratio, the camera crops that scene to your desired proportions. That's fine if you need a particular aspect ratio right away — you've just *got* to upload a new square profile picture to your Facebook or LinkedIn page, for example. But I prefer to stick with the whole-sensor capture and then crop to whatever proportions I want in my photo editor. By starting with the largest possible original subject area, I can make cropped copies at a variety of aspect ratios. If, on the other hand, I capture an image at, say, a 1:1 ratio (a square), and need a 5 x 7-inch print later, the composition of the original image may not lend itself to that 5 x 7 box.

Setting Picture Resolution

Have you ever seen the painting *A Sunday Afternoon on the Island of La Grande Jatte*, by the French artist Georges Seurat? Seurat was a master of a technique known as *pointillism*, in which scenes are composed of thousands of tiny dots of paint, created by dabbing the canvas with the tip of a paintbrush. When you stand across the room from a pointillist painting, the dots blend together, forming a seamless image. Only when you get up close to the canvas can you distinguish the individual dots.

Digital images work something like pointillist paintings. Rather than being made up of dots of paint, however, digital images are composed of tiny squares of color known as *pixels*. *Pixel* is short for *picture element*. If you display an image in a photo-editing program and then use the program's Zoom tool to magnify the view, you can see the individual pixels, as shown in the inset in Figure 4-5. Zoom out on the image, and the pixels seem to blend together, just as when you step back from a pointillist painting.

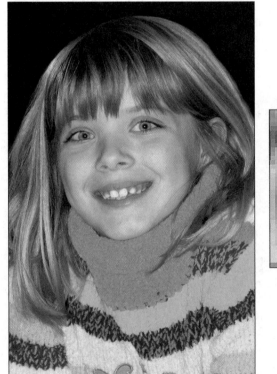

FIGURE 4-5: Zooming in on a digital photo enables you to see its individual pixels.

The number of pixels in an image is referred to as *resolution.* You can define resolution either in terms of the *pixel dimensions* — the number of horizontal pixels and vertical pixels — or total resolution, which you get by multiplying those two values. This number is usually stated in *megapixels,* or MP for short, with 1 megapixel equal to 1 million pixels.

Every digital photograph is born with a set number of pixels, which you control by using the capture settings on your digital camera. Check your camera manual to find out how to access the setting; it may be called Image Size, Resolution, Quality, or something similar. Note, too, that in some cases, you set the resolution separately from the file type (JPEG or Raw, covered later in this chapter). But on other models, the two are adjusted together.

Choosing the right resolution setting is critical because it affects three aspects of a digital photo:

>> The maximum size at which you can produce good prints

>> The display size of the picture when viewed on a computer monitor, a television, or another screen device

>> The size of the image file, which in turn affects how much storage space is needed to hold the file

To help you determine the right pixel population for your photos, the following three sections explore each of these issues.

Pixels and print quality

Generating a good print from a digital photo requires that you feed the printer a certain number of pixels per linear inch, or *ppi.* So the pixel count of a photo determines how large you can print the image without noticing a loss of picture quality.

Figures 4-6 through 4-8 illustrate this issue. The first image has resolution of 300 ppi; the second, 150 ppi; and the third, 75 ppi. Why does the 75-ppi image look so much worse than its higher-resolution counterparts? Because at 75 ppi, the pixels are bigger, and the bigger the pixel, the more easily your eye can figure out that it's really just looking at a bunch of squares. Areas that contain diagonal and curved lines, such as the edges of the coins and the handwritten lettering in the figure, take on a stair-stepped appearance.

FIGURE 4-6:
A photo with an output resolution of 300 ppi looks terrific.

150 ppi

FIGURE 4-7:
At 150 ppi, the picture loses some sharpness and detail.

If you look closely at the black borders that surround Figures 4-6 through 4-8, you can get a clearer idea of how resolution affects pixel size. Each image sports a 2-pixel border. But the border in Figure 4-8 is twice as thick as the one in Figure 4-7 because a pixel at 75 ppi is twice as large as a pixel at 150 ppi. Similarly, the border around the 150-ppi image is twice as wide as the border around the 300-ppi image.

75 ppi

FIGURE 4-8:
Reducing the
resolution to
75 ppi causes
significant
image
degradation.

TIP

How many pixels are enough to guarantee great prints? Well, it depends in part on how close people will be when viewing the pictures. Consider a photo on a billboard, for example. If you could climb up for a close inspection, you would see that the picture doesn't look very good because billboard photos are typically very low-resolution images, with few pixels per inch. But when you view them from far away, as most of us do, they look okay because our eyes blend all those big pixels together. Unless you're doing billboard photography, however, people will be viewing your images at a much closer range, so a higher resolution is required.

The resolution you need to produce the best prints also varies depending on the printer, but I usually shoot for 300 ppi. For quick reference, Table 4-1 shows you the approximate pixel count you need in order to produce traditional print sizes at that resolution. The first set of pixel values represents the pixel dimensions (horizontal pixels by vertical pixels); the value in parentheses represents the total pixel count, in megapixels (MP). Your mileage may vary, however, so don't panic if an image you want to print has fewer than 300 ppi. You may be satisfied with prints made with a lower resolution — just don't go too low, for the reasons made obvious by Figures 4-7 and 4-8.

TABLE 4-1

How Many Pixels for Good Prints?

Print Size (in Inches)	Pixels for 300 ppi
4 x 6	1200 x 1800 (2 mp)
5 x 7	1500 x 2100 (3 mp)
8 x 10	2400 x 3000 (7 mp)
11 x 14	3300 x 4200 (14 mp)

Chapter 9 provides an in-depth look at printing, talking more about the whole pixel-count issue and exploring other factors that affect print quality. In the meantime, keep these pixel pointers in mind:

>> **Select the resolution that matches your print needs** *before* **you shoot.** Yes, some photo programs enable you to change the number of pixels in an existing image, a process called *resampling.* But adding pixels — *upsampling* — isn't a good idea. When you take this step, the photo-editing software simply makes its best guess as to what color and brightness to make the new pixels. And even high-end photo-editing programs don't do a good job of pulling pixels out of thin air, as illustrated by Figure 4-9.

75 ppi upsampled to 300 ppi

FIGURE 4-9:
Here you see the result of upsampling the 75-ppi image in Figure 4-8 to 300 ppi.

To create this figure, I started with the 75-ppi image shown in Figure 4-8 and resampled the image to 300 ppi in Adobe Photoshop, one of the best photo-editing programs available. Compare this new image with the 300-ppi version in Figure 4-6, and you can see just how poorly the computer adds pixels.

With some images, you can get away with minimal upsampling — say, 10 to 15 percent — but with other images, you notice a quality loss with even slight pixel infusions. Images with large, flat areas of color tend to survive upsampling better than pictures with lots of intricate details.

>> **Use the highest resolution setting for pictures you may want to crop later.** The numbers in Table 4-1 assume that you're printing the *entire* photo. If you crop the photo before printing, you need more original pixels to generate a given print size because you're getting rid of a portion of the image.

For example, the left image in Figure 4-10 shows the tightest framing I could achieve with my camera, given the distance between the bird and my lens. Because I captured the image at a resolution of 24 mp, I could crop to the better composition shown on the right and still have plenty of pixels to produce a good print. In fact, the cropped file contains about 5.3 mp, so I can output a much larger print than fits on this page.

FIGURE 4-10: I used a high-resolution setting to capture the original (left), which enabled me to crop away excess background and still have enough pixels to produce a good print (right).

Pixels and screen images

REMEMBER

Although resolution has a dramatic effect on the quality of printed photos, it's irrelevant to the quality of pictures viewed on a monitor, a television, or another screen device. The number of pixels controls only the *size* at which the picture appears.

A bit of background to help you understand this issue: Like digital cameras, computer monitors (and other display devices) create everything you see on the screen out of pixels. When you display a digital photo, the monitor simply uses one screen pixel to display one image pixel.

For example, Figure 4-11 shows a screen capture taken from a 24-inch monitor that I use for a Windows computer. Windows enables you to adjust the resolution

of the monitor (as does the Mac operating system), with each setting resulting in a different number of screen pixels. Usually, you get the best display when using the monitor's *native* (default) resolution, which on this monitor, is 1920 x 1200 pixels.

Monitor resolution: 1920 x 1200 pixels

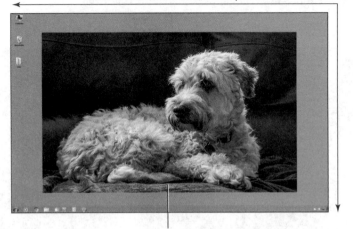

FIGURE 4-11:
When the monitor screen resolution is set to 1920 x 1200 pixels, my 1536 x 960-pixel photo consumes most of the display.

Image resolution: 1536 x 960 pixels

After setting my monitor to that resolution, I used the Windows display-customization options to place a 1536 x 960-pixel photo of my office assistant and life coach in the center of the display. The picture consumes just that number of screen pixels, with the remaining screen area occupied by the various Windows desktop icons and the plain blue background I chose as the desktop background.

Of course, for most onscreen uses, you don't want the picture to take up the entire display area or even as much screen space as shown in my example. When you share pictures on Facebook, for example, post them in an online gallery, or include them in a presentation, you need to leave ample screen space for text and other page elements.

The upshot is that you need far fewer pixels for images destined for screen display purposes than you do to produce large prints. Which begs the question: What do you do if you want to be able to print your pictures *and* share them online or use them for other screen purposes? Always set the camera resolution to match the print size you have in mind. As illustrated in the preceding section, you can't add pixels later successfully to achieve a good print. You can, however, dump pixels from a high-resolution original to create a copy that's appropriately sized for the screen. Your camera may offer a built-in tool that creates a low-resolution copy; if it doesn't, you can get the job done in any photo editing program.

Chapter 9 has more details about preparing a picture for online use.

Pixels and file size

Many factors affect the size of the data file needed to store a digital picture, including the complexity of the scene (the level of detail, the number of colors, and so on). The file format in which the image is stored, usually either JPEG or Raw, explained later in this chapter, also affects file size. But all other things being equal, an image with lots of pixels has a larger file size than a low-resolution image.

Although more pixels translates to better prints, as outlined earlier in this chapter, the large files needed to contain those pixels create several problems:

>> **Large files require more storage space.** When you're shooting huge files, it doesn't take too long to fill up a camera memory card, computer hard drive, or a cloud (online) storage account. And if you archive your files on DVD, which I recommend for your most treasured images, you can wind up with a huge disc collection in no time, given that the maximum storage capacity of a DVD is about 4.7GB, or gigabytes. (One GB equals 1,000MB.)

>> **Large files take longer for the camera to capture.** The more pixels you ask your camera to capture, the longer it needs to process and record the picture file to your memory card. That additional capture time can be a hindrance if you're trying to capture action shots at a fast pace.

>> **Large files strain your computer.** Large files make bigger demands on your computer's memory (RAM) when you edit them. You also need lots of empty hard drive space for editing because the computer uses that space as temporary storage while it's processing your images. (This temporary storage is sometimes referred to as *virtual memory* or *scratch disk* space.)

>> **Large files are inappropriate for online use.** When placed on a web page or sent via email, photos that contain bazillions of pixels are a major annoyance. First, the larger the file, the longer it takes to download. And if you send people a high-resolution image in an email, they may not be able to view the whole image without scrolling. Remember, most computer monitors can display only a limited number of pixels. (See the preceding section for details.)

TIP

All that said, large files are a fact of life if you want to capture images at your camera's highest resolution and quality settings. But do consider whether you *always* need to max out the pixel count. Are you really going to want to print the picture of your grandma's birthday cake or your new car at 8 x 10 inches or larger? If not, dialing down resolution a notch makes sense.

PPI IS NOT DPI!

The capabilities of printers are also described in terms of resolution. Printer resolution is measured in *dots per inch*, or *dpi*, rather than in pixels per inch. But the concept is similar: Printed images are made up of tiny dots of color, and dpi is a measurement of how many dots per inch the printer can produce. Generally, the higher the dpi, the smaller the dots, and the better the printed image, although gauging a printer solely by dpi can be misleading.

Some people, including some printer manufacturers and software designers, mistakenly interchange dpi and ppi. *But a printer dot is not the same thing as an image pixel.* Most printers, in fact, use multiple printer dots to reproduce one image pixel.

Setting the File Type

Your camera may offer a choice of file types, or *file formats*, in computer lingo. The format determines how the camera records and stores all the bits of data that comprise the photo, and the format you choose affects file size, picture quality, and types of computer programs you need to view and edit the photo.

Although many formats have been developed for digital images, most camera manufacturers have settled on just two: JPEG and Camera Raw. A handful of cameras also offer a third format, called TIFF, although that option has largely been replaced by Camera Raw.

Each of these formats has its pros and cons, and which one is best depends on your picture-taking needs. The next sections tell you what you need to know to make a file-format decision.

WARNING

Do not confuse your camera's *file-format* control with the one that *formats* your camera memory card. The latter erases all data on your card and sets it so that it's optimized for your camera. Don't freak out about this possibility: When you choose the card format option, your camera displays a warning to let you know that you're about to dump data. You get no such message for the file-format control.

As for how you select a file format, the process varies from camera to camera, so check the manual. On some cameras, you set the format and resolution together; on others, the two are controlled separately.

JPEG

Pronounced "jay-peg," this format is standard on every camera. *JPEG* stands for Joint Photographic Experts Group, the organization that developed the format.

JPEG is the leading camera format, for two important reasons:

>> **All web browsers, email programs, and mobile devices can display JPEG images.** So you can share your pictures online seconds after you shoot them. Furthermore, every image-editing program for both the Mac and Windows supports working with JPEG photos.

>> **JPEG files are smaller than Raw or TIFF files.** That means that you can store more pictures on your memory card as well as on your computer's hard drive or whatever image-storage device you choose. Smaller files also take less time to transmit over the web.

The drawback to JPEG is that in order to trim file size, it applies *lossy compression,* a process that eliminates some original image data. (Many digital-imaging experts refer to this process as simply *JPEG compression.*) Heavy JPEG compression can significantly reduce image quality, especially when the image is printed or displayed at a large size.

Figure 4-12 offers an example of the bad things that can happen with excessive JPEG compression. The image takes on a parquet tile look and often exhibits random color defects — notice the bluish tinges around the eyelashes and near the jaw line. These defects are known collectively in the biz as *JPEG artifacts,* or simply *artifacts.*

Now for the good news: Most cameras enable you to specify the level of JPEG compression that you want to apply, and at the highest-quality setting, the file undergoes only a little bit of compression. The result is a file that provides the benefits of the JPEG format with little, if any, noticeable damage to picture quality, as evidenced by the example in Figure 4-13. Sure, the file size is larger — the high-quality JPEG in Figure 4-13 has a file size of 400K (kilobytes) versus the 33K size of the low-quality version in Figure 4-12 — but what good does that small file size do you if the picture is lousy? Both pictures contain the same number of pixels, by the way, so the quality differences you see are purely a result of compression amounts.

To sum up, as long as you stick with the highest-quality JPEG file your camera can produce, this format is the right choice for all but the most demanding photographers. (If you fall in the latter camp, explore the Camera Raw format, explained in the next section.) And note that even if you choose your camera's lowest-quality JPEG setting, it's highly unlikely that you'll see the level of destruction shown in

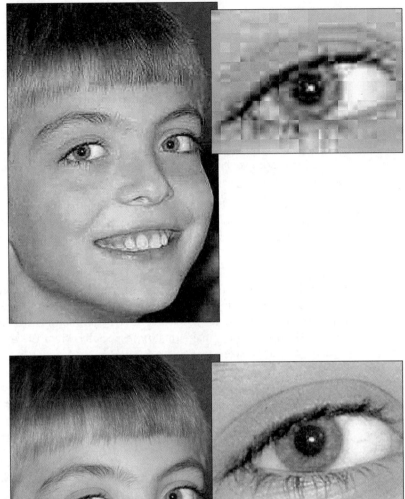

FIGURE 4-12:
Too much JPEG compression destroys picture quality.

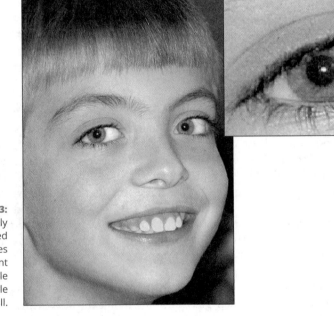

FIGURE 4-13:
But a lightly compressed JPEG produces excellent images while keeping file sizes small.

Figure 4-12 — the defects in the picture are exaggerated so that you can more easily see what JPEG artifacts look like.

Figuring out which camera setting delivers the top-quality JPEG file requires a look at your camera manual because the options differ between models. Typically, compression settings are given vague monikers: Good/Better/Best or High/Normal/Basic, for example.

These names refer not to the amount of compression being applied, but to the resulting image quality. If you set your camera to the Best setting, for example, the image is compressed less than if you choose the Good setting. Also, some cameras may use similar names to refer to image-size (resolution) options rather than JPEG-quality options.

You should find a chart in your manual that indicates how many images you can fit into a certain amount of memory at different compression settings. But you need to experiment to find out exactly how each setting affects picture quality. Shoot the same image at all the different settings to get an idea of how much damage you do if you opt for a higher degree of compression.

If your camera offers several resolution settings, do the compression test for each resolution setting. Remember that resolution and compression work together to determine image quality. You can usually get away with more compression at a higher resolution. Low resolution combined with heavy compression yields results even a mother couldn't love.

When you edit images in a photo editor, you can save the altered file in the JPEG format. If you do, though, you apply another round of lossy compression. Each pass through the JPEG compression machine does further damage, and if you edit and save to JPEG repeatedly, you *can* wind up with the level of artifacting shown in Figure 4-12. So you should instead save works in progress in a format such as TIFF (explained later in this chapter), which does a much better job of preserving picture quality. Should you want to share your edited photo online — which requires a JPEG image — you can create a copy of your final TIFF image and save the copy in the JPEG format.

Camera Raw

When you shoot in the JPEG format, your camera takes the data collected by the image sensor and then applies certain enhancements — exposure correction, color adjustments, sharpening, and so on — before recording the final image. These changes are based on the picture characteristics that the manufacturer believes its customers prefer.

The *Camera Raw* format, sometimes called simply *Raw,* was developed for photo purists who don't want the camera manufacturer to make those decisions. Camera Raw records data straight from the sensor, without applying any post-capture processes. After transferring the files to a computer, you then use special software known as a *raw converter* to translate the sensor data into the actual photograph.

REMEMBER

Unlike JPEG, Camera Raw isn't a standardized format. Each manufacturer uses different data specifications and names for its Raw format. Nikon Raw files are called NEF or NRW files, for example, while Canon's versions go by the name CRW or CR2, depending on the camera model.

Whatever the specific name, Raw image capture offers the following advantages:

>> **No risk of JPEG compression artifacts:** Raw files offer higher image quality because they don't undergo the kind of serious file compression that causes the defects associated with JPEG lossy compression. Again, though, as long as you stick with your camera's highest-quality JPEG setting, you may have difficulty detecting much difference in quality between the JPEG and Raw version of an image unless you greatly enlarge the photo.

>> **Greater creative control:** When you process your "uncooked" picture data in a raw converter, you can specify characteristics such as brightness, color saturation, sharpness, and so on, rather than dine on whatever the JPEG version might serve up. To keep up the cooking analogy, imagine that you put together a special dish and you realize after it comes out of the oven that you accidentally used cayenne pepper when your recipe didn't call for any. If your dish were like a Raw file, you'd be able to go back to the beginning of your cooking session and remove the pepper. With JPEG, that pepper would be a done deal. And that's what photographers like about Raw — files captured in this format give you much more control over the final look of your images.

>> **Greater latitude for editing the picture:** Raw capture also gives you a bit of a photographic safety net. Suppose that you don't get the exposure settings quite right, for example, when you shoot a picture. With JPEG, the camera decides how brightly to render the shadows and highlights, which can limit you in how much you can retouch that aspect of your picture later. With Raw, you can specify what brightness value should be white, what should be black, and so forth, giving you greater ability to achieve just the image brightness and contrast you want — a benefit that's especially great for pictures taken in tricky light.

>> **Higher bit depth:** *Bit depth* is a measure of how many distinct color values an image file can contain. With JPEG, your pictures contain 8 bits each for the red, blue, and green color components, or *channels,* that make up a digital image, for a total of 24 bits. That translates to roughly 16.7 million possible colors.

On most cameras, choosing the Raw setting delivers a higher bit count. You may be able to set the camera to collect 12 or more bits per channel, for example. However, you may not really ever notice any difference in your photos — that 8-bit palette of 16.7 million values is more than enough for superb images. Where having the extra bits can come in handy is if you really need to adjust exposure, contrast, or color after the shot in your photo editing program. In cases where you apply extreme adjustments, having the extra original bits sometimes helps avoid a problem known as *banding* or *posterization*, which creates abrupt color breaks where you should see smooth, seamless transitions. (A higher bit depth doesn't always prevent the problem, however, so don't expect miracles.)

Of course, like most things in life, the benefits of Raw do come at a price. First, most low-priced cameras don't offer the format. But Raw also costs you in the following ways, which may be enough for you to stick with JPEG even if your camera is dual-natured in terms of file format:

>> **Raw files require some post-capture computer time.** You can't take a Raw image straight from the camera and share it online, use it in a screen presentation, retouch it in a photo editor, or, well, do much of *anything* with it until you process it in a Raw converter, which you can find in photo-editing programs such as Adobe Photoshop. Most camera manufacturers also provide a tool to do the job. As part of the conversion process, you specify critical image characteristics: color, sharpness, contrast, and so on. Then you save a copy of the processed Raw file in a standard file format, such as JPEG or TIFF (explained in the next section).

Processing Raw files isn't difficult, but it does take time that you may prefer to spend behind the camera. And if you have a hate-hate relationship with computers, Raw is definitely not for you. Some cameras do have a built-in "mini converter" — that is, you can create a JPEG copy of a Raw image right in the camera. That feature makes the process faster and simpler, but it's not ideal because you have to make judgments about the picture based on a small camera monitor and you typically can specify only a handful of image characteristics. In other words, it's all the inconvenience of Raw without the creative-control benefits.

>> **You may not be able to view thumbnails of your images on your computer without converting them, either.** You can still see the Raw filenames, but not image thumbnails.

However — and here's some good news — most camera companies offer their own image-browsing software for free. (Look on the CD that came with your camera or check the manufacturer's online support site for a program download link.) You should be able to view and maybe even print Raw images by using those manufacturer-created programs — just not in most third-party programs.

>> **Raw files are larger than JPEG files.** Again, Raw files aren't compressed, so they can be significantly larger than JPEG files, even if you capture the JPEG image at the lowest possible amount of compression. So you can store fewer Raw files on a memory card than JPEG files. (If your camera offers the Raw format, the manual should provide details on the size of its Raw files versus JPEG versions.) In addition, because you probably want to hang on to your original Raw files after you convert them, just for safety's sake, you ultimately wind up with at least two copies of each image — the Raw original and the one that you converted to a standard format.

In short, because of the added complication of working with Raw files, you're better off sticking with JPEG if you're a photo-editing novice, a computer novice, or both. Frankly, the in-camera processing that occurs with JPEG is likely to produce results that are at least as good as, if not better than, what you can do in your photo editor if you're not skilled at the task. (Just remember the earlier warning about saving files that you edit in the TIFF format instead of JPEG.)

TIP

Some cameras offer a setting that creates both a Raw file and a JPEG file so that you have a version of the image that you can use immediately and another that you can use if you're inclined to spend hours editing it. Of course, you consume even more camera memory with this option because you're creating two files — and later, you'll have yet one more file after you process the Raw file on your computer. Depending on the camera, you may be able to choose a different resolution for your JPEG photos than you use for the Raw versions. You also may be able to select the amount of JPEG compression that's applied to the JPEG version.

TIFF

The third player in the image file format game is *TIFF*, which stands for Tagged Image File Format. Like Camera Raw, TIFF also offers higher picture quality than JPEG because TIFF files don't go through the JPEG lossy-compression mill. TIFF has long been the standard format for images destined for professional printing, where the highest quality is required.

Before the emergence of Camera Raw, some high-end cameras offered TIFF as an alternative to JPEG. Most cameras, now, though, don't offer the option to record images as TIFF files. Instead, TIFF is a *destination format:* You save an edited JPEG file in TIFF format, for example, so that no more compression and data loss occur. Or if your camera offers the ability to save files in the Camera Raw format, you can save them in TIFF format after you process them so that you preserve the best image quality.

DNG: ADOBE'S ANSWER TO RAW INSECURITY

Adobe Systems offers another digital-image file format, DNG. Short for Digital Negative Format, *DNG* was created in response to growing concerns about the fact that every camera manufacturer uses its own, specially engineered flavor of Camera Raw. This Photo Tower of Babel makes it difficult for software designers to create programs that can open every type of Raw file, which in turn makes it difficult for people to share Raw files. That issue isn't a huge problem for the average consumer, but it's a pain for professionals who sometimes must work with Raw images from many photographers. In addition, the possibility exists that future software may not support earlier generations of Raw files, leaving people with images they can no longer open (think videotapes and 8-track audio recordings).

The idea of DNG is to provide a format that can be universally read by all photo programs but retains the "unbaked" quality of a Raw file, which is something that TIFF and JPEG can't do. So far, DNG hasn't caught on in a big way, but it is popular with photographers who shoot Raw and don't want to invest in software updates with every new camera. If you want to translate your Raw files to DNG, the Adobe website (www.adobe.com) offers a free converter that can handle files from many cameras. Of course, there's no guarantee that DNG will be around 100 years from now, either, and some photo programs can't open DNG files. But with Adobe backing the format, it's not a bad idea to give yourself the safety net of making DNG copies of your Raw files.

TIFF does present two problems: First, TIFF files are much larger than JPEG files. In addition, web browsers and email programs can't display TIFF photos. If you do want to share a TIFF file online, you need to open the file in a photo editor and save a copy of it in the JPEG format.

Looking at a Few Additional Setup Options

Along with the picture settings already discussed, take a few minutes to consider the following options, which affect overall camera operation. You find these options on most cameras, although you need to consult your camera manual to determine the specific option name and how to adjust the setting.

>> **Date and time:** Your camera records the current date and time in the image file, along with details about what other camera settings were in force when you shot the picture. In many photo editors and image browsers, you can view this information, known as *metadata*. (*Meta,* for *extra,* data.) Having the correct

date and time in the image file enables you to have a permanent record of when each picture was taken. More importantly, in many photo programs, you can search for all pictures taken on a particular date.

TIP

Some cameras also have a time-stamp menu option that slaps a text label with the picture date and time on the image itself. Because this information is always stored in the image file, there's no need to permanently mar an image with the text label. You can always add a text label in a photo editor later, if you want, but you can't get rid of it if it's created as part of the original image file.

>> **Auto shutoff:** To conserve battery power, many cameras turn off automatically after a few minutes of inactivity. The drawback is that you can miss fleeting photographic opportunities — by the time you restart the camera, your subject may be gone. If you're not happy with the way this option works, see whether you can adjust the length of time that the camera must be idle before auto shutdown occurs; some cameras also give you the option of turning the feature off entirely.

WARNING

>> **Shoot without memory card:** When this feature is enabled, you can take a photo without a memory card installed in the camera. The image is stored in a tiny bit of internal camera memory but usually isn't retained for more than a few minutes. The point of the function is to enable camera salespeople to demonstrate cameras without having to keep memory cards in all of them. To avoid any possibility that you'll shoot all day without a memory card, turn off this function. It may go by another name, such as Slot Empty Release, so check your manual for information.

>> **Instant review:** After you take a picture, your camera may display it automatically for a few seconds. On some cameras, you can't take another picture until the review period has passed, and if that's the case with your model, you may want to turn off instant review when you're trying to capture fast-paced subjects. And because monitors consume power, also turn off instant review if you're worried about running out of battery juice. You may also be able to adjust the length of the instant-review period.

>> **File numbering:** Cameras assign filenames to photos, often beginning with a few letters and a symbol (for example, IMG_0023.JPG, DSCN0038.JPG, or something similar). You can often set up your camera to number files beginning with certain numbers, and some cameras actually let you put in a few of your own letters with the file numbers (although it's usually very limited).

WARNING

Some cameras have an option that automatically restarts the file-numbering sequence when you swap out a memory card. For example, if the current memory card contains a file named IMG_0001.JPG and you put in a new memory card, the camera assigns that same filename to the first picture you take. Obviously, this option can lead to trouble after you download pictures to

your computer, because you can wind up with multiple pictures that share the same name. So check your manual to find out whether this option exists on your camera, and if so, avoid it.

>> **Sound effects:** Digital cameras are big on sounds: Some play a little ditty when the camera is turned on. Some beep to let you know that the camera's autofocus or autoexposure mechanism has done its thing, and others emit a little "shutter" sound as you take the picture. Some cameras have even said "Goodbye" in this odd little digitized voice when you turned the camera off. Before heading to a wedding or any other event where your camera's bells and whistles won't be appreciated, check your camera menu to see whether you can silence them or at least turn down the volume.

>> **Shooting information display:** Most cameras display some information about the current picture settings on the monitor, as shown on the left in Figure 4-14. If you find that data distracting, you may be able to hide it, as shown on the right. Usually, you alter the display type by pressing a button labeled Info or DISP (for display), but check your manual for details.

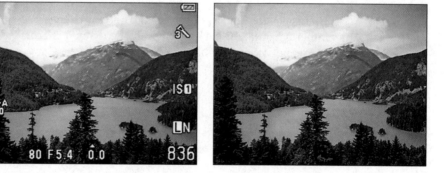

FIGURE 4-14: If the shooting data displayed on the monitor becomes distracting (left), you may be able to hide it (right).

>> **Viewfinder and monitor alignment guides:** On some cameras, you can display a grid in the viewfinder or monitor, as shown on the left in Figure 4-15. The grid comes in especially handy when you're shooting landscapes or other scenes where it's important to frame the shot so that the horizon is level. Depending on the camera, you may even be able to display a little digital level, as shown on the right in the figure, to let you know when the camera is level with the horizon.

WARNING

>> **Monitor brightness:** Adjusting the monitor brightness can make pictures easier to view in bright light. But be careful: The monitor may then give you a false impression of the image exposure. Before you put your camera away, double-check your pictures in a setting where you can use the default brightness level. As another alternative, you may be able to display an exposure guide called a *histogram;* see Chapter 5 for details.

FIGURE 4-15:
You may be able to display alignment aids in the monitor or viewfinder.

» **Button customization:** If you own a higher-end camera, you may also have the option to change the function of certain camera buttons. For example, some cameras have a Function (FN) button, which you can assign to perform any number of tasks, from turning on self-timer shooting to setting the image picture quality. These options are best left alone until you have a good grasp of all the camera's operations — if you start changing the button functions, instructions in the camera manual or any other camera guide won't work.

That concludes my list of basic setup options to check; be sure to flip through your camera manual (or click through, if the manual is provided in electronic format) to find out other options.

2

Taking Your Photography to the Next Level

Chapter 5

Taking Control of Exposure

etting a grip on the digital characteristics of your camera — resolution, file type, and so on — is critical. But don't get so involved in this side of digital photography that you overlook traditional photography fundamentals such as proper exposure and lighting. All the megapixels in the world can't save a picture that's too dark or too light.

To that end, this chapter tackles all things exposure-related, explaining such basics as how shutter speed, aperture, and ISO affect your pictures and how you can solve common exposure problems. Also look here for information about flash photography, advanced exposure features such as shutter-priority autoexposure and aperture-priority autoexposure, and ways to manipulate exposure to meet your creative goals.

Understanding Exposure

Entire books have been written on the subject of exposure, which may lead you to believe that exposure is an incredibly complex issue. And you *can* get into lots of arcane details about the science behind how cameras turn light into photographs, if you're interested. But if you're not the science-y type, I have good news: You can take a huge leap forward in your photographic skills by familiarizing yourself with just three exposure controls: aperture, shutter speed, and ISO. The next several sections get you up to speed on these three critical settings.

Introducing the exposure trio: Aperture, shutter speed, and ISO

Any photograph, whether taken with a film or digital camera, is created by focusing light through a lens onto a light-sensitive recording medium. In a film camera, the film negative serves as that medium; in a digital camera, it's the image sensor, which is an array of light-responsive computer chips.

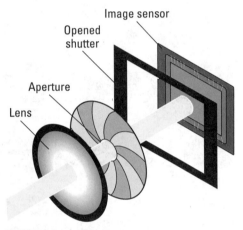

Between the lens and the sensor are two barriers, known as the *aperture* and *shutter,* which together control how much light makes its way to the sensor. The actual design and arrangement of the aperture, shutter, and sensor vary depending on the camera, but Figure 5-1 offers an illustration of the basic concept.

FIGURE 5-1:
The aperture size and shutter speed determine how much light strikes the image sensor.

The aperture and shutter, along with a third feature known as *ISO,* determine *exposure* — what most would describe as the picture's overall brightness. This three-part exposure formula works as follows:

>> **Aperture (controls *amount* of light):** The *aperture* is an adjustable hole in a diaphragm set just inside the lens. By changing the size of the aperture, you control the size of the light beam that can enter the camera. Aperture settings are stated as *f-stop numbers,* or simply *f-stops,* and are expressed with the letter *f* followed by a number: f/2, f/5.6, f/16, and so on. The lower the f-stop number, the larger the aperture, and the more light is permitted into

the camera, as illustrated by Figure 5-2. To put it another way, raising the f-number stops more light.

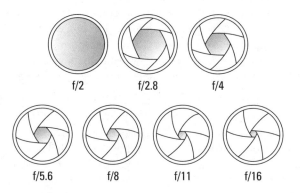

The range of possible f-stops depends on the lens and, if you use a zoom lens, on the zoom position (focal length) of the lens. Your camera or lens manual should spell out the f-stops you can use.

>> **Shutter speed (controls *duration* of light):** The shutter works something like, er, the shutters on a window. When you aren't taking pictures, the camera's shutter stays closed, preventing light from striking the image sensor, just as closed window shutters prevent sunlight from entering a room. When you press the shutter button, the shutter opens briefly to allow light that passes through the aperture to hit the image sensor. The exception to this scenario is when you compose images using the camera's monitor instead of a viewfinder — the shutter remains open so that your image can form on the sensor and be displayed on the camera's LCD. Then, when you press the shutter release, the shutter first closes and then reopens for the actual exposure.

This description, however, applies to a traditional, mechanical shutter similar to the one represented in Figure 5-1. Many digital cameras now use an *electronic shutter* instead. With this design, the image sensor simply passes the current image data to the memory card for the duration of the exposure.

Either way, exposure time is referred to as the *shutter speed* and is measured in seconds: 1/60 second, 1/250 second, and so on. On most cameras, an inches mark (") is used to indicate shutter speeds of 1 second or more: 1", for example, means a shutter speed of 1 second. The range of shutter speeds varies from camera to camera; again, check your manual for specifics.

In addition to specific shutter speeds, your camera may offer a *bulb setting,* which keeps the shutter open indefinitely as long as you press the shutter button. Usually, you must set the camera to manual exposure mode and then cycle past all other available shutter speeds to reach the bulb setting. Some

cameras, though, offer a Bulb exposure mode that saves you that trouble, automatically shifting the shutter speed to the bulb setting.

>> **ISO (controls light *sensitivity*):** ISO, which is a digital function rather than a mechanical structure, enables you to adjust how responsive the image sensor is to light. The term *ISO* is a holdover from film days, when an international standards organization rated each film stock according to light sensitivity: ISO 200, ISO 400, ISO 800, and so on. As with the range of f-stops and shutter speeds, the range of ISO settings varies from camera to camera.

On a digital camera, the sensor doesn't actually get more or less sensitive when you change the ISO — rather, the light "signal" that hits the sensor is either amplified or dampened through electronics wizardry, sort of like how raising the volume on a radio boosts the audio signal. But the upshot is the same as changing to a more light-reactive film stock: A higher ISO means that less light is needed to produce the image, enabling you to use a smaller aperture, faster shutter speed, or both. (In other words, from now on, don't worry about the technicalities and just remember that ISO equals light sensitivity.)

Distilled to its essence, the image–exposure formula is just this simple:

>> Aperture and shutter speed together determine the quantity of light available to expose the image.

>> ISO determines how much the image sensor reacts to that light and, therefore, how much light you need to expose the picture.

The tricky part of the equation is that aperture, shutter speed, and ISO settings affect your pictures in ways that go *beyond* exposure. You need to be aware of these side effects, explained in the next section, to determine which combination of the three exposure settings will work best for your picture. I introduce these concepts briefly in Part 1 of this book; the next three sections dig more deeply into the topic.

Aperture also affects depth of field

Along with altering exposure, the aperture setting also affects *depth of field,* or the distance over which objects in the picture appear sharply focused. Figure 5-3 illustrates this issue. Notice that the background in the left image, captured at f/6, is much blurrier than its sibling, taken at f/22. The right image has a greater depth of field due to the higher f-stop.

You can use this aperture side effect to your creative advantage: For example, if you're shooting a landscape and want to keep both near and distant objects as sharply focused as possible, you choose a high f-stop number. Or, if you're shooting a portrait and want objects in the background to be softly focused, you choose a low f-stop number, which reduces depth of field.

f/6, shallow depth of field f/22, large depth of field

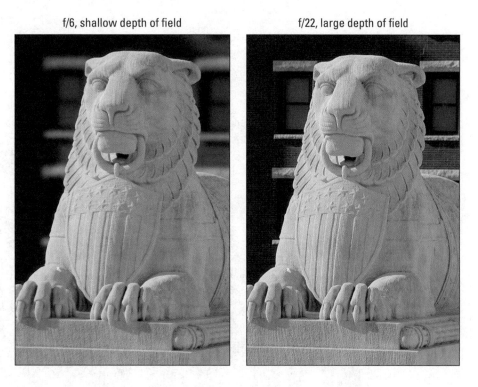

FIGURE 5-3:
A higher f-stop increases depth of field, or the distance over which objects appear sharply focused.

One point to note, though: How much depth of field you get at any f-stop varies depending on the camera and the lens. Cameras that use small image sensors produce a greater depth of field than those with larger sensors. So, the background blurring you see at f/6 may be more or less than what you see in my example. Experiment to gauge depth-of-field possibilities with your camera and lens.

REMEMBER

Adjusting the aperture setting is just one way to manipulate depth of field. The subject-to-camera distance, subject-to-background (or foreground) distance, and lens focal length all affect depth of field as well. Chapter 2 offers examples of each of these depth-of-field factors.

Shutter speed also affects motion blur

Like the aperture setting, shutter speed affects the apparent focus of your image, but in a different way: Shutter speed determines whether any moving objects in the scene appear blurry or sharp.

I introduce this topic in Chapter 2, but it's an important concept, so here's a recap:

>> **To freeze motion, use a fast shutter speed.** The speed you need to stop action depends on how fast your subject is moving. In the left image in Figure 5-4, for example, a shutter speed of 1/100 second left the jumping children blurry. Setting the shutter speed to 1/300 second caught them cleanly in

mid-jump. For the second image, I raised the ISO setting to enable the faster shutter speed. Another choice in this scenario is to open the aperture more, assuming that you don't mind the reduction in depth of field that will result.

1/100 second　　　　　　　　　　　　　　1/300 second

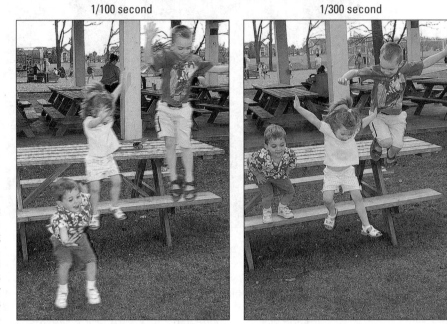

FIGURE 5-4:
In addition to affecting exposure, shutter speed determines whether moving objects appear blurry.

> » **To blur motion, use a slow shutter speed.** On occasion, you may want to use a slow shutter to intentionally blur your subject. For example, I used a shutter speed of one second to make the fountain water in the foreground appear misty in the Las Vegas scene shown in Figure 5-5. In action shots, a shutter speed that allows just a slight blur can emphasize the feeling of motion. And in nighttime street scenes, a long exposure turns moving car tail-lights into trails of streaming light. (See Chapters 2 and 7 for more illustrations of slow-shutter speed photos.)

ISO also affects image noise

TECHNICAL STUFF

When you raise the ISO setting to make the image sensor more reactive to light, you increase the risk of producing noise. *Noise* is a defect that looks like sprinkles of sand and is similar in appearance to film *grain*, a defect that often mars pictures taken with high ISO film.

Figures 5-6 and 5-7 illustrate the impact of ISO on quality, showing the same subject captured at ISO 200, 400, 800, and 1600. When you print pictures at a small size, as in Figure 5-6, noise may not be apparent to the eye; instead, the image may have a slightly blurry look, as in the ISO 800 and 1600 examples in Figure 5-6.

Figure 5-7 shows close-up views of each image so that you can more easily compare the loss of detail and increase in noise.

Of course, for some shooting scenarios, you may be forced to use a higher ISO. For example, if you're trying to capture a moving subject in less than ideal lighting, you may need to raise the ISO in order to use the fast shutter speed necessary to freeze the action.

A few other critical points about ISO and noise:

>> **Noise levels vary from camera to camera.** The examples you see here illustrate noise produced by a specific camera. Some cameras, especially newer models, produce much better high-ISO images than others. Bottom line: Experiment with ISO settings, assuming that your camera gives you control over this feature. Then evaluate your test shots to see how much quality you can expect to give up when you raise ISO. And if you're in the market for a new camera, read reviews to find out how models you're considering perform at different ISO settings.

ISO 200 ISO 400

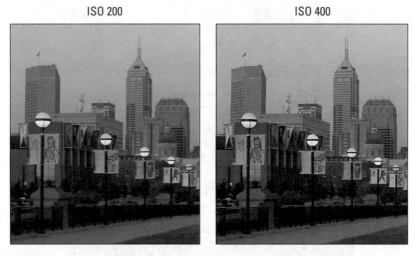

ISO 800 ISO 1600

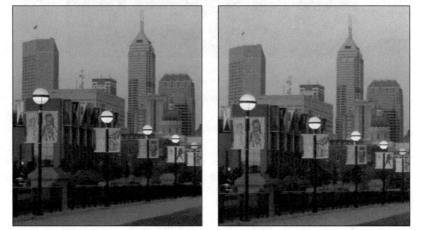

FIGURE 5-6:
Raising the
ISO setting
increases light
sensitivity,
but also can
produce a
defect known
as *noise*.

Be aware that cameras specifically geared to produce little noise at very high ISO settings sometimes generate more noise than you might expect at *low* ISO settings.

>> **Auto ISO adjustment may not be your friend.** When you shoot in automatic exposure modes, the camera typically adjusts ISO for you. Some cameras, how-ever, give you a choice between automatic ISO adjustment and manual ISO con-trol. If you have the option, sticking with manual is the best idea. In automatic mode, the camera may ramp up the ISO to a point that produces more noise than is acceptable to you. Some cameras allow you to limit the top ISO that can be selected in auto mode or to specify the shutter speed at which ISO increase occurs, which makes Auto ISO more palatable. But if you're a stickler for image quality, it's better to control this aspect of your picture-taking yourself.

>> **Long exposure times also can cause noise.** A high ISO isn't the only cause of noise; a long exposure time (slow shutter speed) can also produce the defect. So, how high you can raise the ISO before the image gets ugly varies depending on shutter speed.

PREVENTING SLOW-SHUTTER CAMERA SHAKE

When you set a slow shutter speed, handholding the camera creates the risk of camera shake, which can cause the entire image to appear blurry. The longer the exposure, the greater the risk.

The length of time that people can successfully handhold a camera varies, so experiment to see where you enter the danger zone. Also turn on image stabilization, if your camera or lens offers it; that feature can enable sharper handheld shots at slower shutter speeds.

Some cameras display a shaky-hand symbol, like the one shown here, to alert you when shutter speeds drop below a certain point. But if your camera doesn't — and most intermediate and advanced cameras assume that you don't need this assist — you need to keep an eye on shutter speed yourself.

To avoid the possibility of camera shake, put your camera on a tripod or find another way to stabilize the camera. Check the manual, though, to find out whether you should turn off image stabilization when using a tripod; in some cases, the feature can actually cause blur in tripod shots.

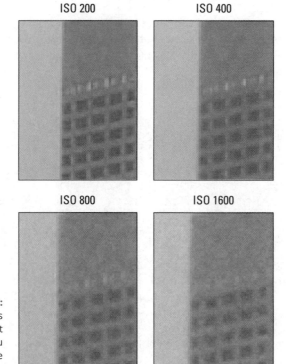

ISO 200 ISO 400

ISO 800 ISO 1600

FIGURE 5-7:
Noise becomes more apparent when you enlarge images.

Doing the exposure balancing act

As you change any of the three exposure settings — aperture, shutter speed, and ISO — one or both of the others must also shift in order to maintain the same image brightness. Say that you're shooting a soccer game and you notice that although the overall exposure looks great, the players appear slightly blurry at the current shutter speed. If you raise the shutter speed, you have to compensate with either a larger aperture, to allow in more light during the shorter exposure, or a higher ISO setting, to make the camera more sensitive to the light — or both.

As the previous sections explain, changing these settings impacts your image in ways beyond exposure. As a quick reminder:

>> **Aperture** affects depth of field, with a higher f-stop number producing a greater zone of sharp focus.

>> **Shutter speed** affects whether motion of the subject or camera results in a blurry photo. A faster shutter "freezes" action and also helps safeguard against overall blur that can result from camera shake when you're handholding the camera.

>> **ISO** affects the camera's sensitivity to light. A higher ISO makes the camera more responsive to light but also increases the chance of image noise.

When you boost that shutter speed to capture your soccer subjects, you have to decide whether you prefer the shorter depth of field that comes with a larger aperture or the increased risk of noise that accompanies a higher ISO.

Everyone has his or her own approach to finding the right combination of aperture, shutter speed, and ISO, and you'll no doubt develop your own system as you become more practiced at using the advanced exposure modes. In the meantime, here's how I handle things:

>> I always use the lowest possible ISO setting unless the lighting conditions are so poor that I can't use the aperture and shutter speed I want without raising the ISO.

>> If my subject is moving (or might move, as with a squiggly toddler or antsy pet), I give shutter speed the next highest priority in my exposure decision. I might choose a fast shutter speed to ensure a blurfree photo or, on the flip side, select a slow shutter speed to intentionally blur that moving object, an effect that can create a heightened sense of motion.

>> For images of nonmoving subjects, I make aperture a priority over shutter speed, setting the aperture according to the depth of field I have in mind. For portraits, for example, I use the largest aperture (the lowest f-stop number, known as shooting *wide open,* in photographer speak) so that I get a short depth of field, creating a nice, soft background for my subject. For landscapes, I usually go in the opposite direction, stopping down the aperture as much as possible to capture the subject at the greatest depth of field.

I know that keeping all this straight is overwhelming at first, but the more you work with your camera, the more the whole exposure equation will make sense to you. You can find tips for choosing exposure settings for specific types of pictures in Chapter 7.

Adjusting f-stop, Shutter Speed, and ISO

Most cameras give you control over ISO, but whether or not you have full control over aperture and shutter speed depends on your camera. If your camera offers only automatic exposure, you may not even have any control over these settings.

If you own an intermediate or advanced camera, you should have the option to shoot in manual mode, which enables you to control all three exposure settings. You also can usually choose a semiautomatic mode, where you have some input over exposure but also get an assist from the autoexposure system. Check out the section "Using "priority" exposure modes" later in this chapter for more

information on two of these semiauto modes: aperture-priority autoexposure and shutter-priority autoexposure.

Your camera manual should spell out which exposure modes offer what level of exposure control and explain how to adjust the various settings. Also check that manual to find out how the camera indicates the current exposure settings. On cameras that have a viewfinder, you may see the current shutter speed, f-stop, and ISO in the viewfinder display, as shown on the left side of Figure 5-8. Some cameras also display the settings in the camera monitor, as shown on the right. And with some cameras, you can check exposure settings either way. (The viewfinder and monitor may also display several other pieces of information related to other camera settings, as they do here.) Advanced cameras typically also have a smaller settings display on top of the camera or underneath the monitor.

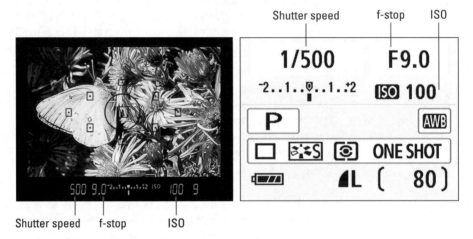

FIGURE 5-8: You may be able to view exposure settings in the viewfinder or on the monitor display.

If you use a point-and-shoot camera, however, you may be able to view the current settings on the monitor only, even if the camera has a viewfinder. And if you have a very basic, fully automatic camera that handles exposure for you, you may not even be able to view the aperture and shutter speed settings until *after* you take the picture and download it to your computer. Then you can open the photo in a program that can read the camera *metadata,* which records the settings you used to take the picture. See Chapter 8 for more about viewing metadata. Doing so, by the way, is a great way to learn more about how aperture, shutter speed, and ISO affect the look of your pictures.

The next several sections provide information on additional features related to choosing the right f-stop, shutter speed, and ISO settings.

Taking advantage of exposure guides

When it comes to checking exposure, the image shown on the camera monitor can be misleading. The actual image may be brighter or darker than what you see onscreen because the display is affected by the ambient light in which you view the image and on the brightness of the monitor itself.

For more reliable exposure guidance, find out whether your camera offers an exposure meter, histogram, or highlights display mode, all of which you can explore in the next three sections.

Reading the meter

An *exposure meter* offers before-the-shot assistance. This simple bar graph indicates whether the camera thinks your current settings will produce a good exposure, as shown in Figure 5-9. When you see a single bar at the 0 mark, as in the third illustration, you're good to go. Bars appearing on the side of the meter that sports a minus sign indicate underexposure; bars on the plus-sign side predict overexposure. The more bars that appear, the greater the potential exposure problem. (Note that some cameras place the positive end of the meter on the left while other models put it on the right, so inspect the meter closely to see which is which on your camera.)

FIGURE 5-9:
The exposure meter indicates whether the current camera settings will produce a good exposure.

REMEMBER

A few pointers about the way exposure meters operate:

>> **You may need to press the shutter button halfway to display the meter.** Your half-press wakes the exposure system and tells the meter to do its thing.

>> **Where and when the meter appears depends on your camera and shooting mode.** The meter may appear in the viewfinder, monitor, or top LCD readout, depending on your camera. But on most cameras, the meter appears only when you shoot in manual exposure mode. In other modes, the meter typically appears only if the camera anticipates an exposure problem or if you enable Exposure Compensation, an autoexposure adjustment feature I discuss later in this chapter, in the section "Applying exposure compensation."

>> **The meter readout depends on the *metering mode*.** This setting determines which part of the frame the camera analyzes when calculating exposure. Normally, the entire frame is measured. You can read more about metering modes later in this chapter, in the section "Changing the Metering mode."

>> **Keep the lens trained on your subject while checking the meter.** If your camera displays the meter only in the monitor (or if you prefer to view the meter there), don't move the camera after pressing the shutter button to display the meter. All too often, people frame the shot, press the shutter button halfway to activate the meter, and then point the lens at the ground so that they can get a better look at the display. The problem is that most cameras continue adjusting exposure settings until you take the picture, so as soon as you move the camera, it takes a new reading. So when the lens is pointing down, you're viewing the proper settings for photographing the ground and not your subject. For this reason, I encourage you to rely on the viewfinder meter if your camera offers one.

Interpreting a histogram

A *histogram* is a chart that plots out the brightness values of all pixels in the photo, using a scale of 0 (black) to 255 (white). For example, the histogram shown in Figure 5-10 represents the accompanying butterfly photo. The horizontal axis of the chart displays brightness values, with shadows on the left and highlights on the right. The vertical axis shows you how many pixels fall at each brightness value. A spike at any point indicates that you have lots of pixels at that particular brightness value.

FIGURE 5-10: A histogram tells you how many pixels fall at each point on the brightness scale, from 0 (black) to 255 (white).

Shadows — Highlights

0 255

Some cameras can display a histogram on the monitor in shooting mode, helping you suss out exposure settings before you snap the shot. Most models, however, offer this tool only during playback; you may need to change your camera's default playback settings to display it.

Normally, a histogram that resembles a bell-shaped curve, or something close to it, is a good sign because well-exposed photos typically contain more *midtones* (areas of medium brightness) accented by highlights and shadows. This fact has led some photographers to believe that their exposure decisions should be based on generating this so-called perfect histogram. But unless you plan to frame and exhibit your histogram instead of your photograph, this idea is hogwash. There — I said it. Bring it on, histogram perfectionists!

Here's the thing: You have to interpret a histogram with respect to the brightness values of your subject. You're just not going to see a ton of pixels at the dark end of the scale when you're photographing a polar bear against a snowy backdrop, for example. However, if you look at your camera's histogram and it has a big spike to the left, it may be that your photo is too dark, in which case you need to adjust the exposure settings or add a flash. If it's spiked to the right, your photo may be too bright. It's normal to have a few odd spikes here and there, though.

Displaying playback "blinkies"

The problem with both the meter and the histogram is that although they can indicate an exposure issue, they don't tell you *which* parts of the image are under- or overexposed. To provide this information, many cameras offer a playback mode that causes any pixels that are pure white — that is, the ones that have a brightness value of 0 — to blink in the display. Most photographers refer to this as "blinkies" mode, but the official name on most cameras is Highlights Display mode.

Again, consider the blinkies display with respect to your subject. When you shoot a portrait against a very bright background, you may see lots of blinkies in the background. If your subject is well exposed, ignore those blinkies — it's the subject that matters. But if the blinkies occur on the person's face or hair, that's a signal to adjust the exposure settings or find different light in which to shoot your subject and try again.

WHAT'S A "STOP"?

Ready for another bit of photography lingo? The word *stop* is used to indicate a specific amount of exposure change. Increasing exposure by one stop means to select an f-stop or shutter speed that doubles either the amount of light (f-stop) or the duration of the light (shutter speed). Decreasing exposure by one stop means to cut the light in half. On a digital camera, you can also increase exposure by a stop by doubling the ISO value or decrease it by a stop by halving the ISO value.

Changing the Metering mode

Some cameras offer a choice of exposure *metering modes.* This setting determines the area of the frame that the camera analyzes in order to choose exposure settings for you when you take advantage of autoexposure. When you shoot in manual exposure mode, the data reported by the exposure meter is also based on the frame area measured in the current metering mode.

The three standard metering modes, usually represented by the symbols shown in the following list, work as follows:

>> **Whole-frame metering:** This setting analyzes the light throughout the entire frame. Depending on your camera, it may be called *matrix metering, multizone metering, evaluative metering, pattern metering*, or another, similar name.

>> **Center-weighted metering:** In this mode, the camera measures the light in the entire frame but assigns a greater importance — weight — to the center of the frame.

>> **Spot metering:** This mode gives you pinpoint exposure control, telling the camera to set exposure based on just a small area of the frame. Most cameras start out using the center of the frame to calculate exposure, but you may be able to choose a different metering spot.

How large an area the camera uses in spot metering varies depending on the camera. Also, you may get two spot-metering settings, with one measuring a slightly larger area than the other. The larger-spot metering option is often called *partial metering.*

Whole-frame metering is typically the default setting and usually produces good results. The exception is when the background is much brighter or darker than the subject, which can result in an over- or underexposed subject. Figure 5-11 offers an example. The left image was taken using whole-frame metering. Because the camera saw so much darkness in the frame, it used an exposure that left the white rose overexposed, leaving almost no detail in the petals. Changing to spot metering corrected the white rose, but left the red rose too dark, as shown in the middle image. For this scene, center-weighted metering produced the best exposure balance. However, if that red rose were out of the picture, the spot-metering image would be preferable because the white rose retains more detail.

In theory, you should select the best metering mode for your subject every time you shoot. But in practice, I usually stick with whole-frame metering unless I am shooting portraits, in which case I opt for spot metering so that my subject's exposure takes priority. I also use that setting when I visit the local bird sanctuary, again setting the metering spot on the bird I'm photographing. That way, snowy-white birds aren't overexposed when they're posing amid dark green foliage, and the darker-hued birds aren't underexposed when photographed against a bright blue sky.

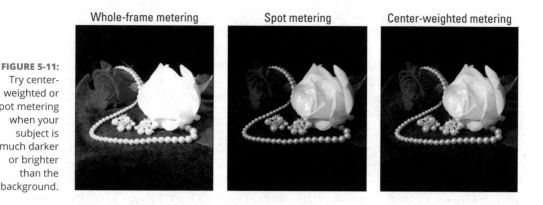

| Whole-frame metering | Spot metering | Center-weighted metering |

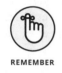

REMEMBER

Of course, when you switch to spot or center-weighted metering, your background may become too dark or too bright. On some newer cameras, you may find an option that brightens the shadows without also making the highlights too bright — see the later section "Expanding Tonal Range" for details. But if your camera doesn't offer such options, you just have to choose which part of the scene is the most important, exposurewise.

Using "priority" exposure modes

In addition to regular autoexposure modes, where the camera sets both aperture and shutter speed, your camera may offer *aperture-priority* autoexposure or *shutter-priority* autoexposure.

On some cameras, aperture-priority autoexposure is abbreviated as A; on others, Av. The *a* stands for aperture; the *v* stands for value. Shutter-priority autoexposure is abbreviated by either the letter *S* or *Tv*, for time value. (Shutter speed determines the exposure time.) Oh, and if you see the letters *AE*, as you will if you read many photography magazines, it's an abbreviation for autoexposure.

Whatever they're labeled, these options offer more control while still giving you the benefit of the camera's exposure brain. Here's how they work:

» **Aperture-priority autoexposure:** This setting gives you control over the aperture (f-stop). After you set the aperture, the camera selects the shutter speed necessary to correctly expose the image at that f-stop, taking into account the current ISO setting when making its decision.

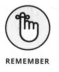

REMEMBER

By altering the aperture, you change depth of field — the range of sharp focus. The earlier section "Aperture also affects depth of field" explores this relationship between aperture and depth of field. Aperture isn't the only way to adjust depth of field, though, so see Chapters 2 and 6 for the whole story.

>> **Shutter-priority autoexposure:** In shutter-priority mode, you choose the shutter speed, and the camera selects the correct f-stop. This mode is good for times when your scene contains moving objects because shutter speed determines whether those objects appear blurry or are "frozen" in place. See the earlier section "Shutter speed also affects motion blur" for more details about shutter speed.

WARNING

Assuming that the ISO value doesn't change, you theoretically should wind up with the same exposure no matter which aperture or shutter speed you choose, because as you adjust one value, the camera makes a corresponding change to the other value, right? Well, yes, sort of. Remember that you're working with a limited range of shutter speeds and apertures (your camera manual provides information on available settings). So, depending on the lighting conditions, the camera may not be able to properly compensate for the shutter speed or aperture that you choose.

Suppose that you're shooting outside on a bright, sunny day. You take your first shot at an aperture of f/11, and the picture looks great. Then you shoot a second picture, this time choosing an aperture of f/4. The camera may not be able to set the shutter speed high enough to accommodate the larger aperture, which means an overexposed picture.

Here's another example: Say that you're trying to catch a tennis player in the act of smashing a ball during a gray, overcast day. You know that you need a high shutter speed to capture action, so you switch to shutter-priority mode and set the shutter speed to 1/500 second. But given the dim lighting, the camera can't capture enough light even with the aperture open to its maximum setting, so your picture turns out too dark unless you increase the ISO setting, making the camera more sensitive to light.

These issues would arise even in manual exposure mode, however. If you don't have enough light or if there's too much light, *you* can't dial in workable exposure settings, either. For this reason, I rely on aperture- or shutter-priority modes for most shots. Letting the camera do half of the exposure heavy lifting frees me up to concentrate on other issues, including composition. The only time I switch to manual exposure is when I want to dial in specific combinations of aperture and shutter speed or when I'm after an unusual exposure — that is, a result that the autoexposure system wouldn't normally deliver.

You don't have to shift to manual mode in those situations, however; by using the tools described in the next section, you can modify the results that the autoexposure system produces on your next shot.

Adjusting Autoexposure Results

Autoexposure is a useful tool, and for most subjects and lighting conditions, produces good results. But it's not foolproof, and it can't read your mind on occasions when you want to purposely under- or overexpose an image to evoke a certain photographic look or mood. Not to worry: Even using autoexposure mode, you may be able to adjust the brightness of your next shot by using the features outlined next: exposure compensation and autoexposure lock (AE Lock).

TIP

Another possible autoexposure fix lies in the exposure metering mode, which I cover earlier in this chapter. Again, that setting tells the camera which part of the frame to analyze when setting exposure. So if the metering mode is set to measure the entire frame, you may get different exposure results if you shift to spot metering mode, which enables you to base exposure primarily on your subject. Even then, though, the picture may still come out too bright or too dark for your tastes, so you may need to combine metering mode adjustment with these other autoexposure fixes.

Applying exposure compensation

This feature, often referred to as *EV (exposure value)* compensation, bumps the exposure up or down a few notches from what the camera's autoexposure computer thinks is appropriate.

The setting is often marked with a little plus/minus symbol like the one shown in the margin, and you typically choose from settings such as +0.7, +0.3, 0.0, −0.3, −0.7, and so on, with 0.0 representing the default autoexposure setting. (If you're an old-school photographer, it may help you to know that these settings represent exposure stops. For example, EV −0.3 reduces the exposure by one-third of a stop.)

How you adjust the amount of compensation varies from camera to camera, but the settings themselves are simple to understand:

>> **For a brighter exposure, raise the EV value.** The scene in Figure 5-12 is a classic example of the problem that occurs when you have a dark subject against a bright background: The camera, choosing exposure settings that average out the brightness values of the entire frame, left the palm tree too dark for my taste. So I applied EV compensation of +1.0 to produce the brighter result on the right.

>> **For a darker exposure, lower the value.** In Figure 5-13, the original exposure didn't have the drama I was after with this composition, and highlights in the sunlit brick and the candle flame are *blown out:* Areas that should span a range of brightness values have been so overexposed that you're left with a blob of white pixels. To get the more artistic result on the right, I dialed in EV −1.0.

EV 0.0 EV +1.0

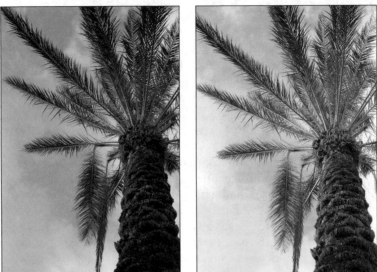

FIGURE 5-12:
The original
autoexposure
setting left
the palm tree
too dark;
raising the EV
setting to +1.0
produced the
brighter result.

EV 0.0 EV -1.0

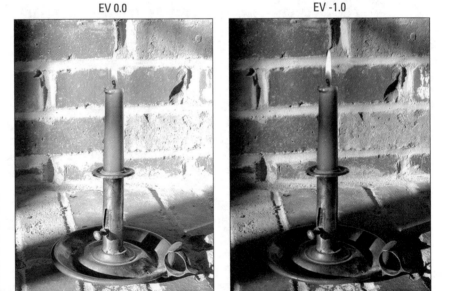

FIGURE 5-13:
Here, the
autoexposure
system blew
out the
highlights;
lowering the
EV value solved
the problem.

TIP

On some cameras, the exposure meter that helps you assess exposure in manual exposure mode appears whenever you enable exposure compensation. For example, if you dial in an adjustment of EV +1.0, you see a bar under the 1.0 mark on the positive side of the meter. This readout can get confusing because you naturally assume that you're about to overexpose the picture. But remember: The meter is based on what *the camera* considers the ideal exposure — which is what you get

when the EV value is 0.0 (no compensation). When you set the EV compensation level to +1.0, you are, in essence, asking the camera to overexpose the shot by one stop over what it thinks is ideal.

WARNING

Make it a practice to reset the Exposure Compensation value to EV 0.0 after you finish shooting the subject that required the adjustment. You can easily forget that you enabled the option and then not be able to figure out why everything is too bright or too dark when you move on to your next subject. If you do get weird exposure results on a shot, check this setting first to make sure that you didn't leave compensation turned on by accident.

AE Lock (autoexposure lock)

When you use autoexposure, most cameras continually measure and adjust exposure settings from the time you press the shutter button halfway to set focus until the time you take the picture. Usually, that system works well because it accounts for any lighting changes that may occur at the last second. But on occasion, you may want to interrupt the continuous exposure adjustment and lock in the current settings. Some cameras offer an AE Lock feature that does just that.

Your camera may have a button specifically set aside for this function, or you may be able to assign it to a Function (FN) button or another button. Many cameras offer a button labeled AE–L/AF–L, which locks both autoexposure and autofocus, respectively, when pressed. (You often can customize the button so that it locks exposure only if you prefer.)

Expanding Tonal Range

A scene like the one in Figure 5-14 presents the classic photographer's challenge: Choosing exposure settings that capture the darkest parts of the subject appropriately causes the brightest areas to be overexposed. And if you instead *expose for the highlights* — that is, set the exposure settings to capture the brightest regions properly — the darker areas are underexposed.

In the past, you had to choose between favoring the highlights or the shadows. But now photographers have a couple ways to work around the problem:

>> **In-camera image manipulation:** Some cameras now have tools that brighten the shadows without altering the highlights, enabling you to stretch a photo's *tonal range* — the range of shadows to highlights, also called *dynamic range.* Some Nikon cameras, for example, offer a feature called Active D-Lighting, which tackles the problem in two stages: First, the original

exposure is slightly underexposed, to ensure that highlights are properly rendered. Then, before the image is written to the memory card, it undergoes a software process that brightens only the darkest shadows. I used this tool to create the improved seal image in Figure 5-14. Some Canon cameras offer a similar tool called Highlight Tone Priority, and some Sony models offer DRO (dynamic range optimizer). Check your camera manual to find out whether you have this sort of option at your disposal.

» **HDR (high dynamic range) imaging:** This term refers to a technique in which you photograph the same subject multiple times, exposing some images for the darkest areas, some for the *midtones* (areas of medium brightness), and some for the highlights. You then use special HDR software to combine the exposures, specifying which parts of the frame to pull from which exposure.

For a great example of HDR work, take a look at the images in Figures 5-15 and 5-16, both from photographer Dan Burkholder (www.danburkholder. com). In the first image, you see the scene captured at a single exposure. The waterfall is beautiful, but you can't see much detail in the shadows. The second image offers the HDR version, created by combining the shot from Figure 5-15 with seven additional exposures. With the expanded tonal range possible through HDR, you now can see the moss-covered rocks that the water is spilling over.

Original image

Image with expanded tonal range

FIGURE 5-14: Some cameras have features that brighten shadows without also blowing out highlights.

FIGURE 5-15:
Here you see one of the exposures that photographer Dan Burkholder used to create the HDR image in Figure 5-16.

FIGURE 5-16:
The final HDR image includes a greater tonal range than can be captured in a single exposure.

TIP

Some cameras offer automated HDR, capturing and blending multiple exposures with one press of the shutter button. The automated features usually don't capture more than a couple of frames, and you don't have much control over the exposure shift between frames or how frames are blended into the

HDR composite. Still, they often produce better results than you can achieve in a single exposure.

Figure 5-17 shows the type of results you can expect. This scene illustrates a problem often faced by real estate agents taking photos of their clients' homes: How to capture both the interior of the house and the exterior landscaping that's visible through the windows. The first two shots show you what I was able to capture in a single exposure. When I set the exposure based on the exterior, the interior was underexposed. When I instead exposed for the interior, the view out the doors became too bright. To produce the final image, I enabled automated HDR mode. Is it perfect? Well, I'd like the interior to be slightly brighter and the exterior to be a tad darker. But it's a definite improvement over the other two exposures.

WARNING

However you approach HDR, use a tripod to make sure that the framing doesn't change between shots — otherwise, the HDR software, whether in-camera or on your computer, can't successfully blend the frames. Also, maintain the same f-stop throughout all frames so that the depth of field doesn't shift from one frame to the next. Avoid scenes that contain moving objects, including people, in the blended HDR frame, moving objects will appear at partial opacity along the path they took while the shutter was open.

Exposed for highlights Exposed for shadows HDR Mode, 3-stop setting

FIGURE 5-17: Some cameras offer automated HDR shooting, which I used to produce the third image in this series.

Bracketing Exposures

Creating HDR images requires you to *bracket* exposures, which means to capture the scene at different exposure settings. But bracketing isn't just for HDR: For tricky exposures, it's a good idea to capture the subject at a few different exposure settings, to increase your chances of coming home with at least one frame that you like. I took this approach when shooting the skyline scene shown in Figure 5-18, for example.

How you accomplish bracketing depends on what exposure modes are available to you:

>> In **manual** exposure mode, change the shutter speed, aperture, or ISO between each shot. For Figure 5-18, I adjusted shutter speed.

>> In the **automatic** exposure modes (including shutter- and aperture-priority autoexposure modes), shoot the subject using three different exposure compensation settings. Simply changing the shutter speed or aperture won't do the trick — as soon as you change one of those settings, the camera adjusts the other to compensate so that the final exposure is the same, no matter what.

TIP

Some cameras also offer *automatic exposure bracketing.* With this feature, often abbreviated as AEB, you take a series of successive shots, and the camera automatically adjusts exposure between each capture. Usually, you can select the number of frames and the amount of exposure shift between each frame. Check your camera manual to find out what your camera offers and how it works.

f/5.6, 1/20 second, ISO 100

f/5.6, 1/40 second, ISO 100

f/5.6, 1/60 second, ISO 100

FIGURE 5-18:
Automatic bracketing records the same subject several times, using different exposure settings for each shot.

Adding Flash

You can't create a picture without light (unless, of course, you're shooting with a night–vision camera). Fortunately, most cameras enable you to use flash to illuminate your subject when the ambient lighting is insufficient.

On basic cameras, you may have no control over the flash beyond being able to turn it on or off. Some cameras don't even give you that option, taking over the decision of when flash is needed. But if you're shooting with an intermediate or advanced model, you may be able to adjust various flash settings, each of which

has a different impact on your photos. Even starter cameras sometimes offer one or two of these features. You also may have the option of using a built-in, pop-up flash or attaching a larger, external flash head to the camera.

The rest of this chapter explores the most common flash options. But understand that good flash photography involves many more techniques and tools than I have room to cover in this book. I encourage you to seek out other sources of information on the subject. One great place to start is the website www.strobist.com. (*Strobe* is another word for *flash*.) Also, check your camera manufacturer's website; Nikon, Canon, and other big names in the photography business offer helpful, free tutorials to help you improve your flash photographs.

Enabling and disabling flash

On most cameras, the exposure mode you use determines whether you can enable or disable flash. In Auto mode, for example, the camera may decide whether flash is needed, preventing you from having any say in the matter. But in advanced modes such as aperture-priority autoexposure, the camera may bow out of the decision, leaving it up to you to enable flash if you see fit.

The following list describes the standard ways in which you enable and disable a built-in flash — assuming of course, that your camera gives you that flexibility:

» **Flash button:** On intermediate and advanced cameras that offer a pop-up flash, look for a button like the one shown on the left in Figure 5-19. To bring the flash out of hiding, just press that button. Again, you may need to shoot in advanced exposure mode to have this option. To stop using flash, just gently press down on the flash unit to put it away.

FIGURE 5-19: When you shoot in advanced exposure modes, you may need to press a button like this one to enable flash.

Flash button

Flash Off exposure mode

» **Flash Off exposure mode:** Some cameras offer Flash Off exposure mode, which usually sports a label like the one shown on the right side of Figure 5-19. This mode works just like Auto mode, detailed in Chapter 3, but disables flash.

» **Flash mode:** Some cameras offer a variety of *flash modes,* each of which affects flash firing in slightly different ways. You usually adjust this option via the camera's main settings screen, as shown in Figure 5-20, or via a menu option. Sometimes, you press a Flash button while rotating a dial to adjust the flash mode. (In other words, check your camera manual for how-tos.)

FIGURE 5-20:
You also may be able to turn flash off and on via the Flash mode setting.

I explain some of the more complex flash modes later in this chapter, in the section "Exploring special flash modes," but for the purposes of this discussion, look for these two flash modes:

- *Flash on:* This setting causes the flash to fire no matter what the ambient light, which is why it is sometimes called *force flash.* You may also see this setting represented by the term *fill flash* or *fill-in flash.* The idea is that even though there's enough light to expose most of the scene, you need a little flash light to fill in the shadows. Typically, the symbol representing this mode looks like a lightning bolt, as shown in Figure 5-20. See the sidebar "Using flash outdoors," later in this chapter, for tips on using flash in bright light.

- *Flash Off:* In this mode, represented by a symbol like the one labeled in Figure 5-19, the flash won't fire — no way, no how. It's designed primarily for venues such as churches and museums that don't permit flash photography. But you may also want to turn off the flash simply because the quality of the existing light is part of what makes the scene compelling, for example. Or, you may want to go flashless when you're shooting highly reflective objects, such as glass or metal, because the flash can cause *blown highlights* (areas that are completely white, with no tonal detail).

WARNING

- When you turn off the flash in an autoexposure mode, the camera may reduce the shutter speed to compensate for the dim lighting. That means you need to hold the camera steady for a longer period to avoid blurry images. Use a tripod or otherwise brace the camera for best results. You also can consider raising the ISO setting to increase the camera's sensitivity to light (but be aware that you may introduce noise into the photo).

USING FLASH OUTDOORS

TIP

Most people think about flash as purely a way to light a dark scene or shoot indoor pictures. But flash can also come in handy when you're shooting outdoors on a sunny day. Remember, in this situation, your light source is coming from above, so although there may be adequate light on top of your subject, the front may not be illuminated, especially if you're shooting a portrait of someone wearing a brimmed hat, as in the examples shown here. Without flash, the shadow from the hat obscured the subject's face. Adding flash threw just enough additional light on her face to produce a well-exposed portrait.

To use flash in bright light, you may need to set the flash mode to Fill Flash or whatever setting causes the flash to fire regardless of the ambient light. (In Auto flash mode, the camera is unlikely to see the need for flash.) You also may need to shoot in an advanced exposure mode that permits you to control whether the flash fires.

There's one other complication to understand: Because of the way that the camera must synchronize the burst of flash light with the action of the shutter, most cameras limit you to a top shutter speed in the range of 1/200 to 1/250 seconds. Some go even lower, limiting you to a mere 1/60 second. So, in very bright daylight, you may overexpose the photo by using flash — even if you stop the aperture down to its smallest opening (permitting the least amount of light to hit the sensor) and use the lowest ISO setting (making the camera less sensitive to that light). Here are three possible workarounds to this problem:

- **Use high-speed flash, if your camera has that capability.** Some advanced models enable you to use *high-speed flash* when you attach an external flash head. In that mode, you can access the full range of shutter speeds and raise the shutter speed high enough to properly expose the photo. (This is how professional portrait photographers use flash in their outdoor work.)

- **Add a neutral-density filter to your lens.** Like sunglasses for your lens, a neutral density filter cuts the amount of light that can enter the lens, allowing you to use a slower shutter speed and still expose the image correctly.

- **Shoot in the shade.** The simplest fix? Just move your subject into the shade. Now you can use the flash to adequately light the face without overexposing the image.

In addition, colors may appear slightly warmer or cooler than usual, which is a phenomenon that can occur any time you mix two different light sources — in this case, flash and daylight. For information on how to use your camera's white-balance control to adjust colors if needed, see Chapter 6.

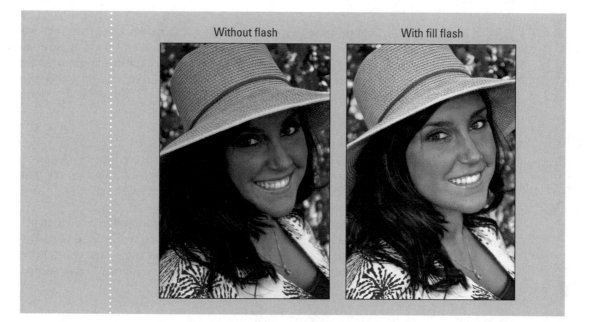

Without flash | With fill flash

Exploring special flash modes

In addition to the two basic flash modes, Flash On and Flash Off, your camera may offer the three flash-mode settings outlined next.

Flash with red-eye reduction

Anyone who's taken "people pictures" with a point-and-shoot camera — digital or film — is familiar with the problem of *red-eye,* where the flash reflects against the subject's retinas and the result is a demonic red glint in the eye. Red-eye reduction mode, typically represented by an eyeball icon, aims to thwart this phenomenon by firing a low-power flash before the "real" flash goes off or by emitting a beam of light from a lamp on the camera body for a second or two before capturing the image. The idea is that the prelight, if you will, causes the pupil of the eye to shut down a little, thereby lessening the chance of a reflection when the final flash goes off.

Unfortunately, red-eye reduction flash doesn't always work perfectly. Often, you still wind up with fire in the eyes — hey, the manufacturer promised only to *reduce* red-eye, not eliminate it, right? Worse, your subjects sometimes think the prelight is the actual flash and start walking away or blink just when the picture is being captured, so if you shoot with red-eye mode turned on, be sure to explain to your subjects what's going to happen.

TIP

The good news is that, because you're shooting digitally, you can repair red-eye easily. Some cameras have an in-camera red-eye remover that you can apply after you take a picture. If not, the fix is easy to make in a photo-editing program. Many online printing sites and in-store photo kiosks even have tools that let you do the job before you order your prints.

Slow-sync flash

Slow-sync flash, a specialty flash mode, increases the exposure time beyond what the camera normally sets for flash pictures. The name comes from the way that the timing of the flash light is synchronized with the shutter action.

With a normal flash, your main subject is illuminated, but background elements beyond the reach of the flash are dark, as in the first example in Figure 5-21. The longer exposure time provided by slow-sync flash allows more ambient light to enter the camera, resulting in a brighter background, as shown in the second example in the figure.

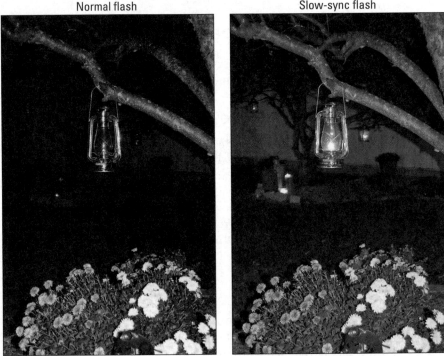

Normal flash · Slow-sync flash

FIGURE 5-21: Slow-sync flash produces a brighter background than normal flash mode.

Whether a brighter background is desirable depends upon the subject and your artistic mood. However, remember that the slower shutter speed required for slow-sync flash can easily result in a blurred image; both camera and subject must remain absolutely still during the entire exposure to avoid that problem. As a point of reference, the exposure time for the normal flash example in Figure 5-21 was 1/60 second, and the slow-sync exposure time was a full second.

Rear-curtain sync

Normally, the flash fires at the beginning of the exposure, an arrangement known as *front-curtain sync.* In Rear-Curtain Sync Flash mode, the flash fires at the end of the exposure. The classic use of this mode is to combine the flash with a slow shutter speed to create trailing-light effects like the one you see in Figure 5-22. With Rear-Curtain Sync, the light trails extend behind the moving object (my hand, and the match, in this case), which makes visual sense. If instead you use slow-sync flash, the light trails appear in front of the moving object.

Using an external flash

Although your camera's built-in flash offers a convenient alternative for lighting the scene, the light it produces is typically narrowly focused and fairly harsh. When you're shooting your subject at close range,

FIGURE 5-22:
Rear-curtain sync is combined with a slow shutter to create motion trails that extend behind a moving subject.

a built-in flash can leave some portions of the image overexposed or even cause *blown highlights* — areas so overexposed that they're completely white, without any detail. Moving farther from your subject isn't always an option, either, because the range of most built-in flashes is about 8 to 10 feet. And a built-in flash often leads to red-eyed people, as all of us know too well.

Some digital cameras can accept an auxiliary flash unit, which helps reduce blown highlights and red-eye because you can move the flash farther away from, or at a different angle to, the subject. (The closer the flash is to the lens, and the more direct the angle to the subject's eyes, the better the chance of red-eye.)

Additionally, external flash heads have a longer reach than a built-in flash, yet typically produce a more pleasing result, illuminating the subject with a more widespread, and thus softer, light. If you buy a flash with a rotating head like the

one shown in Figure 5-23, you can bounce the light off the ceiling for an even more diffused effect.

Figure 5-24 has an example: Notice that in the first shot, taken with the flash angled directly at the subject, strong shadows appear behind the subject, and the light is harsh on the skin. For the second shot, I aimed the flash head upward so that the light hit the ceiling and then fell down softly on the subject, eliminating background shadows and producing much more pleasing lighting. (Be sure that the ceiling is white if you try this technique — otherwise, the bounced light will take on the color of the ceiling.)

When you attach an external flash, the camera's onboard flash is disabled (if the camera has one), but the auxiliary flash works automatically with the camera, just like an on-camera flash. However, to ensure full compatibility, you need to buy an external flash that's set up to work with your specific camera.

FIGURE 5-23:
An external flash with a rotating head offers more flexibility and better illumination than a built-in flash.

Direct flash Bounced flash

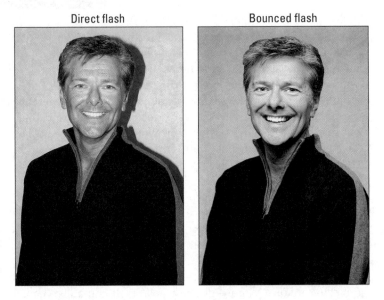

FIGURE 5-24:
Here you see the difference between direct (left) and bounced (right) flash lighting.

Adjusting flash power

When you use flash, the camera automatically sets the flash power according to what it thinks is necessary. But many cameras enable you to adjust the strength of the flash light through a feature called *flash exposure compensation,* or *flash EV.* This feature works just like exposure compensation, which adjusts overall exposure to produce a darker or brighter image, but instead varies the strength of the flash. Usually, the option is represented by a little plus/minus symbol alongside a lightning bolt — the universal symbol for flash. It's easy to use: As with exposure compensation, settings are stated in numerical terms, such as +1.0, −1.0, and so on. If you want more flash power, you use a positive flash EV value: +0.3, +0.7, and so on. For less flash power, you select a negative value.

Figure 5-25 offers an example of how this feature works. I shot this picture at an outdoor farmers' market, in a stall that was shaded by a large awning. I wanted to add flash to bring a little more light to the scene, but at the default flash power,

the flash light was just too hot, blowing out the highlights in the fruit. So I reduced the flash power by setting the flash compensation value to −1.3, which added just a small pop of light without overpowering the subject.

No flash Flash EV 0.0 Flash EV -1.3

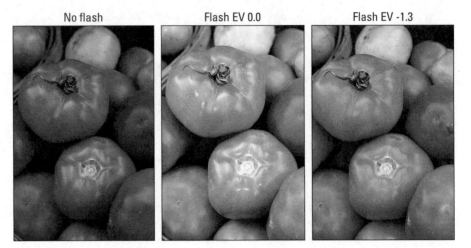

FIGURE 5-25:
Flash exposure compensation enables you to adjust the strength of the flash.

For advanced photographers, some cameras also offer manual flash power control. If you go this route, the camera doesn't take any role in setting flash power; you dial in exactly how much flash power you want to use.

In addition to using these flash adjustments, you can diminish flash power by using a mechanical solution: Place a diffuser over the flash head. For example, Figure 5-26 shows a diffuser designed to work with the pop-up flashes on dSLR cameras. The diffuser in the figure is made by Lumi-Quest (www.lumiquest.com) and sells for under $15, but you can find other styles of diffusers for built-in flashes and also for external flash heads. Regardless of the style or size, the idea is to spread and soften the flash light, helping to eliminate harsh shadows and create more flattering light. If you do much flash photography, especially portrait photography, adding a diffuser to your camera bag is one of the best investments you can make.

FIGURE 5-26:
You also can buy diffusers that soften the harsh light of a built-in flash.

Chapter 6

Manipulating Focus and Color

Today's digital cameras offer an abundance of focus and color features. But if you don't understand how they work, you may get unexpected (and unacceptable) results. You may want to photograph a particularly stunning rose bloom in your garden, for example. If that rose is surrounded by other plants, the camera's focusing system may lock onto one of them instead, which can cause the rose to appear blurry in the photo. Or you may discover that at the current color settings, the camera renders the rose petals as a solid blob of orange instead of accurately capturing the subtle shades of yellow and coral that actually make the flower a stunner.

To help you avoid such miscues, this chapter explains common focusing and color-related options. The early sections detail the most important aspects of focus, covering such topics as getting the best results from your camera's autofocusing system and achieving different creative goals by manipulating *depth of field* (the distance over which sharp focus is maintained). The second part of the chapter dives into the color pool, explaining how to deal with off-kilter colors and offering tips about subtle color adjustments you can use to enhance different subjects. To wrap things up, I explain a feature that affects both color and subject sharpness.

Diagnosing Focus Problems

Several factors affect focus, so to find the solution to a focusing concern, you first have to identify the cause. Here's a quick symptoms list that will point you in the right direction:

>> **The entire picture is blurry.** This problem, illustrated in the first photo in Figure 6-1, is the result of *camera shake* — camera movement during the exposure. Camera shake is a possibility any time you handhold the camera, and the slower the shutter speed, the greater the risk. To remedy the situation, put the camera on a tripod or find another surface on which to place the camera so that you can get a steady shot.

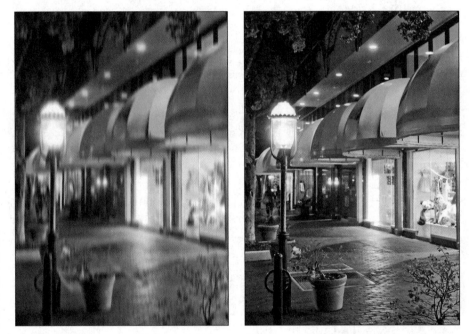

FIGURE 6-1: Camera shake causes allover blur (left); use a tripod to ensure sharp shots (right).

TIP

If you must handhold the camera, find out whether your camera or lens offers image stabilization. That feature, when enabled, can compensate for small amounts of camera shake.

>> **My subject is blurry, but the rest of the picture is sharp.** This problem can be caused by a couple of errors:

- *The subject moved, and the shutter speed wasn't fast enough to freeze the action.* To catch a tack-sharp picture of a moving subject, you need a fast shutter speed. How fast depends on your subject's speed. In the first photo

in Figure 6-2, for example, the duck on the left was moving his head too fast to be captured cleanly at a shutter speed of 1/60 second. Bumping the shutter speed up to 1/250 second froze the action successfully, as shown in the photo on the right.

f/6, 1/60 second, ISO 100 f/6, 1/250 second, ISO 400

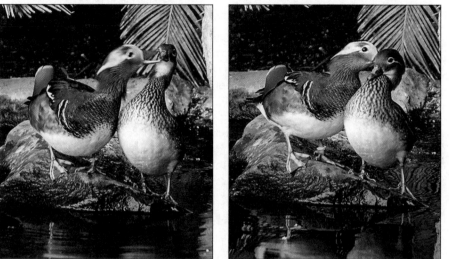

FIGURE 6-2: If moving objects are blurry, try using a faster shutter speed.

WARNING

In order to maintain the proper exposure when you raise the shutter speed, which reduces exposure time, you must choose a lower f-stop setting (to allow more light into the camera) or raise the ISO setting (to make the camera more sensitive to light). In Figure 6-2, I adjusted ISO. Chapter 5 talks more about exposure; for more tips on shooting a moving target, check out Chapter 7.

- *The subject is outside the focusing zone.* By default, most cameras base focus either on the object closest to the lens or the object at the center of the frame. To make things even more complex, the designated focus point may change depending on your exposure mode — the camera may use a different point in Auto mode, for example, than it does in Close-up mode.

 Obviously, it's critical to know the spot your camera targets when setting focus so that you can be sure that your subject is within that focusing area. Depending on your camera, you may be able to designate a specific focusing point or area other than the one used by default; see the section "Getting good autofocusing results," later in this chapter, for a bit more explanation.

>> **Too much (or too little) of the scene is in focus.** When you focus the camera, you establish the point of sharpest focus. Whether objects in front of or behind the focus target are also in focus depends on the depth of field.

Your camera's focus controls don't affect this aspect of your photos; instead, you manipulate depth of field by adjusting aperture (f-stop), focal length, and camera-to-subject distance. See "Playing with Depth of Field," later in this chapter, for details.

» **The camera won't focus.** Assuming that your camera isn't broken, you may simply be too close to your subject. Again, every lens has a close-focusing limit, which you should be able to determine with a look at your camera or lens manual.

If you're using autofocusing, another possible cause is the subject itself. Even the best autofocusing systems have trouble with certain subjects, such as reflective surfaces and objects under water or behind a fence. Dim lighting is also problematic for autofocusing systems, as are scenes in which little contrast exists between your desired focus point and the surrounding area. The easiest fix is to focus manually, if your camera permits it. Another option is to look for an easy-to-focus object that's the same distance from the camera as your subject, lock focus on that object, and then reframe to your desired composition and take the picture. Again, check out "Getting good autofocusing results" for specifics on that technique.

» **The scene in the viewfinder looks blurry even when the camera indicates that focus is set.** Go ahead and take the picture, and then determine whether the image is in fact correctly focused. If it is, you may simply need to adjust the viewfinder to your eyesight. You do this by using a *diopter adjustment control,* a little dial or switch located near the viewfinder. (Chapter 3 has details.) On the other hand, if your test shot is as blurry as the viewfinder indicates and none of the preceding solutions solves the problem, your camera or lens may need repair.

TIP

Dirt or dust on your lens can also cause focusing miscues, so keep your lens-cleaning supplies handy. If you have a filter attached to the lens (such as a neutral density filter), remove it to make sure that no debris is trapped between it and the lens. Then clean both the lens and the filter.

Understanding Focusing Systems

Focusing features on digital cameras range from very basic to extremely complex. On touchscreen-enabled cameras, you may be able to simply tap the monitor screen to focus. On advanced cameras, you can choose from manual focusing or autofocusing, and most high-end models offer a seemingly endless list of ways to modify the camera's focusing behavior.

Knowing how your camera's focusing system works is critical to getting sharp shots. The following sections describe the most common focusing schemes and how you can make the most of them.

Getting good autofocusing results

Because the steps you take to autofocus vary widely depending on the type of camera you use, I can't provide step-by-step instructions for autofocusing. But Chapter 3 provides a basic recipe for autofocusing using the typical default camera settings, and the following list provides additional information that may help you sort things out on your camera.

>> **On cameras that offer both autofocusing and manual focusing, you may need to enable autofocusing.** On an interchangeable-lens camera, you may find a control on the lens or camera body (or both) that switches the system from manual to autofocus. For example, Figure 6-3 shows the switch as it appears on a Canon dSLR and lens combo. Other cameras require you to switch the focusing method to auto via a menu option.

>> **Determine the location of autofocusing points within the frame.** The camera can focus only on objects that fall under the focus points, so it's critical that you take this step.

Auto/Manual focus switch

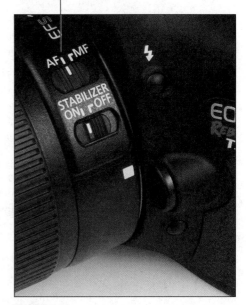

FIGURE 6-3:
Some dSLR lenses have a switch that sets the camera to autofocus mode.

Most cameras display marks in the viewfinder or monitor to indicate the autofocus points. The left screen in Figure 6-4 shows one example of how autofocus points are represented in the viewfinder on some Canon dSLRs. You may not always see individual points; sometimes the camera simply displays a border around the frame area that contains the focus points. If your camera doesn't have a viewfinder or you use Live View (you compose the scene using the monitor instead of the viewfinder), you may instead see a rectangular focus frame like the one shown on the right in the figure.

Autofocus points Focus frame

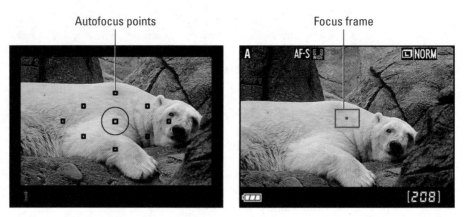

FIGURE 6-4:
The autofocus areas may be indicated by little squares in the viewfinder (left) or by a single focus frame (right).

WARNING

Which focus points are active and which one the camera checks first to establish focusing distance may vary depending on the exposure mode or certain autofocusing settings. In some cases, the markings in the displays change depending on those settings. (See the next bullet point for more on this topic.)

Also, some cameras display additional marks that aren't related to focusing. The center circle in the viewfinder shown on the left in Figure 6-4, for example, indicates the spot-metering zone, an exposure feature offered on some Canon cameras. And when the scene displayed in the viewfinder differs significantly from the area that the camera will actually photograph, framing marks are usually provided to let you know where the edges of the picture will be.

>> **If your camera has a shutter button, remember to use the two-stage button-pressing technique.** To set focus, press the button halfway down and hold it there. Don't simply press the button all the way down to take the picture in one motion; if you do, the camera doesn't have adequate time to set focus and exposure.

REMEMBER

When you're ready to take the shot, gently (but firmly) press the shutter button the rest of the way, being careful not to move the camera in the process. Remember, any camera movement while the shutter is open can blur the image.

>> **Find out whether your camera offers single-point focusing, multiple-point focusing, or both. Here's how these options work:**

● *Single-point autofocusing:* The camera bases focus on the object that falls under a specific focus point. Usually, the default focus spot is in the center of the frame. But you may be able to select a different focus point by either using a control on the camera or, on touchscreen-enabled devices, tapping the screen.

- *Multiple-point autofocusing:* With this setup, also known as multispot autofocusing, the camera considers all focusing points. It then sets focus on the object nearest the lens or, in some cases, the object occupying the largest portion of the frame (such as a large building).

To control this part of the autofocusing system, look for a setting that has a name such as *AF mode, AF-area mode,* and the like. (The AF stands for *autofocus.*) You may need to shoot in an advanced-exposure mode to access this setting, though; in Auto and scene shooting modes, the camera may make this decision for you.

TIP

Some cameras enable you to choose which option you want to use. You may even find additional focusing schemes; for example, you may be able to base focus on a small cluster of focus points in a particular area of the frame. This option is usually referred to as *zone autofocusing.* Or you may be able to reduce the number of available focus points to make it easier to select a point when you use single-point autofocus. (Scrolling the point-selection cursor to get to your desired point takes less time when the camera is set to display only 11 points, for example, instead of 39 points.) Look for this kind of option on your camera's advanced setup menu(s).

» **For stationary subjects, use single-servo autofocusing; for moving subjects, use continuous-servo autofocusing.** Don't get freaked out by the techie-sounding names — these two options are actually easy to understand:

- *Single-servo autofocusing:* In this mode, focus is locked at the moment the camera achieves focus. Once and done, if you like (thus, *single servo*). This option is usually best for portraits, landscapes, and any nonmoving subject.

 Single-servo autofocus enables you to use the "focus and reframe technique" when you want your subject to appear somewhere other than under the selected focus point. Compose the picture initially so that the subject *is* under that point and then press the shutter button halfway to set focus. Keep the button pressed down halfway, reframe as desired, and then press the shutter button the rest of the way to take the picture. Figure 6-5 illustrates this technique. On touchscreen devices, you may be able to lock focus by tapping the screen instead.

 When you reframe, after locking focus, be careful not to change the distance between the camera and your subject, or else focus will be off. In photography lingo, keep the camera on the same *focal plane.*

WARNING

- *Continuous-servo autofocusing:* This mode is designed for photographing moving subjects. The camera sets the initial focusing distance just as it does in single-servo mode, but then adjusts focus continuously as needed up to the time you take the shot. So if you set focus on a subject that's 20 feet in front of you but don't take the picture until the subject is 10 feet away, it should still be in focus.

Not all cameras offer this degree of autofocusing flexibility, however. Some models don't offer continuous autofocusing, and others decide for you whether to use single- or continuous-servo autofocusing. If the camera senses motion in front of the lens, it uses continuous-servo autofocusing; if not, it sticks with single-servo.

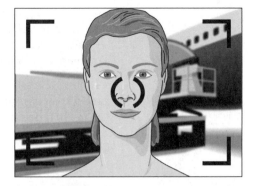

Even on cameras that do enable you to make the call, the default mode is usually the automatic (camera's choice) setting. To access the other options, you may need to switch to an advanced exposure mode, such as aperture-priority autoexposure or manual exposure.

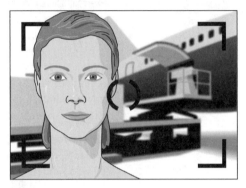

FIGURE 6-5:
After locking focus on your subject, you can reframe the shot, if you want.

Also note that these settings go by different names, depending on the manufacturer. For example, most Canon cameras use the terms *One Shot* for single-servo autofocus; *AI Servo* for continuous autofocus (AI stands for *artificial intelligence*); and *AI Focus* for the automatic mode that lets the camera decide whether focus is locked. Nikon, on the other hand, uses the terms AF-S for single-servo; AF-C or AF-F for continuous-servo (C for continuous and F for full-time autofocusing); and AF-A to represent the Auto setting.

» **When focus is set, the camera may emit a beep or display a focusing symbol in the displays.** Usually, a little light in the viewfinder turns green, the camera emits a beep, or both. With cameras that use a focusing frame like the one shown in Figure 6-4, the frame turns green. If your camera has a viewfinder, the focusing points that the camera used to set focus may also light briefly.

With continuous autofocusing, most cameras send the focus-achieved signal only when the initial focusing distance is set. Some don't provide that signal at all in continuous-autofocus mode.

>> **Your camera may offer special focusing modes that choose the closest or farthest possible focusing distance.** Point-and-shoot cameras sometimes provide one or both of these specialty focus modes:

- *Macro* focusing mode allows you to focus at a closer distance than you normally could. It's designed for shooting close-ups, in other words. On some cameras, selecting the Close-up exposure mode automatically enables this focus option.

- *Infinity mode* does the opposite. It sets focus at the farthest point possible and is designed for shooting subjects at a long distance. Your camera may select this focus setting automatically when you shoot in certain automatic exposure modes, such as the Landscape and Fireworks scene modes. (See Chapter 3 for more information about automatic scene modes.)

For each of these focus settings, check your camera's manual to find out the proper camera-to-subject distance.

TIP

USING OTHER BUTTONS TO AUTOFOCUS

Advanced and intermediate-level cameras often sport one or both of the following buttons to give you alternative ways to initiate and lock autofocus:

- **AE-L/AF-L button:** The initials stand for *autoexposure lock/autofocus lock.* When you use continuous autofocusing, you can press and hold this button to interrupt focus adjustment and lock focus at the current distance. When you release the button, continuous autofocusing begins again. By default, pressing the button also locks in the current autoexposure settings, which are otherwise adjusted up to the time you take the shot when you shoot in most exposure modes. If you consult your camera menus, you may find an option that enables you to modify the function of this button so that it locks focus only or exposure only, depending on which setup you find more helpful.

- **AF-ON button:** This button is related only to autofocusing. It enables you to initiate autofocusing, lock the focusing distance, and start and stop continuous autofocusing without pressing the shutter button halfway. Because the button is usually on the back of the camera, photographers refer to this option as *back-button autofocus.*

Note that some cameras have a button labeled simply AF. This button usually is provided for a purpose other than starting and stopping autofocusing. Instead, it brings up a screen where you can modify autofocusing settings.

Finally, remember that even the most capable autofocus system may have trouble doing its job in dim lighting. Certain types of subjects also confuse autofocus mechanisms: Objects behind vertical bars (such as a lion at the zoo), low-contrast scenes (think gray boat sailing in foggy weather), and highly reflective objects are among the biggest troublemakers.

If your camera offers manual focusing, the easiest solution is to switch to that mode and do the focus work yourself. But you can also use the focus-and-reframe focusing technique mentioned earlier: Lock focus on something else that's the same distance away from the lens as your subject, and then reframe the shot as needed.

Focusing manually

On some cameras, you can opt out of autofocus and instead rotate a focusing ring on the lens to focus manually. You first may need to set a switch on the lens or camera body to manual-focus mode, select manual focusing from a camera menu, or both. The steps you use and the placement of the focusing ring vary, so check out those camera and lens manuals for details.

If your lens doesn't offer a focusing ring, you may be able to set focus manually. Some cameras enable you to set focus by using a switch or lever on the camera or by entering a specific focusing distance via a menu option.

TIP

Even when you focus manually, some cameras offer tools to assist you in achieving focus. Here are some of these features:

>> **Standard "focus achieved" signals:** Your camera may send the same signals as it does when you use autofocusing. For example, the focus indicator lamp may light, the camera may beep at you, or both.

>> **Focus peaking:** Some cameras can display highlights on the monitor to indicate which areas are in focus. You can usually choose the colors for the highlights. If your camera has an electronic viewfinder, you may be able to see the highlights in the viewfinder as well as on the monitor. With a camera that has an optical viewfinder, the focus-peaking display appears only if you set the camera to Live View mode (the setting that disables the viewfinder so that you can compose the scene using the monitor).

>> **Display magnification:** You may be able to magnify the screen display so that you can verify that focus is set precisely on your subject. Again, on cameras with an optical viewfinder, you must be in Live View mode to use this feature.

>> **Rangefinder:** You also may be able to swap out the exposure meter for a focusing aid called a *rangefinder*. Figure 6-6 gives you a look at the range-finder design used on some Nikon cameras, for example. The bars under the rangefinder meter indicate whether focus is set behind, in front of, or on your subject. Just keep in mind that because the rangefinder is based on the same focusing system that the autofocus system employs, subjects that confuse the autofocus system also render the rangefinder unable to find a focusing target.

FIGURE 6-6:
A rangefinder is a focusing aid that provides feedback when you focus manually.

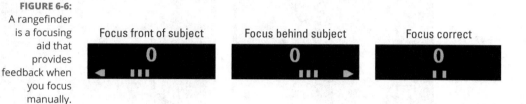

Focus front of subject Focus behind subject Focus correct

Playing with Depth of Field

One way to become a more artful photographer is to learn how to control *depth of field*, which refers to the distance over which sharp focus is maintained.

Chapter 2 introduces you to this concept and offers several examples of how to put depth of field to creative use, but here's a quick recap:

>> **Shallow depth of field:** The subject is sharp, but objects at a distance are blurred, as in the left image in Figure 6-7. This treatment is perfect for por-traits because it prevents the background from drawing attention from the subject. You can also use shallow depth of field to help a subject stand apart from a similarly colored background (see Figure 6-9, later in this section.)

REMEMBER

One often overlooked point on this treatment: For the background to appear blurry, some distance must exist between it and the subject. The farther the background is from the subject, the blurrier it appears. Ditto for objects in front of the subject.

>> **Large depth of field:** A large depth of field extends the sharp-focus zone over a greater distance. Landscapes and architectural shots like the one on the right in Figure 6-7 typically benefit from a large depth of field. Focus in this image was set on the foreground figure, but the ones in the distance look nearly as sharp.

Shallow depth of field Large depth of field

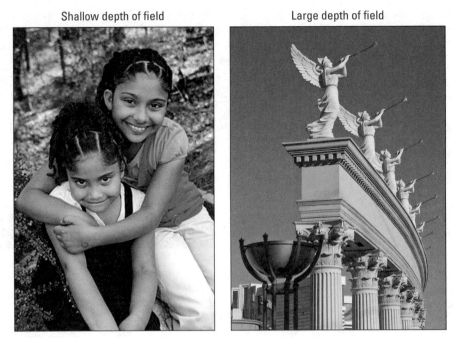

FIGURE 6-7:
Shallow
depth of field
is ideal for
portraits (left);
landscapes
benefit from
a longer zone
of sharp focus
(right).

TIP

A long depth of field is also helpful when you're photographing a subject that's moving quickly toward or away from you. The larger the depth of field, the greater your chances of capturing a moment when the subject is within the sharp-focus zone.

With the "whys" of manipulating depth of field out of the way, here are the three ways you can modify this aspect of your picture:

>> **Adjust the aperture (f-stop).** Chapter 5 introduces you to the aperture setting, or *f-stop*, which is an exposure control that also affects depth of field. The higher the f-stop number, the greater the depth of field. The water lily images in Figure 6-8 show an example: At f/6.3, the leaf and the watery background are much blurrier than in the f/20 example.

It's important to understand that the f-stops I used in the sample photos may not produce similar results on your camera. I mention this technical caveat in Chapter 1, but it bears repeating: The depth of field produced by any f-stop depends on the size of the image sensor and how close that sensor is to the camera lens. Experiment to get a feel for what to expect when you adjust aperture on your camera.

A few other reminders about using aperture to manipulate depth of field:

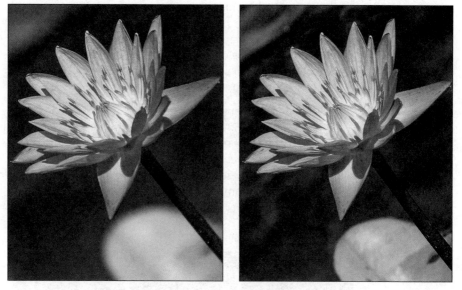

f/6.3, 1/1250 second, ISO 400 f/20, 1/125 second, ISO 400

FIGURE 6-8:
Changing the aperture is one way to adjust depth of field.

- *As you change the f-stop, either the shutter speed or ISO must also change to maintain the same exposure.* As you raise the f-stop, which reduces the size of the aperture, you must use a slower shutter speed or higher ISO to compensate for the reduced light that results from the smaller aperture opening.

- *Try using aperture-priority autoexposure mode when you want to control depth of field.* In this mode, (normally identified by *Av* or *A* on your camera's mode dial), you set the f-stop, and the camera selects a shutter speed that will deliver a good exposure.

- *Some scene modes also are designed to deliver a short or long depth of field.* For example, Portrait mode typically selects a wide aperture setting to produce a shallow depth of field, and Landscape mode typically selects a narrow aperture to produce a greater depth of field. The extent to which these automatic modes can adjust aperture depends on the light and the aperture settings available on your lens, though, so they won't always produce the desired depth of field.

- *A traditional (optical) viewfinder doesn't show the depth of field that your f-stop setting will produce.* That preview isn't possible because the aperture doesn't actually adjust to the selected f-stop setting until you press the shutter button. However, some cameras often provide a *depth-of-field preview button.* When you press the button, the camera adjusts the aperture to the chosen f-stop, and you can then preview aperture-related depth of field in the viewfinder. If you're using a small aperture, the scene may appear very dark because not much light is coming through the lens.

>> **Change the lens focal length.** *Focal length,* measured in millimeters, determines the camera's angle of view, how large objects appear in the frame, and — the important point for this discussion — depth of field. A long focal length, such as the one you get from a telephoto lens, produces a shallow depth of field. A wide-angle lens, on the other hand, has a short focal length and produces a large depth of field.

Figure 6-9 offers an example. Both photos were taken at an aperture of f/5.6; however, the top image was taken at a shorter focal length (wider angle), so more of the scene remains in the sharp-focus zone. Also understand that the original 174mm-version contained a great deal more background area (because of the wider angle of view). I cropped the image so that the subject filled about the same amount of the frame as the 270mm version.

174 mm

270 mm

FIGURE 6-9: Zooming to a longer focal length also decreases depth of field.

If your camera has an optical zoom, you can change focal length by simply zooming in and out. (Your camera manual should spell out the range of focal lengths for the lens.) Or if you own an interchangeable-lens camera, you can buy lenses of various focal lengths or even a couple of zoom lenses that each offer a different focal-length range. If your camera doesn't have an optical zoom, though, you're stuck with a single focal length. And digital zoom, a feature found on some cameras, does *not* produce a shift in depth of field; digital zoom simply results in cropping and enlarging the existing image.

>> **Change the distance between camera and subject.** As you move closer to your subject, you decrease depth of field; as you move away, you extend depth of field.

REMEMBER

To put it all together, then, decide how much depth of field best suits your subject, and then combine aperture, focal length, and camera-to-subject distance to create the look you want. Remember the following formulas, illustrated in Figure 6-10:

FIGURE 6-10:
Combining all three techniques enables you to achieve the minimum or maximum depth of field.

Greater depth of field:
Select higher f-stop
Decrease focal length (zoom out)
Move farther from subject

Shorter depth of field:
Select lower f-stop
Increase focal length (zoom in)
Move closer to subject

>> **For minimum depth of field (subject sharp, distant objects blurry):** Use a wide aperture (low f-stop number) and a long focal length (telephoto lens), and move as close as possible to your subject. Be sure not to exceed the minimum close-focusing distance of your lens, though.

>> **For maximum depth of field (subject and distant objects sharp):** Use a small aperture (high f-stop number) and a short focal length (wide-angle lens), and move back from your subject as much as possible.

Controlling Color

In the film photography world, photographers manipulate color by using different films and lens filters. If you want landscapes that feature bold blues and vivid greens, for example, you choose a film known to emphasize those hues. If you're shooting portraits, on the other hand, you might add an amber-tinted filter onto your lens to infuse the scene with a warm, golden glow that flatters skin tones.

Things work differently in the digital world, but you still have several options for manipulating color — in fact, more so than in the film world, and without having to lug around a bag of different films and filters, too. The rest of this chapter explains the standard digital-camera color features and also helps you solve some common color problems.

Exploring the world of digital color

Like film cameras, digital cameras create images by reading and recording the light reflected from a scene. But how does the camera translate that brightness information into the colors you see in the final photograph?

The next three sections explain this mystery and decode some of the color-related techie-terms you may encounter when you browse digital photography magazines, websites, and other forums.

RGB: A new way of thinking about color

Digital images are known as *RGB* images because they are created by mixing red, green, and blue light. Monitors, scanners, and digital projectors also use this light-based color technology. In fact, so does the human eye.

To understand the process, you need to know that light can be broken into three color ranges: reds, greens, and blues. Inside your eye, three receptors correspond to those color ranges. Each receptor measures the brightness of the light for its particular range. Your brain then combines the information from the three receptors into one multicolored image in your head.

Just like your eyes, a digital camera analyzes the intensity — sometimes referred to as the *brightness value* — of the red, green, and blue light in a scene. Then the camera's computer brain mixes the brightness values to create the full-color image.

Digging through color channels

After your camera analyzes the amount of red, green, and blue light in a scene, it stores the brightness values for each color in separate portions of the image file. Digital-imaging professionals refer to these collections of brightness information as *color channels.*

Some cameras enable you to view separate histograms for the red, green, and blue image channels during picture playback. (A *histogram* is a chart that plots out the brightness values in a photo.) Chapter 8 talks more about this feature and how to interpret the results, if you're interested.

In addition, Photoshop and certain other high-level photo editing programs enable you to manipulate the red, green, and blue color channels independently in order to tweak color and exposure. You also may encounter the word *channel* when reading camera reviews. A writer may note, for example, that a camera produces more image noise — that's the defect that looks like grains of sand — in one channel than in the others. Should you care about that? Not unless you're an imaging wonk who is used to tackling noise in a photo editor using channel-by-channel adjustments. A noisy image is a noisy image, no matter which channel is responsible. But at least now when you encounter the term, you can nod knowingly and sound impressive when you explain it to photographers who didn't take the time to read this section.

Choosing a color space (sRGB and Adobe RGB)

By default, your camera captures images using the *sRGB color space,* which refers to an industry-standard spectrum of colors. (The *s* is for *standard,* and the *RGB* is for red, green, blue, which, again, are the primary colors in the digital color world.) This color space was created to help ensure color consistency as an image moves from camera (or scanner) to monitor and printer; the idea was to create a spectrum of colors that all devices can reproduce.

Because sRGB excludes some colors that *can* be reproduced in print and onscreen, at least by certain devices, some cameras enable you to shoot in the Adobe RGB color space, which contains a larger spectrum of colors. Figure 6-11 compares the

two color spaces and how they fit into the larger *gamut* (range) of colors that the human eye can perceive.

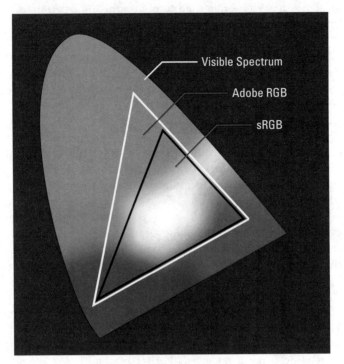

FIGURE 6-11:
Although
Adobe RGB can
capture more
colors than
sRGB, using
the larger color
space isn't a
good idea for
most people.

Although capturing a larger color spectrum sounds like a no-brainer, choosing Adobe RGB isn't necessarily the right choice. Consider these factors when making your decision:

» Some colors in the Adobe RGB spectrum can't be reproduced in print; the printer substitutes the closest printable color, if necessary.

» Home photo printers and retail photo labs are geared toward sRGB files. If you send an Adobe RGB file to the printer, its printed colors may be off because the printer may not correctly translate the Adobe RGB colors to the sRGB color space.

» Computer monitors, tablet displays, and even digital projectors are also set up around the sRGB spectrum. Again, feeding the display an Adobe RGB image can lead to color confusion unless the monitor is specifically tuned to render colors in the Adobe RGB space.

» If you want to retain the original Adobe RGB colors when you edit images in a photo-editing program, the program must support that color space. For that kind of support, you usually need to invest in a professional editing solution

such as Adobe Photoshop or Adobe Lightroom. You also must be willing to study the topic of digital color because you need to use specific software and printing settings to avoid mucking up the color works.

Long story short: Stick with sRGB unless you're schooled enough in this topic to set up a color-managed viewing, editing, and printing system (*workflow*, in photography lingo).

TECHNICAL STUFF

MORE COLOR TERMINOLOGY

In addition to RGB, sRGB, and Adobe RGB (explained in the earlier section "Exploring the world of digital color," you may occasionally encounter the following color-related terms, especially if you get involved with professional publishing:

- **CMY/CMYK:** Whereas light-based devices mix red, green, and blue light to create images, printers mix ink to emblazon a page with color. Instead of red, green, and blue, however, printers use cyan, magenta, and yellow as the primary color components. This color model is called the CMY model, for reasons you no doubt can figure out.

 Because inks are impure, producing a true black by mixing only cyan, magenta, and yellow is difficult. Most photo printers and commercial printing presses add black ink to the CMY mix. This model is called CMYK (the *K* is used to represent black because commercial printers refer to the black printing plate as the *key* plate). Four-color images printed at a commercial printer may need to be converted to the CMYK color mode before printing.

- **Grayscale:** A grayscale image is composed of black, white, and shades of gray — what most people refer to as a black-and-white image. Technically speaking, a black-and-white image contains only black and white, with no shades of gray in between. At least, that's how terms are defined in the official digital-color dictionary. But because only graphical artists and a few of us who enjoy verbal precision care about this distinction, I hereby agree to using the terms *grayscale* and *black-and-white photo* interchangeably.

- **CIE Lab, HSB, and HSL:** These acronyms refer to three other color models for digital images. CIE Lab defines colors using three color channels: One channel stores luminosity (brightness) values, and the other two channels each store a separate range of colors. (The *a* and *b* are arbitrary names assigned to these two color channels.) HSB and HSL define colors based on hue (color), saturation (purity or intensity of color), and brightness (in the case of HSB) or lightness (in HSL). About the only time you're likely to run into these color options is when mixing paint colors in a photo-editing program. Even then, the onscreen display in the color-mixing dialog boxes makes it easy to figure out how to create the color you want.

Using white balance to adjust color

If the colors in your picture are out of whack — skin tones are green or pink, for example — you no doubt have an issue related to the camera's *white-balance* setting. This feature is designed to compensate for the fact that different light sources have varying *color temperatures,* which is a fancy way of saying that they contain different amounts of red, green, and blue light and thus cast their own color bias on a scene.

TECHNICAL STUFF

Color temperature is measured on the Kelvin scale, illustrated in Figure 6-12. The midday sun has a color temperature of about 5500 Kelvin, which is sometimes abbreviated as 5500K — not to be confused with 5500 kilobytes, also abbreviated as 5500K. When two worlds as full of technical lingo as photography and computers collide, havoc ensues. If you're ever unsure which *K* is being discussed, just nod your head thoughtfully and say, "Yes, I see your point."

At any rate, the human eye manages the perception of color temperature naturally, and no matter if you're in an office with fluorescent light, under a bright sun, or in a living room with house lamps, when you see red, it looks red (assuming no difficulties with color blindness, of course). However, cameras aren't as sophisticated as your brain at accommodating various lighting conditions and the colors being illuminated by them.

Film photographers use special films or lens filters designed to compensate for different light sources. But digital cameras, like video cameras, get around the color-temperature problem by using a process known as white balancing. *White balancing* simply tells the camera what combination of red, green, and blue light it should perceive as pure

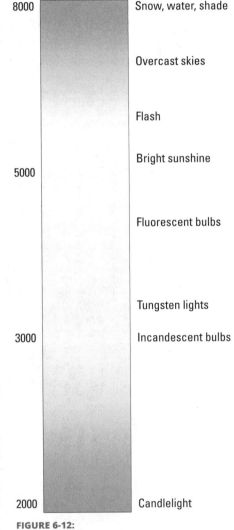

FIGURE 6-12:
Each light source emits its own color cast.

white, given the current lighting conditions. With that information as a baseline, the camera can then accurately reproduce the other colors in the scene.

On some digital cameras, white balancing is handled automatically, but most models give you the option to set the white balance manually to match the light source. That feature comes in handy when your subject is lit by two light sources that have different color temperatures. Figure 6-13 shows one such example. For this shot, my subject was lit primarily by tungsten studio lights, which have a yellow color cast (refer to Figure 6-12). But an adjacent window allowed some daylight into the room, and because it was a cloudy day, the light had a slight blue tint. The mixture of the two light sources confused the automatic white-balance system, resulting in the yellowish cast shown in the first shot. After I set the White Balance option to Tungsten, my whites were once again white.

FIGURE 6-13:
Using two different light sources confused the automatic white balance system (left); modifying the White Balance setting corrected the problem (right).

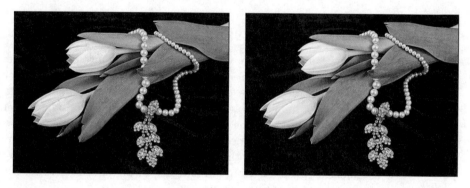

When you take the White Balance reins, choose the option that most closely matches your most prominent light source. Table 6-1 shows some common manual settings. These settings are usually represented by graphical icons; the ones in the table are generic, but most cameras use similar symbols to represent the white-balance settings.

That's the short story on white balance: Turn to this control any time your colors look out of whack. But also investigate the tactics explored in the next few sections, which present additional white-balance features and uses.

WARNING

Get in the habit of resetting the White Balance option back to AWB (automatic white balance) after you're done using a manual setting. Otherwise, if you shoot another photo in different light, the color is likely to appear wrong in that photo.

TABLE 6-1 **Manual White-Balance Settings**

Icon	Setting	Use
☀	Daylight or Sunny	Shooting outdoors in bright light
☁	Cloudy	Shooting outdoors in overcast skies
	Fluorescent	Taking pictures in areas with fluorescent lights
	Incandescent	Shooting under incandescent lights (standard household lights)
⚡	Flash	Shooting with the flash
K	Kelvin	Select a specific Kelvin temperature

White-balance shift

Some cameras offer a way to refine white balance beyond what you can do with the six or seven usual manual settings. Suppose that you're using incandescent lamps but the Incandescent setting on your camera doesn't quite produce neutral colors. You may be able to nudge the white-balance adjustment in small increments to eliminate the problem. For example, on some Canon cameras, you can tweak the white-balance adjustment by moving a little marker inside a color grid, shifting hues along both a blue/amber axis and a green/magenta axis, as shown in Figure 6-14. The setting in the figure shifts the white balance three steps toward amber and one toward magenta.

FIGURE 6-14: On some cameras, you use this type of control to adjust white balance in small increments.

This feature sometimes goes by the name *white-balance shift*; on other models, it may go by the name *white-balance fine-tune* or a similar term. But regardless of the label, this feature offers precise control over white balance.

Typically, the shift increments are geared toward a measure called a *mired* ("my-redd"), which indicates the degree of color correction applied by a traditional colored-lens filter. Each white-balance adjustment increment equals so many mireds (usually, five). If you're hip to the whole mired issue, check the fine print in your camera manual for details on how your model handles the situation.

Custom white balancing based on a gray card

Some cameras allow you to shoot a reference photo that the camera analyzes to determine the right amount of white balancing needed to completely remove any color casts. This feature is usually the most reliable and efficient way to ensure accurate color.

Here's how it works: You take a picture of a neutral gray card, illuminating the card with the same lighting that you plan to use for your shot. (You can buy cards made just for this purpose at your local camera store for under $20.) The camera then determines what white-balance adjustment is needed to get that image to a neutral color state. The adjustment information is stored as a custom setting, and any time you shoot in that same light, you select that custom setting as the white-balance option, and the camera applies the same correction to ensure color accuracy.

In a pinch, you can also use a piece of white paper or card stock as the source of your custom white-balance setting. Just make sure that the paper or card is really and truly neutral in color.

White-balance bracketing

If you're unsure about the light illuminating your subject, you may want to try *white-balance bracketing*, which means taking a picture of the same item several times with different white-balance settings. Then you have a variety of color renditions from which to choose.

Some cameras offer automatic white-balance bracketing that handles the changes between exposures for you. You first select a white-balance setting: Auto, Sunny, Cloudy — whatever. Then you tell the camera to take one shot at that setting, take a second shot at a setting that shifts colors in one direction, and a third that shifts colors in another direction.

Using white balance for effect

Colors are often described as being either "cool" or "warm." Cool colors fall into the blue/green range of the color spectrum; warm colors, the red/yellow/orange spectrum. Light, too, is often said to be cool or warm: Candlelight, for example, is a very warm light, whereas flash is a very cool light.

MANAGING COLORS (AND COLOR EXPECTATIONS)

One concern often voiced by digital photographers is that the colors they see on their camera monitors often look quite different when the picture is displayed on a computer monitor. An even bigger complaint is that printed colors don't look the same as when they're displayed on that computer monitor.

The first step to solving the problem is to get your expectations in line, which means understanding the different color worlds involved in the process: the colors that your eyes see, the colors that your camera can capture, and the colors that can be reproduced in print.

Unfortunately, no camera is as capable as the human eye at capturing certain shades and intensities of color. And no printer can reproduce with ink all the colors that can be displayed by a camera or computer monitor, which create colors by projecting light. In technical terms, you're dealing with different color *spaces,* or *gamuts,* which can be compared to boxes of crayons that each hold a slightly different assortment of colors. When your camera doesn't have the right crayon to record a color in a scene, it simply uses the closest available one — the same way you might draw with a midnight blue crayon if you lost your navy blue one. The printer does the same thing when outputting your photos.

To sum up, perfect color matching simply isn't possible. You can, however, do a number of things to get the best possible color consistency, the most important of which is to calibrate the computer monitor on which you view your images. See Chapter 9 for more information on that topic as well as other tips for getting printed color more in line with onscreen colors.

REMEMBER

Talking about colors as being cool and warm can get confusing if you're also pondering the Kelvin scale. Colors that give off the bluish light have a higher Kelvin temperature than those that give off a warmer light, and most of us are used to thinking of a higher temperature as warmer. Don't think too much about it — it's more important that you're aware of the colors of different light sources than their Kelvin temperatures.

Back to the discussion at hand: Film photographers often apply tinted filters to the ends of their lenses to purposefully add a warm or cool cast to their subjects. With digital, however, you may be able to do the same thing simply by using your camera's white-balance controls.

Assuming that your camera offers manual white-balance settings, you can simply experiment with different settings to see which ones provide the warming and cooling effects you want. The trick is to choose a white-balance setting that's

actually designed for a light source that has a different color temperature than your actual light source, as follows:

>> **For warmer colors:** Choose a white-balance setting designed for the bluish light sources that fall at the top of the Kelvin scale, such as flash or clouds. The camera, thinking that the light is very blue, shifts colors to the warmer side of the scale. And if you're shooting in light that's actually *not* cool, the resulting colors wind up being shoved slightly past neutral to warm.

>> **For cooler colors:** Choose a white-balance setting designed for the warm-colored light sources at the bottom of the Kelvin scale, such as Incandescent. Again, the camera applies what it thinks is the right amount of cooling needed to make your whites white, but the adjustment again takes your colors past neutral, this time to the cooler side of the color range.

As an example, take a look at Figure 6-15. The actual light in this scene was from strong, bright daylight coming in through the overhead windows. At the Daylight white-balance setting, the colors were neutral — or to put it another way, rendered without a color cast from the light. Shooting the scene using the Cloudy setting produced the result you see in the right figure. The camera applied an overly strong warming effect, thinking that it needed to compensate for the bluish tint of cloudy skies. The change is most evident in the green ironwork at the top of the scene and in the walls, which appear almost tan in the original but golden in the Cloudy version.

Balanced for actual light (daylight) Balanced using Cloudy setting

FIGURE 6-15: You can trick the white-balance control into serving as a digital warming filter.

Of course, this trick works only to a certain degree. If you select Cloudy, for example, hoping to make colors warmer, you won't see any effect if you're actually shooting in cloudy conditions. Instead, the setting just neutralizes the cloudy light. The degree of color change that occurs when you select a different white-balance setting depends on how far the actual light source is from that setting.

TIP

If your camera offers white-balance shift, you may be able to tell the camera that you always want to push colors slightly to the warm or cool side any time you select a certain white-balance setting. If you find that your camera consistently produces colors that are too cool for your liking at the Cloudy setting, for example, you can dial in a correction that increases warming in cloudy light.

Investigating JPEG Picture Presets

When you shoot in the JPEG file format, the camera applies certain color adjustments as it creates the image. At the same time, it may tweak contrast and apply some *sharpening*, which is a process that boosts contrast in a way that creates the illusion of slightly sharper focus. (Note *slightly sharper* — sharpening isn't a fix for images that are extremely soft.)

The adjustments that are made depend on a setting that goes by various names, including *Picture Style*, *Picture Control*, or *Optimize Image*. The available settings vary depending on your camera, but you typically get a choice of the settings described in the following list (again, the specific names vary; I used some of the common monikers here):

>> **Standard or Normal:** This option captures the image using characteristics that the manufacturer considers suitable for the majority of subjects.

>> **Neutral or Flat:** At this setting, the camera doesn't enhance color, contrast, and sharpening as much as in the other modes. The setting is designed for people who want to precisely manipulate these picture characteristics in a photo editor. By not overworking colors, sharpening, and so on when producing your original file, the camera delivers an original that gives you more latitude in the digital darkroom.

>> **Vivid or Intense:** In this mode, the camera amps up color saturation, contrast, and sharpening.

>> **Portrait:** This mode tweaks colors and reduces sharpness in a way that is designed to produce soft skin texture and pleasing skin tones.

>> **Landscape:** This mode emphasizes blues and greens and increases contrast and sharpening.

>> **Monochrome:** This setting produces black-and-white photos.

With the exception of Monochrome, the extent to which the selected preset affects an image depends on the subject and the camera — though Figure 6-16 offers a look at the same scene as produced by four typical presets. As you can see, there's not a lot of difference, although the blues in the Landscape version are decidedly more intense than in the other versions and the Neutral version is clearly under-saturated and lacks contrast. This scene also points up another hiccup related to JPEG presets: What option do you choose if your scene contains both people — suitable for the Portrait option — and a landscape, as here?

Standard Portrait

Landscape Neutral

FIGURE 6-16:
You may be able to choose from several picture-rendering presets, each of which tweaks color, contrast, and sharpness slightly differently.

In my experience, the default setting truly does work best for most shots, and on some cameras, you don't even notice as much difference between the various pre-set styles as shown in the figure. I stick with the default. Your mileage may vary, though, so take test shots at each of your camera's settings.

Keep in mind these additional points:

» **You may not be able to choose which preset is applied when you shoot in Auto mode, scene modes, or other automatic exposure modes.** Most cameras don't give you control over this feature unless you shoot in an advanced mode (programmed autoexposure, manual, aperture-priority auto-exposure, or shutter-priority autoexposure).

» **Don't confuse these Portrait and Landscape settings with the Portrait and Landscape exposure modes.** I know — like this stuff isn't confusing enough, you have to deal with two settings bearing the same option names? But the deal is this: Assuming that you shoot in an exposure mode that gives you control over these presets, you can select any one you like — you can snap a photo of a mountain landscape using the Portrait setting, if that's the look you want. If, on the other hand, you shoot in Landscape scene mode, the camera automatically selects the Landscape setting. And in the Portrait scene mode, the file is processed according to the Portrait preset color/sharpness/contrast recipe.

» **Using black-and-white mode isn't the best route to a black-and-white photo.** When you take a photo in black-and-white mode, the camera captures a full-color image and then just *desaturates* (removes all color from) the photo. Depending on the original colors in the scene, this can lead to a fairly "blah" black-and-white image. A better choice is to capture the image in full color and then do the conversion to black-and-white in a photo-editing program. Assuming that you own a capable program, you'll have much more control over how the colors in the image are translated to grayscale. As an example, Figure 6-17 shows the simple, in-camera monochrome version of a color origi-nal and one that I created using my photo editor. For my custom conversion, I darkened pixels that were green in the original, helping to set the subject apart from the background a little more.

Some cameras offer a built-in editing tool that creates a copy of a color photo and converts the copy to a black-and-white image. That's an okay option if you need a grayscale version of the photo right away, but again, you don't get any control over the conversion (the results are the same as shooting in black-and-white mode).

At the very least, take one shot of the subject in color and one in black-and-white mode. You can always go from color to grayscale after the fact, but you can't do the opposite.

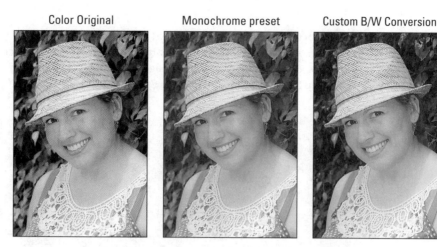

Color Original · Monochrome preset · Custom B/W Conversion

FIGURE 6-17: Monochrome mode usually results in a flat, low-contrast, black-and-white photo; converting a color original in a photo program gives you more control over how each color is translated to grayscale.

>> **You may be able to modify presets or create your own presets.** For example, some cameras enable you to adjust the amount of sharpening, contrast, color saturation, and other parameters that are made by a particular preset. Even better, you can sometimes create and store your own, custom preset in addition to the prefab ones.

If you want to get big-time into presets, you can even go online and download presets that other photographers have created. You might find a preset designed to capture a particular landmark at sunset, for example. Check your camera manual to find out whether this option exists, and if so, how to install the presets in your camera.

Shooting Raw for Maximum Control

In the Raw file–capture format, the camera doesn't apply white balancing or any of the other color, sharpness, or contrast adjustments that are made by the JPEG presets discussed in the preceding section. Instead, you specify these image attributes (and more) when you convert the Raw file to a standard format (such as TIFF) on your computer.

Although Raw capture involves more time behind the computer and has a few other complications you can explore in Chapter 4, shooting in this format gives you a much finer degree of control over these picture characteristics than you get in JPEG, even if you play with all available capture settings.

Take a look at the screen shown in Figure 6-18, which shows one of multiple panels of options found in the Adobe Camera Raw converter tool, which is provided with several Adobe photo programs, including Photoshop and Lightroom.

This particular panel is one of my favorites because it enables you to adjust the hue (basic color), saturation (intensity of color), and luminance (brightness) of individual color ranges. For this image, I was able to tweak sky and sea colors separately from skin tones and from the clothing colors.

FIGURE 6-18: Here's a look at the Adobe Camera Raw file-conversion tool; on this panel, you can manipulate the brightness of individual color ranges separately.

I find Raw especially helpful when I'm shooting in mixed lighting sources and can't find just the right white-balance setting or another adjustment to produce neutral colors. If you shoot JPEG and your photos have a color cast, it's sometimes difficult to make things right even using a powerful photo-editing program. But with Raw, the color isn't locked in when the file is created, so you always get a second chance. Additionally, because the Raw format can retain a slightly greater range of brightness values than the JPEG format, it gives you a bit more latitude if you need to adjust exposure after the shot.

That's not to say that you should completely ignore white balance and the other settings explained in this chapter when you shoot in the Raw format, however. For one thing, the picture you see during playback on the camera monitor is a JPEG preview of the image as it will appear if you stick with the current white-balance setting. So, if the color is way off, judging the overall result of the picture is a little difficult. It's hard to tell whether a red flower is properly exposed, for example, if the entire image has a blue color cast. And when you open the picture file in a Raw converter, the software initially translates the picture data according to the recorded white-balance setting. Getting as close as possible from the get-go can thus save you some time tweaking colors during the conversion stage.

Chapter 7

Getting the Shot: How the Pros Do It

Earlier chapters in this book explain the fundamentals of good photo composition and describe the most common digital camera features, from settings that affect exposure to controls for manipulating focus and color. This chapter takes things a step further, sharing more tips for shooting specific types of pictures: portraits, landscapes, action shots, and close-ups.

REMEMBER

One note before you dig in: Keep in mind that there are no hard-and-fast rules as to the right way to shoot a portrait, a landscape, or whatever. Feel free to wander off on your own, tweaking this exposure setting or adjusting that focus control, to discover your own creative vision. Experimentation is part of the fun of photography, after all — and thanks to your camera monitor and the option to delete images that don't work, it's an easy, completely free proposition.

Capturing Captivating Portraits

The classic portraiture approach is to keep the subject sharply focused while throwing the background into soft focus, as shown in Figure 7-1. In other words, the picture features a shallow *depth of field* — only objects very close to the subject are within the zone of sharp focus. This artistic choice emphasizes the subject and

helps diminish the impact of any distracting background objects in cases where you can't control the setting.

Chapters 2 and 6 explain depth-of-field techniques fully, but here's a quick recap on how to achieve that blurry-background look:

FIGURE 7-1:
A blurry background draws attention to the subject and diminishes the impact of any distracting background objects.

>> **Set your camera to Portrait or aperture-priority exposure mode.** One way to shorten depth of field is to use a low f-stop setting, which opens the aperture. Portrait mode, found on many cameras, automatically opens the aperture as much as possible. This scene mode also usually warms colors and softens skin.

However, to precisely control depth of field, switch to aperture-priority autoexposure mode, if available. In this mode, you choose the f-stop setting, and the camera selects a shutter speed to properly expose the photo. Of course, if you're comfortable with manual exposure mode, in which you set both aperture and shutter speed, that's an option as well. Either way, the lower the f-stop number, the shallower the depth of field.

>> **Zoom in, get closer, or both.** Zooming to a longer focal length also reduces depth of field, as does moving physically closer to your subject.

WARNING

However, avoid using an extremely long focal length, which can flatten and widen faces. A wide-angle lens also can distort features. (A focal length in the 70-135mm range works best.)

>> **Move your subject farther from the background.** The greater the distance between the two, the more background blurring you can achieve.

WARNING

When shooting group portraits, be careful not to go *so* shallow that the zone of sharp focus doesn't extend to everyone in the group. With extremely short depth of field, the people in the front may be in sharp focus but people even a few inches behind may appear in slightly soft focus.

In addition to considering depth of field, these other tips can improve your people pics:

» **Pay attention to the background.** Scan the entire frame, looking for intrusive objects that may distract the eye from the subject. If necessary, reposition the subject against a more flattering backdrop. Inside, a softly textured wall works well; outdoors, trees and shrubs can provide nice backdrops as long as they aren't so ornate or colorful that they diminish the subject (for example, a magnolia tree laden with blooms).

» **For indoor portraits, shoot flash-free if possible.** Shooting by available light rather than flash produces softer illumination and avoids the problem of red-eye. During daytime hours, pose your subject near a large window to get results similar to what you see in Figure 7-2. No sun? Try turning on lots of room lights to get the job done.

Courtesy of Mandy Holmes

FIGURE 7-2:
For soft, even lighting, forego flash and instead expose your subject using daylight coming through a nearby window.

In dim lighting, you may need to bump up the ISO (light sensitivity) setting so that you can use a shutter speed fast enough to freeze any movement of your subject. (It's not easy to convince a baby or toddler to stay still during a photo shoot.) Also note that in Portrait mode, the camera may not allow you to shoot without flash in dim lighting. If your camera offers a No Flash scene mode (it may be called Museum mode or something similar), try that instead. Again, the camera may in that case increase ISO — and whether it's you or the camera in charge of that setting, remember that a high ISO can translate to *noise,* which gives your photos a speckled look.

» **If using a flash for your indoor and nighttime portraits is necessary, try these techniques for best results:**

 • *Turn on as many room lights as possible.* The more ambient light, the less flash illumination is required. The additional light also causes the pupils to constrict, reducing the chances of red-eye.

 • *Try using red-eye reduction flash mode.* Red-eye is caused when light from the flash is reflected by the subject's retinas. In red-eye reduction flash

mode, the camera emits a brief preflash light to constrict the subjects' pupils and thus reduce the amount of light that can hit the retina. Just be sure to warn your subject not to stop smiling until after the real flash fires!

One other trick for lessening red-eye when you use a built-in flash is to pose subjects so that they're not looking directly at the camera lens. That way, the flash doesn't strike the eyes directly. You can shoot your subjects in profile or looking upward toward the ceiling, for example — after all, a face-forward pose isn't a requirement of a great portrait.

- *For subjects that can stay perfectly still, try slow-sync flash.* This flash mode simply lets you use a shutter speed that's slower than the one normally used for flash pictures. This enables the camera to soak up more ambient light, producing a brighter background and reducing the flash power that's needed to light the subject.

TIP

If your camera has a Nighttime Portrait mode, choosing that setting automatically enables slow-sync flash. You can also use shutter-priority autoexposure mode or manual exposure mode, if available on your camera, to set the shutter speed yourself.

Figure 7-3 illustrates how slow-sync flash can really improve an indoor portrait. In the left image, shot in Portrait scene mode with normal flash, the camera selected a shutter speed of 1/60 second. At that speed, the camera has little time to soak up any ambient light, so the scene is lit primarily by the flash. That caused two problems: The strong flash created some *hot spots* (areas of overexposure) on the subject's skin, and the window frame is much more prominent because of the contrast between it and the bushes outside the window. Although I shot this photo during the daytime, the bushes appear dark because the exposure time was brief and they were beyond the reach of the flash.

For the second example, I used shutter-priority autoexposure and set the shutter speed to 1/4 second. This exposure time was long enough to permit the ambient light to brighten the exteriors to the point that the window frame almost blends into the background, and because less flash power was needed to expose the subject, the lighting is much more flattering. In this case, the bright background also helps to set the subject apart because of her dark hair and shirt. If the subject had been a pale blonde, this setup wouldn't have worked as well, of course.

WARNING

Anytime you use slow-sync flash, don't forget that a slower-than-normal shutter speed means an increased risk of blur due to camera shake. So always use a tripod or otherwise steady the camera, and remind your subjects to stay absolutely still, too, because they will appear blurry if they move during the exposure. I was fortunate to have both a tripod and a cooperative subject for my examples, but I probably wouldn't try slow-sync for portraits of young children or pets.

Regular fill flash, 1/60 second Slow-sync flash, 1/4 second

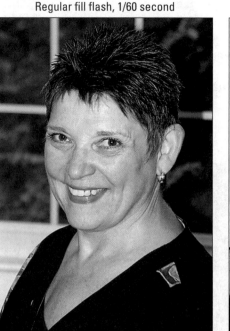 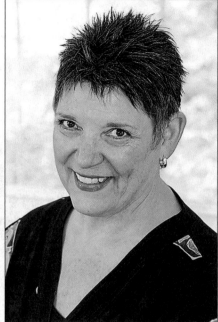

FIGURE 7-3:
Slow-sync flash produces softer, more even lighting and brighter backgrounds.

- *Soften the flash light by adding a diffuser or bouncing the light off the ceiling.* A diffuser is just a translucent screen or covering that you fit over your flash. You can buy diffusers for built-in, pop-up flashes (such as those found on dSLR cameras) and for external flash heads. If you own a flash head that rotates, aim the flash at the ceiling instead of directly at your subject; the light then hits the ceiling and falls back softly on the subject. You also can get nice side-lit portraits by bouncing light off a wall to the left or right of the subject. Just make sure that the surface you use to bounce the flash is white or gray, because the light will take on the color of that surface.

- *Shoot with the camera in a horizontal position.* When a camera is held vertically with the flash on, it's very common to get a strong, unattractive shadow along one side of your subject.

WARNING

» **Experiment with using flash in outdoor daytime portraits.** I know this sounds counterintuitive — why would you need flash during daytime? But think about the direction of the light: It's coming from overhead, which means that there may not be any light directed toward the face.

Consider Figure 7-4 as an example. In this photo, I posed the girls under a shade tree with their backs toward the sun — an option that helps eliminate squinting. In the first image, shot without flash, the subjects are underexposed,

for a couple reasons. First, their faces weren't being hit directly by the sunlight. And second, I was using normal exposure metering, where the camera bases exposure on the entire frame, and the very bright background caused the camera to choose an exposure that left the subjects too dark. (Chapter 5 discusses exposure metering.) Notice, too, that in a few areas, sunlight filtering through the leaves of the trees left distracting bright spots on the faces.

No Flash With Flash

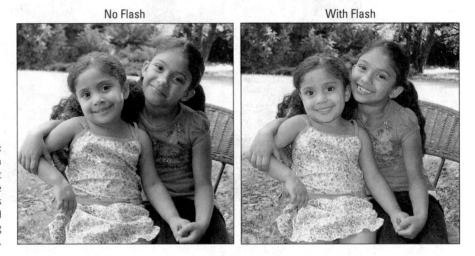

FIGURE 7-4:
Using flash in bright daylight helps eliminate shadows caused by strong overhead light.

Adding flash for the second shot produced a much better result. The flash not only brightened the subjects but also evened out the light and virtually eliminated the overexposed areas on the skin. Additionally, because the camera knew that it would have the advantage of the extra light from the flash, it chose a faster exposure time — 1/125 second as opposed to 1/80 second for the first shot. And with that faster exposure time, the background grass isn't as bright and thus is less distracting.

Chapter 5 talks more about the art of using flash outdoors, but here are just two important points to remember:

- Most cameras don't let you use flash in Portrait mode if the light is very bright, unfortunately. You may be able to move your subject into a shady enough area that the camera thinks flash is needed, however.

- If your subjects are lit by strong daylight, be careful about overexposing them. When you use built-in flash, most cameras limit you to a shutter speed in the neighborhood of 1/200–1/250 second, and in very bright light, that may be too long of an exposure time. Again, try moving the subjects into the shade for better results.

>> **Check image colors if your subject is lit by both flash and ambient light.** If you set the camera's white-balance setting to automatic, enabling the flash tells the camera to warm colors to compensate for the cool light of a flash. If your subject is also lit by a secondary light source, such as room lights or daylight, the result may be colors that are slightly warmer or cooler than neutral. In Figures 7-3 and 7-4, for example, colors became warmer. This warming effect typically looks nice in portraits, giving the skin a subtle glow, but if you aren't happy with the result or want even more warming, you may need to try a different white-balance setting or adjust the image color in an image-editing application. See Chapter 6 for help.

>> **Frame your subject loosely to allow for later cropping to a variety of frame sizes.** If you capture a great portrait, chances are you'll want to print and frame it. To give yourself the flexibility of choosing from different frame sizes — 4 x 6, 5 x 7, and so on — remember to leave a little *head room,* or margin or empty background around the top and sides of the photo. That way, you can crop the picture to different aspect ratios without having to cut off part of the subject's head. See the Chapter 2 for more on this topic.

>> **Don't say "cheese."** The most boring portraits are those in which the subjects pose in front of the camera and say "cheese" on the photographer's cue. If you really want to reveal something about your subjects, catch them in the act of enjoying a favorite activity, using the tools of their trade, or interacting with others. Figure 7-5 offers an example. The formal pose is okay, but the second one is more compelling because it reflects a moment of spontaneous fun.

>> **Expand your definition of *portrait.*** A good portrait doesn't always require a face, as illustrated by Figure 7-6. Showing only two interlocked hands, this image tells the story of a bond between friends and offers a look at the colors of their culture at the same time.

FIGURE 7-5: Catching a moment of brother-sister play produces a much more engaging portrait than a stiff, formal pose.

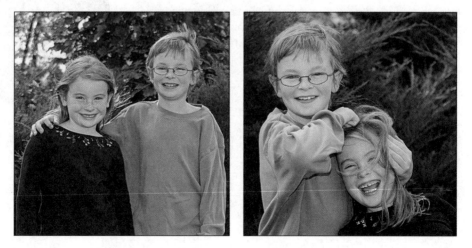

FIGURE 7-6:
A good portrait doesn't necessarily require the subjects' faces.

Courtesy of Corrie Niehaus

Figure 7-7 offers another nontraditional take on a portrait, with the subject appearing in silhouette and facing away from the camera. This one may mean more to me than it does to you because I had a relationship with this particular furball, who could spend hours in front of that screen door, glued to Yard TV (best station ever, if you're a wheaten terrier). But assuming that you're shooting for your own enjoyment (as opposed to taking pictures for someone else), creating an image that will evoke a happy memory years later is the whole point of making a portrait.

FIGURE 7-7:
This photo captured my first furkid doing his job: keeping watch in case something in the yard needed a good barking at.

Shooting Better Action Shots

A fast shutter speed is the key to capturing a blurfree shot of any moving subject, whether it's a butterfly flitting from flower to flower, a car passing by, or a running baseball player.

The shutter speed you need depends on the speed at which your subject is moving, and finding the right setting requires some experimentation. For example, when shooting the hockey player featured in Figure 7-8, I started with a shutter speed of 1/500 second. After checking the photo in my monitor, I could easily see that 1/500 second didn't come close to freezing the action, so I bumped the shutter speed up to 1/1000 second to capture the image shown on the right. Even at that speed, the end of the hockey stick is slightly soft, but I actually like that effect because it adds a sense of motion to the shot.

1/500 second 1/1000 second

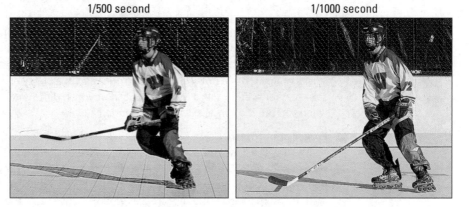

FIGURE 7-8: A shutter speed of 1/500 second wasn't quite enough to stop the motion of this racing hockey player; raising the shutter speed to 1/1000 second did the trick.

As you continue practicing action photography, you'll gain an understanding of what shutter speeds work best for your favorite subjects. But generally speaking, 1/500 second should be fast enough for all but the fastest subjects — my hockey player, cyclists, motorcycles, birds in flight, and so on. And for subjects moving slowly, such as a flower swaying in a gentle breeze or a child walking, you can get away with a much slower shutter speed — even 1/125 second can be enough. Of course, you should take some test shots and inspect the image on the camera monitor closely to make sure that your speed is high enough.

Whatever the speed of your subject, try setting your camera to one of the following exposure modes to capture action:

>> **Shutter-priority autoexposure:** Usually abbreviated S or Tv (for exposure *time value*), this mode enables you to specify an exact shutter speed. The camera then chooses the f-stop needed to expose the image properly. Of course,

you can always switch to Manual exposure and set both shutter speed and aperture yourself.

REMEMBER

Many cameras will tell you if you have set a speed that is too fast to get a good exposure. For example, in some cameras if the aperture value blinks or changes color after you set the shutter speed, the camera can't select an f-stop that will properly expose the photo at that shutter speed. Other cameras may prevent you from choosing a shutter speed that puts you into the exposure danger zone.

>> **Sports mode:** Almost all cameras offer a Sports mode these days, although it may go by some other name (Action, for example). Whatever the name, this mode automatically dials in a fast shutter speed for you. Often, Sports mode also sets the shutter release mode to continuous so that you can fire off a burst of frames as long as you hold down the shutter button.

Here are a few other tips that pros use when capturing action:

>> **Raise the ISO setting to enable a faster shutter, if needed.** In dim lighting, you may not be able to get a good exposure at the chosen shutter speed or in Sports mode without taking this step. Raising the ISO does increase the possibility of noise, but a noisy shot is often better than a blurry one. (Note that some cameras automatically raise the ISO for you in dim lighting as well as when you put the camera into Sports mode.)

>> **Forget about flash.** Using flash isn't usually a workable solution for action shots. First, the flash needs time to recycle between shots, so it slows your shot-to-shot time. Second, most built-in flashes have limited ranges — so don't waste your time if your subject isn't close by. And third, remember that the maximum shutter speed decreases when you use flash; the top speed is usually in the range of 1/200 to 1/250 second. That may not be fast enough to capture your subject without blur. (Some cameras can use a faster shutter speed when you use an external flash, however.)

If you do decide to use flash, you may have to bail out of Sports mode, though; it probably doesn't permit you to use a flash.

>> **Set the camera to burst mode, if available.** This mode may be called Continuous or something similar; often, you enable it via an option called *Drive mode, Release mode,* or *Shooting mode.* Whatever the name, it enables you to record a continuous series of images with a single press of the shutter button. As long as you keep the button down, the camera captures image after image at a rapid pace — three to five frames per second is common, but some high-end cameras can be faster.

>> **In autofocus mode, try *continuous-servo mode,* if available.** Again, the name of the mode varies from camera to camera. When this feature is enabled, the camera initially sets focus when you press the shutter button halfway (or tap to set your focus point on a touchscreen-enabled camera) but adjusts focus as necessary up to the time to take the picture, just in case the subject moves. All you need to do is reframe the shot as needed to keep the subject within the area the camera's using to calculate focus. I used this feature to follow the feathered friend shown in Figure 7-9.

FIGURE 7-9: I used continuous autofocusing, burst-mode shooting, and a shutter speed of 1/1000 to capture this bird transporting a branch to fortify its nest.

This frame was one of many I fired off as the bird carried a branch from the side of a pond to a tree several hundred feet away, finally landing and incorporating the branch into a nest. I set focus initially when the bird was first picking up the branch and then just moved my camera as needed to follow the action. The camera tracked the subject movement and adjusted focus as the bird moved closer and then farther away from my lens.

Be aware, though, that not all cameras can adjust focus between the individual frames of a burst. Instead, the focusing distance set for the first shot is used for all frames. With such cameras, capture a short burst, release the shutter button, and set focus again before taking your next series of frames.

>> **Compose the shot to allow for subject movement across the frame.** To make sure that your subject doesn't move out of the frame before you press the shutter button, compose the image with extra room at the edges.

You can always crop the photo later to a tighter composition if you want. Speaking of cropping, remember that if you plan to crop the photo, setting the picture resolution to a high value helps ensure that the cropped photo will have enough pixels to produce a good, larger print.

>> **A large depth of field gives you a better chance of success when you photograph a subject moving toward you or away from you.** The greater the depth of field, the larger the distance over which sharp focus is maintained. If you use an f-stop of, say, f/5.6 and you're shooting with a telephoto lens, the depth of field will be pretty shallow, and you have to snap the photo at the exact moment the subject is within range of focus. Stopping the aperture down a couple of notches (raising the f-stop number) extends the depth of field so that the subject is within the sharp-focus zone for a longer period of time, giving you more shooting opportunities.

>> **Get to know the habits of your favorite moving subjects.** For example, if you enjoy photographing your daughter's softball team, pay attention to how the various players react after a winning play. After a strikeout, does the pitcher always punch her fist in the air? If you know that detail, you can compose a photo of her well in advance of the pitch, leaving extra room at the top of the frame to accommodate her arm. Photographers who aren't familiar with her routine, on the other hand, wind up with images that don't include that pumped fist, which is important to the moment.

At the very least, spend a few minutes just observing the subjects before you put your eye to the viewfinder, if timing permits. When shooting the scene featured in Figure 7-9, I watched the bird make several trips to and from the nest as it gathered its construction materials so that I had a good idea of the path it would take when I finally started shooting.

TIP

Using these techniques should give you a better chance of capturing any fast-moving subject, but action-shooting strategies also are helpful for shooting candid portraits of kids and pets. Even if they aren't currently running, leaping, or otherwise cavorting, snapping a shot before they do move or change positions is often tough. If an interaction or scene catches your eye, set your camera into action mode and then just fire off a series of shots as fast as you can.

Finally, remember that freezing action isn't the only option for moving subjects. Sometimes, going in the other direction and using a shutter speed slow enough to blur the action creates a heightened sense of motion and, in scenes that feature very colorful subjects, cool abstract images as well. A long exposure time is also how photographers create the misty waterfall and car light-trails like the ones featured in the next section (see Figures 7-11 and 7-12).

Taking in the Scenery

Providing specific camera settings for scenic photography is tricky because there's no single best approach to capturing a beautiful stretch of countryside, a city sky-line, or another vast subject. Take depth of field, for example: One person's idea of a super cityscape might be to keep all buildings in the scene sharply focused, but another photographer might prefer to shoot the same scene so that a foreground building is sharply focused while the others are less so, thus drawing the eye to that first building.

That said, the following tips can help you photograph a landscape the way *you* see it:

REMEMBER

>> **Shoot in aperture-priority autoexposure mode, if available, so that you can control depth of field.** Again, this mode enables you to adjust the aperture, which is one factor in determining depth of field. (Chapters 2 and 6 explain depth of field fully.) The camera then handles the rest of the exposure equation for you by dialing in the right shutter speed.

For a long depth of field, dial in a high f-stop number; for a shallow depth of field, a low number. The portrait examples earlier in this chapter feature a shallow depth of field; contrast those images with the one in Figure 7-10, taken at f/22. Notice that everything from the foreground statue to the monument in the background is in sharp focus.

FIGURE 7-10:
An f-stop of f/22 helped keep the background building as sharp as the foreground statue in this scene.

>> **Try Landscape mode if aperture-priority autoexposure isn't available.** This scene mode automatically selects a high f-stop number to produce a large depth of field, so both near and distant objects are sharply focused. Of course, if the light is dim, the camera may be forced to open the aperture, reducing depth of field, to properly expose the image. Note, too, that Landscape mode typically tweaks the image to increase contrast and produce more vivid blues and greens.

TIP

If you prefer the landscape to have a shallow depth of field, try Portrait mode instead. That mode automatically selects a lower f-stop setting. Here again, though, color and sharpness may also be manipulated slightly — this time, to produce softer edges and warmer colors.

>> **If the exposure requires a slow shutter speed, use a tripod to avoid blurring.** The downside to a high f-stop is that you need a slower shutter speed to produce a good exposure. If the shutter speed drops below what you can comfortably handhold, use a tripod to avoid picture-blurring camera shake. No tripod handy? Look for any solid surface on which you can steady the camera. You can always increase the ISO setting to increase light sensitivity, which in turn allows a faster shutter speed, too, but that option brings with it the chances of increased image noise.

>> **For dramatic waterfall and fountain shots, consider using a slow shutter to create that "misty" look.** The slow shutter blurs the water, giving it a soft, romantic appearance. Figure 7-11 shows this effect. I used a shutter speed of 1/5 second for this shot; the aperture was f/8. Again, use a tripod to ensure that the rest of the scene doesn't also blur due to camera shake.

>> **At sunrise or sunset, base exposure on the sky.** The foreground will be dark, but you can usually brighten it in a photo editor, if needed. If you base exposure on the foreground, on the other hand, the sky will become so bright that all the color will be washed out — a problem you usually can't fix after the fact.

FIGURE 7-11: For misty waterfalls, use a slow shutter speed (and tripod).

This tip doesn't apply, of course, if the sunrise or sunset is merely serving as a gorgeous backdrop for a portrait. In that case, you should enable your flash and expose for the subject.

» **For cool nighttime pics, experiment with a slow shutter.** Assuming that cars or other vehicles are moving through the scene, the result is neon trails of light, as shown in Figure 7-12. The exposure time for this image was ten seconds. Sometimes, if it's *really* dark, you may have to bump up the ISO to a point that it produces a lot of digital noise — but otherwise you might not get the shot, even with a very slow shutter speed.

FIGURE 7-12:
A slow shutter speed (10 seconds) turns the taillights of passing cars into trails of neon light.

Some cameras require that you use a special shutter setting known as *bulb* mode to take exposures longer than 30 seconds, which is the standard slow-shutter limit. Typically available only in manual exposure mode, the bulb setting records an image for as long as you hold down the shutter button.

» **In large landscapes, include a foreground subject to provide a sense of scale.** For example, in the image featured in Figure 7-13, the bench serves this purpose. Because viewers are familiar with the approximate size of a typical wooden bench, they can get a better idea of the size of the vast mountain landscape beyond.

» **Try panorama mode for capturing extra-wide scenes.** Many cameras, including some cellphones, have a tool that enables you to create a *panoramic* image — a photo that's wider than a normal, single frame. Figure 7-14 offers an example. If your camera doesn't have this feature, you can find software tools that enable you to stitch together multiple frames into a panorama. Or you can "cheat" — just shoot a very-wide-angle shot, and then crop away the top and bottom of the frame to create an image with panorama dimensions.

Courtesy of Kristen E. Holmes

Getting Gorgeous Close-ups

Close-up shots can be wonderfully artistic, but they can also be challenging to take. To take good close-ups, try the following settings and techniques:

>> **Check your camera or lens manual to find out the minimum close-focusing distance.** How "up close and personal" varies depending on your equipment. Many cameras and lenses also have a Close-up or Macro focusing mode; you may have to enable this setting to achieve the closest focusing distance.

>> **Take control over depth of field by setting the camera mode to aperture-priority autoexposure mode.** Whether you want shallow, medium, or extreme depth of field depends on the point of your photo. In classic nature photography, for example, the artistic tradition is a very shallow depth of

field, as shown in Figure 7-15, and requires an open aperture (low f-stop value). But if you want the viewer to be able to clearly see all details throughout the frame — for example, if you're shooting a product shot for your company's sales catalog — you need to go in the other direction, stopping down the aperture as far as possible.

>> **If aperture-priority autoexposure isn't available, try the Close-up scene mode.** In this mode, sometimes called Macro mode, the camera automatically opens the aperture to achieve a short depth of field.

Close-up mode means and does different things depending on the camera. In some cases, it simply adjusts the close-focusing distance; in others, it affects aperture as well as some color and contrast characteristics of the image. Check your manual for details.

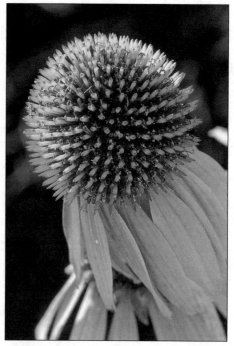

FIGURE 7-15:
Shallow depth of field helps emphasize the part of the scene that you found most interesting.

>> **Remember that zooming in and getting close to your subject also decrease depth of field.** Back to that product shot: If you need depth of field beyond what you can achieve with the aperture setting, you may need to back away, zoom out, or both. (You can always crop an image to show only the parts of the subject that you want to feature.)

>> **When shooting flowers and other nature scenes outdoors, pay attention to shutter speed, too.** Even a slight breeze may cause your subject to move, causing blurring at slow shutter speeds.

>> **Try using fill flash for better outdoor lighting.** As with portraits, a tiny bit of flash often improves close-ups when the sun is the primary light source. You may need to use flash exposure compensation, if available, to reduce the flash output slightly, however, because whenever you fire a flash very close to a subject, it may be overpowering. If you can control the flash directly, turn it down; if not, you may need to cover it with something to diffuse its light. (Even taping a napkin over the flash may be sufficient.) And again, remember that most cameras limit the top shutter speed to around 1/200–1/250 second when you use flash — in very bright light, that may be too slow to avoid overexposing the photo. See Chapter 5 for more tips on flash photography.

» **When shooting indoors, try not to use flash as the primary light source.** Because you're shooting at close range, the light from the flash may be too harsh, even at a low flash exposure compensation setting. If flash is inevitable, turn on as many room lights as possible to reduce the flash power that's needed — even a hardware-store shop light can do in a pinch as a lighting source. (Remember that if you have multiple light sources, though, you may need to tweak the white-balance setting.)

» **To get very close to your subject, invest in a macro lens or a set of diopters.** A true macro lens, which enables you to get really, really close to your subjects, is an expensive proposition; expect to pay around $200 or more. But if you enjoy capturing the tiny details in life, it's worth the investment.

TIP

For a less expensive way to go, you can spend about $40 for a set of *diopters,* which are sort of like reading glasses that you screw onto your existing lens. Diopters come in several strengths — +1, +2, +4, and so on — with a higher number indicating a greater magnifying power. I took this approach to capture the extreme close-up in Figure 7-16, attaching a +2 diopter to my lens. The downfall of diopters, sadly, is that they typically produce images that are very soft around the edges, a problem that doesn't occur with a good macro lens.

FIGURE 7-16:
To extend the lens's close-focus capability, you can add magnifying diopters.

Coping with Special Situations

A few subjects and shooting situations pose additional challenges not already covered in earlier sections. Here's a quick list of ideas for tackling a variety of common "tough-shot" photos:

» **Shooting through glass:** To capture subjects that are behind glass, such as animals at a zoo, you can try a couple of tricks. First, set your camera to manual focusing, if possible — the glass barrier can give the autofocus mechanism fits.

Disable the flash to avoid creating any unwanted reflections, too. Then, if you can get close enough, your best odds are to put the lens right up to the glass. (Be careful not to scratch your lens.) If you must stand farther away, try to position your lens at an angle to the glass.

>> **Shooting out of a car window:** Set the camera to shutter-priority autoexposure or manual mode and dial in a fast shutter speed to compensate for the movement of the car. (Sports scene mode also can produce a fast shutter speed.) Also turn on image stabilization, if your camera offers it. Oh, and keep a tight grip on your camera.

>> **Shooting fireworks:** First off, use a tripod; fireworks require a long exposure, and handholding your camera simply won't work. If your camera has a zoom lens, zoom out to the shortest focal length. For cameras that offer manual focusing, switch to that mode and set focus at infinity (the farthest focus point possible on your lens). It's tough to use autofocusing with fireworks because there isn't any solid object for the autofocusing system to lock onto.

If available, also use the manual exposure setting. Choose a relatively high f-stop setting — say, f/16 or so — and start a shutter speed of 1 to 3 seconds. From there, it's simply a matter of experimenting with different shutter speeds. No manual exposure mode? Try shutter-priority autoexposure mode instead. Some point-and-shoot cameras now have a Fireworks scene mode, too, in which case you can let the camera take the reins.

A few other fireworks tips:

● *Keep the camera steady.* Be especially gentle when you press the shutter button — with a very slow shutter, you can easily create enough camera movement to blur the image. If you purchased an accessory remote control for your camera, this is a good situation in which to use it.

● *Reduce noise.* If your camera offers a noise-reduction feature, you may want to enable it, too, because a long exposure also increases the chances of noise defects. (Keep the ISO setting low to further dampen noise.)

● *Press the shutter button at various intervals.* In addition to experimenting with shutter speed, play with the timing of the shutter release, starting some exposures at the moment the fireworks are shot up, some at the moment they burst open, and so on. For the example featured in Figure 7-17, shutter speed was about 5 seconds, and I began the exposure as the

FIGURE 7-17:
I used a shutter speed of 5 seconds to capture this fireworks shot.

rocket was going up — that's what creates the corkscrew of light that rises up through the frame.

» **Shooting reflective surfaces:** You can reduce glare from reflective surfaces such as glass and metal by using a *polarizing filter*. A polarizing filter can also help out when you're shooting through glass. However, in order for a polarizer to work, you have to position your camera at a certain angle with respect to the sun. Normally, the polarizer works best if you're positioned so that the sun is at one of your shoulders and the lens is then pointed directly in front of you.

Another option for shooting small reflective objects is to invest in a *light cube,* which is essentially a box that is made of white, translucent material, with an opening in front. You put the reflective object inside the cube and then position lights around the outside. The cube acts as a light diffuser, reducing reflections. For large objects, you can get a light tent, which looks a little bit like a tepee but works according to the same principle. Among the companies that make this sort of tool are Westcott (www.fjwestcott.com), Smith-Victor (www.smithvictor.com), and CloudDome (www.clouddome.com).

» **Shooting in strong backlighting:** When the light behind your subject is very strong, the result is often an underexposed subject. You can try using flash to better expose the subject, assuming that you're shooting in an exposure mode that permits flash, or you can use exposure compensation, if your camera offers it, to request a brighter exposure of your subject. (Chapter 5 talks more about this feature.)

For another creative choice, you can purposely underexpose the subject to create a silhouette effect, as shown in Figure 7-18. Just disable flash and then experiment with using a negative exposure compensation value, which produces a darker image, until you get a look you like. Of course, if you use manual exposure, just play with the exposure settings to achieve the look you have in mind.

FIGURE 7-18:
Experiment
with shooting
backlit subjects
in silhouette.

3

After the Shot

Chapter 8

Viewing, Downloading, and Storing Your Pictures

When thinking about the benefits of digital photography versus film photography, I rate being able to view my pictures right away, with no time or money spent on film and processing, at the top of the list. Not only do I save a ton of cash, but I know before I put away the camera whether I got the shot I wanted or need to try again.

Although I'm sure that you can figure out the basics of viewing pictures on your camera, you may not be aware of some of the other cool and useful playback features provided on many cameras today. This chapter introduces you to those options. Following that discussion, I discuss hardware and software products designed for storing and editing your photos after you move them off the camera. To wrap up, the chapter offers help with the process of downloading photos to your computer (or another storage device).

Note: Because the way you view, transfer, and store photos on a smartphone or tablet varies so much depending on the device and its operating system, this chapter concentrates on features related to standalone cameras. However, many tips, especially those related to long-term storage of your files, apply no matter what type of camera you use.

Taking Advantage of Playback Tools

On most cameras, pictures appear briefly on the monitor immediately after you take the shot. To take a longer look, you need to shift the camera into playback mode. Usually, you accomplish this by pressing a button labeled with a right-pointing arrowhead — the universal symbol for playback. You can get a look at a generic version of this symbol in Table 8-1.

TABLE 8-1

Playback Symbols

Look for This Symbol	To Access This Feature
▶	Playback mode
🔍+	Magnify image
🔍−	Reduce magnification
🗑	Delete image
⊶	Protect image

TIP

If your camera offers touchscreen operation, you also can scroll from one picture to the next using the same technique you use on a smartphone or tablet, swiping your finger across the screen to move from one image to the next.

On most cameras, viewing your photos is just the start of the playback functions you enjoy, however. The next sections describe some of the other features you may have at your disposal.

Getting a close-up look at a photo

Most cameras enable you to magnify an image so that you can inspect the details, as shown in Figure 8-1. If your camera has a touchscreen, you can use the standard touchscreen gesture to zoom the display: Put your thumb and forefinger at the center of the monitor and then swipe them outward, toward the edges of the screen. To reduce magnification, use both fingers to swipe inward from the edges of the screen. (These motions are sometimes known as *pinching in* and *pinching out*.)

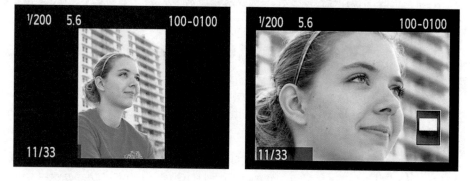

If your camera isn't touchscreen-enabled, you usually activate the zoom-in and zoom-out features by using buttons or other external controls/dials that are labeled with magnifying-glass symbols like the ones shown in Table 8-1. A magnifying glass with a plus sign means zoom in; the minus sign represents the zoom-out function.

Displaying thumbnails and calendars

You also may be able to set the playback display to show thumbnails of multiple images instead of a single photo. In fact, you may be able to choose from several thumbnails views, each of which presents a different number of photos. The left image in Figure 8-2, for example, shows a 9-image view. These displays are helpful when you need to scroll through a lot of pictures to find the ones you want to view. After you locate the first image in the bunch, you can shift back to regular, full-frame view, usually by pressing an OK button or a Set button or by using whatever control you normally use to magnify an image.

Another useful playback option is *calendar view.* In this display, you can click on a date on a calendar page to easily view all pictures taken on a certain day. The right screen in Figure 8-2 shows an example of this display.

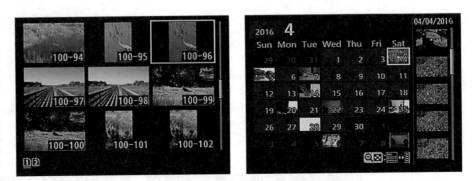

Viewing picture settings (metadata)

When you capture a digital photo, the camera embeds *metadata* — extra data — into the image file. This metadata contains information about the settings you used when recording the picture, including exposure, focus, and color settings as well as the capture date and time.

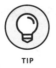

TIP

Checking picture metadata is a great tool for understanding how different camera settings affect your pictures. If a moving subject appears blurry, for example, take a look at the shutter speed — you then know that you need a faster shutter speed to capture that particular subject. Some cameras even display the focus point that was used when the camera set the focusing distance, which is another great bit of information when you need to figure out why part of an image isn't sharp.

Most photo viewing and editing programs can display the metadata associated with a picture file. But you probably don't have to wait until downloading your pictures, because most cameras can display at least some metadata during picture playback. In fact, you may be able to specify from several metadata display options, each of which offers up a different assortment of picture information.

In Figure 8-1, for example, the upper-left corner of the screen reveals the shutter speed and f-stop used (1/200 second and f/5.6). Other data on that screen indicate the folder and file numbers (100 and 0100) and the frame number and total number of frames in the folder (this image is number 11 out of 33 total frames). Figure 8-3, on the other hand, reduces the size of the

Brightness histogram

RGB Histogram

FIGURE 8-3:
Along with critical picture settings, some playback screens display histograms to help you evaluate exposure and color.

image display so that you can see a great deal more capture data along with two *histograms.* (I explain histograms in the next section.)

Check your camera manual to find out how to cycle through the various playback displays. Some displays may be disabled by default; you turn on those hidden display modes via a menu screen. (This option is typically found on a Playback menu or Setup menu.)

Displaying histograms

Chapter 5 introduces you to brightness histograms, which are graphs that plot out the brightness values in an image. Some cameras enable you to display a brightness histogram during playback, as shown in Figure 8-3. Checking the histogram is a great tool for making sure that exposure is correct.

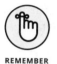

REMEMBER

The left side of the histogram represents shadows; the right side, highlights. And a peak in the graph represents a large collection of pixels at that brightness value. So if you see a large mass of pixels at the left end of the graph, the image may be underexposed. A clump at the right end of the graph may indicate an overexposed image.

Some advanced cameras offer a second type of histogram, an RGB histogram, which displays brightness values on a per-channel basis. The red, green, and blue charts in Figure 8-3 comprise an RGB histogram.

To make sense of an RGB histogram, you need to know a little about digital color theory. Chapter 6 provides an introduction, but here's a quick recap: Digital images are known as *RGB images* because they're created from red, green, and blue light. When you mix red, green, and blue light, and each component is at maximum brightness, you create white. Zero brightness in all three channels creates black. If you have maximum red and no blue or green, though, you have fully saturated red. If you mix two channels at maximum brightness, you also create full saturation. For example, maximum red and blue produce fully saturated magenta.

Back to the RGB histogram: If the histogram shows that all pixels for one or two channels are slammed to the right end of the histogram — indicating maximum brightness values — you may be losing picture detail because of overly saturated colors. A rose petal that should contain a spectrum of shades of red may be a big blob of full-on red, for example. On the other hand, if all three channels show a heavy pixel population at the right end of the histogram, you may have blown

highlights — again, because the maximum levels of red, green, and blue create white. Either way, you may want to adjust the exposure settings and try again.

A savvy RGB histogram reader can also spot color balance issues by looking at the pixel values. But frankly, color balance problems are fairly easy to notice just by looking at the image on the camera monitor, so let's leave that discussion for another lifetime, okay?

For information about manipulating color, see Chapter 6; for exposure-correction tips, refer to Chapter 5.

Displaying highlight alerts ("blinkies")

When a picture is greatly overexposed, areas that should include a range of light tones may instead be completely white. This problem is known as *blown highlights* or *clipped highlights*. Some cameras offer a playback mode in which fully white pixels blink on and off — which is why this view mode is commonly referred to as "the blinkies."

For example, Figure 8-4 shows an image that contains some blown highlights. I captured the screen at the moment the highlight blinkies blinked "off" — the black areas in the figure indicate the blown highlights. (I labeled a few of them in the figure.) But as this image proves, just because you see the flashing alerts doesn't mean that you should adjust exposure — the decision depends on where the alerts occur and how the rest of the image is exposed. In my candle photo, for example, it's true that there are small white areas in the flames and the glass vase. Yet exposure in the majority of the photo is fine. If I reduced exposure to darken those

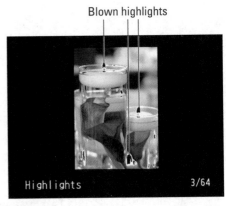

Blown highlights

Highlights 3/64

FIGURE 8-4:
Some cameras offer a display mode that indicates blown highlights with blinking pixels.

spots, some areas of the flowers would be underexposed. In other words, sometimes you simply can't avoid a few clipped highlights when the scene includes a broad range of brightness values. When the blinkies cover an important part of your subject, though, you need to adjust exposure settings and reshoot the photo.

Rating, Deleting, and Protecting Files

In addition to being able to inspect your pictures before downloading them, you also may find in-camera tools for performing the following file-management tasks:

» **Rating files:** This feature enables you to assign each file a rating — for example, five stars for your favorite photos or movies and one star for those that you're likely to delete. The idea is to help you easily find your best (and worst) work when you're browsing a huge image collection.

On most cameras that offer a rating feature, you can set up a slide show, which displays your photos automatically one by one, and specify that the show should include only images that you tagged with a particular rating. You also may be able to tell the camera to delete all files that have a low rating.

When you do download your pictures to your computer, you also can sort your photos by rating. To take advantage of this option, you may need to use the photo software provided by your manufacturer, but some third-party programs also recognize ratings that you assigned in the camera. (The rating is part of the aforementioned metadata that's buried in each image file.)

How you access this feature, of course, depends on your camera, but it's usually represented by a star symbol. In some playback modes, the star rating you assigned appears with the photo.

» **Protecting photos:** Do you see a button or switch marked with a little key symbol like the one in Table 8-1? If so, your camera enables you to protect individual pictures from being erased when you use its Delete option (covered next). No button? Check the Playback menu for a Protect option or, if your camera offers touch-screen operation, a key symbol directly on the screen. However you apply protected status, you usually then see a little key symbol along with the photo, as shown in Figure 8-5. The placement and exact design of the symbol may vary.

Protected symbol

FIGURE 8-5:
The key symbol indicates that the file is locked and can't be accidentally erased.

Here are two important points about this feature:

WARNING

- *Formatting the memory card erases protected photos as well as unprotected ones. Formatting* is a process that wipes a memory card absolutely clean of all data, including protected files. Most cameras provide this function because formatting a card ensures that it's prepared properly for the file-storage system the camera uses. Formatting new cards is a good idea, but be sure that you've emptied the card of all files you want to keep — protected or not — before formatting.

- *Protected photos can't be edited until you unlock them.* Locked picture files remain locked even after you download them, which means that you can't edit or delete them on your computer. However, you should be able to unlock the files easily using most photo editing and browsing programs. Look for a menu command named something like Unlock Photo or Remove Protected Status — typically, the File menu holds this command. If nothing else, the software that shipped with your camera should enable you to unlock downloaded photos. You can always put the memory card back in the camera and use the camera's protect feature to remove the protected status, too.

» **Deleting files:** Got a clunker image that you don't want to keep? No worries; every camera enables you to erase images easily. You usually get more than one way to dump files, in fact.

To erase a single image, first set the camera to Playback mode and display the photo (or movie file). Then look for a button sporting the trash can symbol (shown in Table 8-1) or an onscreen trash can. After you press the button or tap that icon, the camera likely will ask you for confirmation that you really want to erase the photo. Answer in the affirmative, and that picture's zapped into digital oblivion.

TIP

Deleting photos one by one can be tedious, though, which is why most cameras also offer a menu command, usually on the Playback menu, that gives you the choice to erase all images on the card or to select specific files to delete. If your camera has a rating feature, you also may have the option to get rid of photos that have a particular rating.

Setting Up Your Digital Darkroom

With the large file sizes created by today's digital cameras, you can fill up a memory card in no time. I explain the basics of moving files off your cards later in this chapter, but first, you need to think about what computer hardware and software you may need to work with your photos after you download them. The next

sections offer my advice on such matters, including the best way to preserve your digital image files.

Assessing your computer needs

As with selecting a camera, picking the right computer — and determining whether you even *need* a computer — depends on what you want to do with your photos and movies after you shoot them.

Basically, your choices boil down to a "real" computer (a desktop or laptop model, with a built-in keyboard, hard drive, and so on) or a tablet such as the Apple iPad or the Samsung Galaxy Tab. To help you decide, the next two sections describe the pros and cons of each.

Tablets

Most tablets come with installed apps (mini software programs) that you can use to view and share pictures. You also can find several third-party apps that enable you to edit your photos. And for the photographer on the go, carrying a tablet is certainly a lighter, less bulky option than carrying a laptop computer (although some laptops don't weigh much more than a tablet these days).

Tablets have several drawbacks, however. First, they don't have enough onboard storage space to serve as a permanent solution for housing your photo files. And even if they did, I wouldn't recommend that option for long-term storage; tablets are just too vulnerable to damage and theft. To be fair, laptop computers present the same problems. In any case, this issue can be easily solved by investing in a separate storage solution; see the section "Preserving your files," later in this chapter, for some ideas.

Additionally, most tablets don't have the kind of computing power needed to perform serious photo-editing tasks, especially if you're working with large image files. As I write this, some manufacturers are starting to address this issue. Apple's iPad Pro is one example of a tablet that offers greater data-processing power, although it's certainly no match for a well-outfitted laptop or desktop computer. The accuracy of the tablet display is also a concern; image colors, brightness, and sharpness can vary depending on the ambient light in which you view the images and the quality of the display itself. Again, this can also be a problem with laptop monitors, and new tablets being designed for photographers promise better display accuracy. Time will tell if that vow holds true.

Finally, you need to consider the issue of moving pictures from your camera to the tablet. If your camera offers wireless connection, you can use that pathway to transfer photos to the tablet. Some tablets also provide a way to connect a memory

card reader or even the camera itself for file downloading. (You may need to buy an adapter to make this solution work.)

My take? I think a tablet works great as a temporary, portable solution for travel and, if you do photography for a living, for carrying along on remote shoots so that clients can review shots on the spot. And of course, it's perfect for transferring photos to your social media pages and for showing your work to family and friends. But if you're someone who wants to do a lot of photo editing, I recommend stepping up to a regular computer, as explained next.

Desktop and laptop computers

If you plan on doing heavy-duty photo editing, especially with large image files, I recommend a desktop, laptop, or well-equipped two-in-one laptop (the kind where you can detach the keyboard and use the monitor as a tablet). As a rule, you'll get more built-in storage as well as more powerful computing components, which enables faster processing of large image and movie files.

Of course, how a desktop or laptop compares with a tablet in these areas depends on the specs of the system you buy. And just how much storage space, processing power, and other system muscle you need depends on what you want to do with your photos. Pro-level photo-editing programs require heavy-duty systems, but a low-end system is fine for running entry-level photo programs. For video editing, you absolutely need a well-equipped system because that task is one of the most demanding assignments for a computer.

I can't be too specific about what computer specs will work best for you because with the pace at which new components are developed, my words would be outdated before they even made it to the printing press. So instead, the following list provides a general overview of components that make the most difference in computer performance. If you decide to invest in a new system, this information will help you narrow down the list of candidates. You can then check the most current computer magazines or online sites for detailed reviews to make your pick.

TIP

>> **Processor:** This is the "brain" of the computer. *Ergo ipso facto,* the more powerful, the better. However, if you're a value shopper like me, experts suggest that you get the most bang for your buck if you buy a processor one grade under the latest and greatest.

Most computer magazines and sites that review new computer components run performance tests comparing how the processors run Adobe Photoshop, the leading professional imaging software. Suffice it to say, if the processor does well on the Photoshop bench test, it'll serve your digital photography needs.

>> **Hard drive:** The hard drive is the part of the computer that stores your programs, documents, and picture files. If you get a desktop system, you may want to get one that can house two hard drives; that way, you can store your files on one and put programs on the other, which boosts performance.

How much hard drive space you need depends on how many pictures you take and how many other files you keep on your computer. Keep in mind that a computer needs some empty hard drive space to use as temporary data storage space when you're running programs such as a photo editor. If your current hard drive is packed, start doing some house cleaning or consider adding another drive.

If your computer doesn't have room for an additional internal drive, you also have the option of adding an external hard drive. But understand that accessing files stored on an external drive usually takes a bit longer than when you work with files on an internal drive, just because the data needs to make its way through whatever cable (or wireless) connection you use to connect the drive to your computer. So although I do store a backup copy of my image collection on an external drive, I move files that I'm currently editing to my internal drive.

REMEMBER

When looking at hard drives, note the drive speed as well as its capacity. Drive speed determines how quickly the system can read and write data to and from the drive. Again, check performance reviews in computer magazines for the latest speed data.

>> **RAM (random access memory):** When you ask your computer to perform any task, it uses RAM to perform the calculations needed to get the job done, so more RAM equals faster performance.

For minor photo editing, web sharing, and general daily tasks such as emailing and word processing, 4GB (gigabytes) of RAM is probably enough. For more intense photo editing or video editing, double that number (at least). However, note that most programs can utilize only so much RAM, so going full tilt on RAM isn't always necessary. To find out the RAM requirements of the programs you like to run, check the software manufacturer's spec sheets.

TIP

If you're in the market for a new computer, find out how much RAM you can add — every system has a specific limit in the amount of RAM it can hold, so make sure that you don't buy a system that will leave you hamstrung in the future if your RAM needs increase.

>> **Video (graphics) card:** Also called a *display adapter,* this is the component responsible for making text and images appear on the monitor. Buying video cards involves enough arcane terminology that I don't even dream of covering it here, so here's my best advice: Ask your local teenage video-game enthusiast to help you pick a card. If a card performs well for video gaming, which is the most demanding operation the video card must perform, it's sufficient for

photo and imaging work. Of course, computer magazines and gaming magazines also cover these components. (Just don't say I didn't warn you that you'll encounter enough jargon to make your head spin.)

>> **DVD burner:** This component, while not absolutely necessary, provides an option for making backup copies of your files so that in the event of a hard drive failure, you don't lose all your images. Many new computers don't offer a DVD drive, but you can always buy an external burner that you can attach to the computer. Some software also is provided on CD or DVD (DVD burners can read both types of discs), but that delivery method is quickly becoming a thing of the past, with most software vendors making their wares available only for download from the Internet.

>> **Operating system (Windows or Mac?):** The operating system — *OS,* in geek terminology — can make a difference, but not in the way you probably expect. It's not which OS you choose, but which *version* you select. You can run many photography programs on older versions of the Windows or Mac OS, but the newer versions are optimized to work better with digital photos and movies. Some even have built-in tools for editing and sharing your work.

As for the whole Windows-versus-Mac debate: I say, *"pfffffffft."* I've used both for years, and both have brought me the same amount of pleasure and the same amount of pain. You do typically get more computing power for less money if you buy a Windows-based PC, and certainly more programs are available for Windows than Mac, but other than that, it's personal preference, in my opinion. After all, when you open most programs, they look and work the same way regardless of whether you're working on a Windows or Mac machine.

Note that there are some other operating systems, including Linux, but that's an arena for computer "enthusiasts" only. I assume that if you're interested in Linux, you're enough of a computer scholar that you don't need me to tell you about its pros and cons.

>> **Monitor:** If you go with a desktop system, a monitor is another important component of your digital darkroom. It used to be that those big, bulky TV-like monitors (CRT, or *cathode-ray tube,* monitors, to be specific) produced the best-quality computer displays. Not so today: LCD displays have overtaken the market as the standard, and the images they produce are stunning. Many can serve dual duty as HDTV displays, in fact.

What about laptop monitors? Well, I would never rely on using the built-in monitor to evaluate my images, because the displayed colors, brightness, and sharpness can change when you adjust the monitor angle or even move your head a little. I recommend buying a separate monitor that you can connect to your laptop when you need to work on your images.

If you're in the market for a new monitor, research reviews carefully to make sure that the one you select performs well for this use. You may need to shop online because big-box electronics stores typically carry only monitors meant for gaming and online video streaming — which means that colors are overly saturated and everything appears very bright and sharp. That's fine if you only plan to view your photos on this monitor and you like that look. Just understand that your pictures may look very different when printed or viewed on someone else's monitor.

WARNING

Whichever monitor you select, you also need make sure that it's *color calibrated* (set up to display your images accurately). Otherwise, any color or brightness adjustments you make may be off the mark. An uncalibrated monitor is often the cause of print colors not matching onscreen colors, so I cover this topic more in Chapter 9.

Sorting through software solutions

The photo software you use is as critical to your success in the digital darkroom as the hardware. The good news is that if your needs are basic — you just want to view and organize your photos and maybe crop an image or two — you may not need to pay a dime for a good solution. The next sections introduce you to some programs of the free variety as well as a few to consider if you need more features than the free programs provide.

Note: In this chapter, I cover programs designed to be used on a computer rather than a mobile device. See Chapter 10 for a list of my favorite tablet and smart-phone apps.

Basic (and free) programs

If you don't plan on doing a lot of retouching or other manipulation of your photos but simply want a tool for downloading and organizing your pictures, one of the following free programs may be a good solution:

>> **Your camera's own software:** Your camera may have shipped with a CD or DVD that contained free software designed by the camera manufacturer. Or you may be able to download the software from the manufacturer's website. In some cases, these programs provide only basic photo viewing and organizing, but some are quite capable. Nikon, for example, offers Nikon Capture NX-D, shown in Figure 8-6, which offers tools for removing red-eye, cropping pictures, adjusting color and exposure, and processing Nikon Raw files.

FIGURE 8-6:
FIGURE 8-6:
Most camera
manufacturers
offer a free
image browser
and basic
photo editor;
here's a look at
one of Nikon's
programs.

>> **Apple iPhoto or Photos:** Long-time Mac users are no doubt familiar with iPhoto, the browser built into the Mac operating system until very recently. As part of recent operating system updates, iPhoto was replaced by Photos, shown in Figure 8-7.

FIGURE 8-7:
Apple Photos
is a good basic
tool for Mac
users.

» **Windows Live Photo Gallery or Photos:** Recent versions of Microsoft Windows also offer a free photo downloader and browser. The name varies depending on your version of the Windows operating system; Figure 8-8 offers a look at Windows Live Photo Gallery, which ships with Windows 7. In Windows 10, the program is called Photos and looks more like a smartphone or tablet app.

FIGURE 8-8: Windows Live Photo Gallery is free to Windows 7 users.

Advanced (and not free) options

Programs mentioned in the preceding section can handle simple photo editing and organizing tasks, but if you're interested in serious photo retouching or digital-imaging artistry, you need to step up to a full-fledged, photo-editing program. The following list describes the most popular offerings (prices are the manufacturer's suggested retail):

» **Adobe Photoshop Elements:** Elements has been the best-selling, consumer-level, photo-editing program for some time, and for good reason. With a full complement of retouching tools, onscreen guidance for beginners, and an assortment of templates for creating photo projects such as scrapbooks, Elements offers all the features that most consumers need. But don't think this is a lightweight player — you actually get many high-end editing features as well. The program also includes a photo organizer along with built-in tools to help you print your photos and upload them to photo-sharing sites. (You can find out more at www.adobe.com. The program sells for $100.)

>> **Adobe Photoshop and Adobe Lightroom:** I mention these two together because Adobe now makes them available as a two-tiered solution specifically geared to photography. In the past, you could buy both programs separately, but Adobe now uses a subscription-based system. Currently, you pay about $10 a month if you subscribe for a year. (This price enables you to install the programs on two computers.) Lightroom is still available as a standalone purchase ($150), but you can get Photoshop only via subscription.

Photoshop offers the industry's most powerful, sophisticated, retouching tools. In fact, you probably won't use even a quarter of the tools in the Photoshop shed unless you're a digital-imaging professional who uses the program on a daily basis — even then, some tools may never see the light of day.

Lightroom, though, is quickly becoming the preferred alternative for photographers who don't need the high-level tools found in Photoshop. Shown in Figure 8-9, it's also geared to processing large numbers of images quickly. For example, with a few mouse clicks, you can make the same color adjustment to an entire series of images from a day's shoot. (Visit www.adobe.com to find out more about both programs and the subscription program.)

FIGURE 8-9:
Adobe Photoshop Lightroom is a leading choice of studio photographers and others who need to process lots of images.

>> **Affinity Photo:** This new player in the photography world has gotten rave reviews for offering sophisticated editing tools at a bargain price ($50, www.serif.com). As I write this, it is available for Mac computers only (Apple named it the 2015 Mac app of the year), but a Windows version is in the testing stage and may even be available by the time you read this book.

>> **Exposure X:** This program tries to straddle the line between being simple enough for the novice photo editor but also providing tools that the professional photographer sometimes needs, especially in the arena of portrait photography. It can work as a standalone program or as a *plug-in* (add-on tool) with Photoshop or Lightroom. (Point your web browser to www.alienskin. com; the price is about $150.)

>> **ON1 Photo 10:** Here's another inexpensive alternative for photographers who need a well-equipped photo editor and organizer. Previously, ON1 editing tools were marketed separately as Photoshop and Lightroom plug-ins, but now you can get all those tools and more in a stand-alone program. The program still operates as a plug-in if you prefer that option, however. Figure 8-10 shows a look at one section of tools designed for quick and easy portrait retouching. (Head to www.On1.com for details on this $120 program.)

TIP

Not sure which tool you need, if any? Good news: You can download free trials of all these programs from the manufacturers' websites.

Preserving your files

Perhaps the most critical issue for any digital photographer is how to safely store all your files. The following list offers my best advice:

>> **Don't rely on a computer hard drive as your only archival storage option.** Drives occasionally fail, wiping out all files in the process. This warning applies to both internal and external hard drives, including the small portable drives many photographers carry with them these days.

In addition to possible drive malfunction, laptop users have to think about the possibility of theft. I can't tell you how many stories I hear about people who lost all their baby, wedding, or vacation photos because they kept them on a laptop that was stolen.

At the very least, a dual-drive backup is in order. You might keep one copy of your photos on your computer's internal drive and another on an external drive. Or you may set up two external drives, if your internal drive is small. That way, if one drive breaks, you still have all your goodies on the other one.

TIP

I also make it a habit to unplug my backup external drive when I'm not using it, to lessen the chances of it getting fried by a power fluctuation. (Using surge protectors on all your electronics goes a long way toward protecting them from this type of damage, but it can still happen.)

» **Don't use camera memory cards or flash drives as backups, either.** Both are easily damaged if dropped or otherwise mishandled, and being of diminutive stature, are easily lost. Memory cards do fail, too, and although I've only had it happen a couple of times, I would have been seriously upset had those cards held important images. Also consider that as technology evolves, there's a chance that today's memory cards may not be compatible with tomorrow's card readers.

» **If your computer has a DVD drive, back up important files to DVD.** The most stable medium for long-time image storage is an optical disc, by which I mean a CD or DVD. Unlike hard drives, flash drives, and memory cards, DVDs and CDs aren't subject to mechanical or electrical failure (although the drives you need to read the discs aren't safe from those hazards).

Unfortunately, CDs hold only 640MB of data, which makes them impractical for storing the large files that the latest digital cameras produce. DVDs, by contrast, can hold 4.7GB (gigabytes) of data. How many files you can store in that space depends on certain camera settings you use, including resolution and file type (JPEG or Raw). With a high-resolution, Raw, or high-quality JPEG file, you may find yourself burning lots of DVDs. (See Chapter 4 for more information about file types and resolution.) But I still consider DVDs an important component to my file archiving system.

When you shop for blank DVDs, buy high-quality, gold-coated, nonrewriteable (and therefore non-erasable) discs, which have the highest ratings for long storage life. Be aware, though, that the DVDs you create on one computer may not be playable on another, because multiple recording formats and disc types exist: DVD minus, DVD plus, dual-layer DVD, and so on. Keep your eye on the technology horizon and, when you upgrade your computer, be sure it can read your DVDs before you give away your old computer or DVD drive. If not, make copies in a format the new drive can read.

You also need to store your discs properly. If discs get scratched, they may become unreadable, so when you're not using them, keep them in protective

cases, away from extreme heat, and store them in a vertical, upright position rather than stacking them one on top of the other. Also avoid putting stick-on, paper labels on them. The adhesive can cause a mess if repeatedly exposed to the heat of the DVD drive.

>> **Take advantage of cloud storage (online data storage) for a second level of file security.** Even if you do back up your files to DVD, I recommend also storing important files at an online storage site. This practice covers you in the event of fire or another catastrophe that takes out both your computer equipment and your DVDs.

Some cloud storage sites are geared toward photographers, providing not just file storage but also tools for creating slide shows and photo albums, and for sharing your images with others. But if you don't need those features or you want to store documents and other non-image files, cloud services geared toward businesses and other general uses work just as well. Some sites enable you to set up a system of automatic backups, where the computer sends new files to the storage site on a regular basis, with no prompting from you.

How much you'll pay for cloud storage depends on the amount of space you use and what other tools the company provides. To find the right fit, search online or in your favorite photography or computer magazine for recent cloud-storage reviews.

Also keep in mind these pointers:

- *If you shoot in the Raw format, make sure that the site accepts them.* Many photo-oriented cloud companies won't let you store Raw files. You may need to go with a company that doesn't care what type of file you upload to your digital closet.

- *Find out about individual file-size limitations.* Most companies care only about how much total storage space you use, but some limit you to a particular size for each individual file.

- *Make sure that your original files are preserved.* This issue arises mostly on sites that are designed more for photo sharing than storage. When you upload a high-resolution original, such sites often create a lower-resolution copy and toss the high-res version. That's fine for online viewing, but if you need to retrieve your original, you're out of luck.

- *Pay attention to those pesky terms of service.* Reading those agreements is a pain, but shady companies sometimes bury unacceptable terms in those long documents. Of primary concern to photographers is that the company agrees that it has no right to publish, distribute, or otherwise use your photos.

 Certain sites also require you to buy prints or other photo-related products in order to maintain your storage closet. If you don't routinely buy such

products, you may find it cheaper to pay the annual fee at a site that has no purchase requirements.

- *Don't rely on cloud storage alone.* The problem is that you have no guarantee that the company that's storing your photos won't go out of business, leaving you without any way to get your files back. (One extremely alarming case was the closure of a photography-oriented storage site that gave clients a mere 24-hours' notice before destroying their files.) In addition, although some companies offer financial restitution if their storage hardware fails, that money can't get your photos back. So anything you store online should be also kept on DVD or a regular hard drive.

» **Don't forget to print!** One often overlooked archiving option is to print your favorite photos. Presuming that you store them correctly, prints last a long time and aren't subject to hardware failures, electrical disruptions, and the like. Even if you lose every bit of hardware you own, you can have your prints scanned to create new digital originals. Chapter 9 explains the steps to take to give your prints the longest possible life span.

Downloading Your Images

Perhaps the most hated part of digital photography is the inevitable task of transferring files from the camera to some sort of digital storage closet, whether it's a computer hard drive or a cloud storage site. Even if you're a computer pro, this process often involves cryptic menu options, tedious setup routines, and unexpected system hiccups. Profanity, although not encouraged, is an understandable part of the deal.

Because the steps required to complete file transfer vary so much depending on your camera, the computing device you use, and the storage option you choose, I can't provide much detailed assistance in this area. But the next two sections provide some general guidance to get you started.

Looking at connection options

To transfer photos from your camera, the first step is to choose how you want the computer to be able to access your picture files. Depending on your camera, you may be able to use one or all of the following methods:

» **Connect the camera to the computer via USB.** USB stands for *Universal Serial Bus*, which is a technology developed for connecting printers, cameras, and other devices to a computer. A USB *port* is a slot on the computer

where you can plug in a USB cable. Figure 8-11 offers a close-up look at a USB plug and ports, which are typically marked with the symbol labeled in the figure.

To use this method, your camera must have a USB port, and you also need a special USB cable — most cameras require a cable that has a standard USB plug that attaches to your computer's USB port and a smaller plug that goes into the camera. Most camera manufacturers provide USB cables, but if not, you have to buy one from the manufacturer (or from a third-party source that makes the proper cable for your camera).

USB Symbol

FIGURE 8-11:
Most card readers and cameras connect to the computer via a USB cable.

WARNING

Before connecting the two devices, be sure to turn off the camera! Otherwise, you risk harming the camera and damaging the files on the memory card. In addition, fully charge your camera battery before beginning the process; if the battery dies during the file transfer, you may lose some picture data. If you opt for this connection method regularly, you may want to invest in a power adapter, if available for your camera, so that you can run the camera on electrical power rather than waste battery juice.

» **Use a card reader.** A *card reader* is a device that enables a computer to access data directly from a memory card — no camera or battery power required. You just take the card out of the camera and slip it into the card reader when you want to download photos.

Many computers have built-in card readers; if yours doesn't, you can buy an external one that plugs into your computer's USB port. You also can find ways to attach card readers to some tablets. Also, if your printer has a built-in card reader (many do), you may be able to use that card reader to move files to your computer. When I put a memory card in my printer's card reader, for example, I can access the card just as I can any other drive connected to my system. (If your printer is connected to your computer via Wi-Fi, though, the file transfer process can be pretty slow when compared to a reader connected by cable.)

You can buy a card reader that accepts just one type of card or a product like the Lexar model shown in Figure 8-12, which works with the two most common digital-camera card types: SD cards and Compact Flash cards. (Visit www.lexar.com for details on this product.)

FIGURE 8-12:
Just push the
memory card
into the match-
ing slot on the
card reader.

Courtesy of Lexar

WARNING

When shopping for a card reader, be sure that it works with the type of card you're using. Also verify that the reader can cope with the capacity of your card (the amount of storage space it offers). Some SD-card readers handle regular SD cards (4GB maximum capacity), for example, but can't cope with the higher-capacity SDHC or SDXC cards.

» **Transfer wirelessly.** Cellphones and other smart devices can connect to your computer wirelessly, assuming that your computer itself is part of a Wi-Fi network. You also may be able to use Bluetooth, another wireless data-transfer technology, to connect your smart device to your computer.

Many stand-alone cameras also offer Wi-Fi connectivity, sometimes built in and sometimes with an accessory adapter. You usually need to install computer software provided by the camera manufacturer and do some setup work on the camera to enable it to access the wireless network. If your network is password protected, for example, you need to enter the password on a camera menu screen.

TIP

Some cameras, tablets, and smartphones offer a wireless feature named *NFC (Near Field Communication)*. When you place two NFC-enabled devices close to each other, they communicate via their own, private connection. You don't need to access a separate Wi-Fi network to transfer files in this case.

Whichever wireless route you may choose, remember my earlier note regarding the speed of transferring files through a card reader built into a Wi-Fi printer: The transfer speed depends on the speed of the wireless connection but is almost always much slower than using a wired card reader or even cabling your camera to your computer.

If your camera doesn't offer Wi-Fi connectivity and you'd like that file-transfer option, you can buy Eye-Fi memory cards, which offer built-in wireless transfer technology. (Visit the website www.eye.fi for more information about these memory cards.) However, these cards are more expensive than standard cards and not all cameras can use them.

Completing the download process

What happens after you establish a connection between a camera or card reader and the computer depends on your computer's operating system and the software you installed. Here are some possibilities:

>> **You see an icon representing your camera or memory card on your computer desktop or in the file-management window.** For example, Figure 8-13 shows how a card reader shows up as a drive on the desktop on a Mac computer. In some cases, the camera brand name appears along with or instead of a drive letter. (The drive letter will vary depending on how many other drives are on your system.)

Memory-card icon

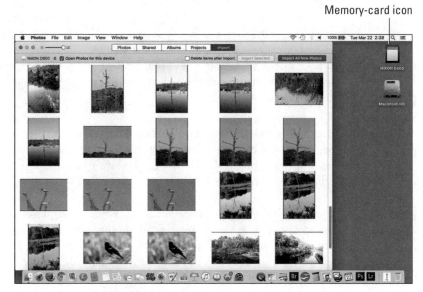

FIGURE 8-13: The memory card appears as a regular drive on the computer.

» **On a computer running Windows, a Windows message box similar to the one in Figure 8-14 appears.** The figure shows the dialog box as it may appear in Windows 7 (the box changes depending on your computer settings). From this window, you can choose from programs that the system believes can handle image file transfers.

» **An installed photo program automatically displays a photo-download wizard.** For example, the downloader associated with your camera software (assuming that you installed that program), Adobe Lightroom, iPhoto, or another photo program may leap to the forefront. Usually, the downloader that appears is associated with the software you most recently installed.

FIGURE 8-14:
Windows 7 may display this initial boxful of transfer options.

TIP

If you don't want a program's downloader to launch whenever you insert a memory card or connect your camera, you can turn off that feature. Check the software manual to find out how to disable the auto launch. On the other hand, if you have a favorite downloading program, you can tell your computer to automatically launch that software when you insert a memory card into your card reader or connect your camera to the computer. Sometimes, you can check a box inside the photo software to make it the priority image-file handler; if not, make your wishes known through the computer's own preferences panels or dialog boxes.

If you're using photo-download software, you should be able to view all your **photos,** select the ones you want to transfer, and specify downloading options such as the name of the folder where you want to store the images. Check the program's Help system for how-tos.

But if you prefer, you can just stick with Windows Explorer or the Mac Finder and use the same drag-and-drop technique that you use to copy files from a CD, DVD, or another removable storage device to your computer. Normally, you have to open a folder or two to get to the actual image files: They're typically housed inside a main folder named DCIM (for *digital camera images*), as shown in Figure 8-15, and then within a subfolder that uses the camera manufacturer's name or folder-naming structure. After you open the folder, you may see thumbnails of the images or simply the names of the files, as in the figure.

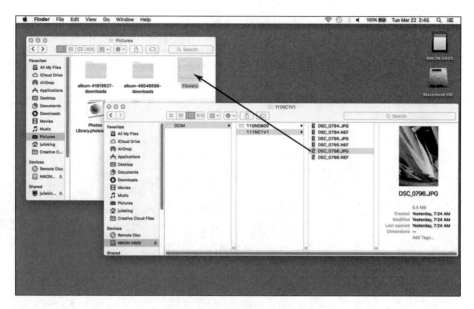

FIGURE 8-15:
On a Mac, you
can drag and
drop files from
a memory
card using the
Finder.

After opening the folder that contains the images, select the ones you want to transfer and then just drag them to the folder on your hard drive where you want to store them, as shown in Figure 8-15. Although it's not visible in the figure, you should see a little plus sign next to the cursor when you drag. The plus sign indicates that you're placing a *copy* of the picture files on the computer; your originals remain on the card.

TIP

A few final downloading tips apply no matter which method you use:

>> **You don't have to use the same program to edit photos that you use to download them.** You can download using your camera's photo browser, for example, and then open and edit the transferred photos in Adobe Photoshop. In some cases, you first need to *import* or *catalog* the transferred photos into the program, which simply tells the program to build thumbnails for the picture files.

>> **Watch out for the erase-after-download option.** Many photo downloading tools offer to automatically erase the original images on your card after you transfer them to the computer. Disable that option just in case something goes haywire. It's not a good idea to erase the images on your card until you're confident that they're safely stored on your hard drive.

>> **Also disable automatic red-eye correction.** Many downloaders also attempt to try to remove red-eye during the download process. This option can cause your downloads to take *forever* as the program tries to locate and fix areas that it thinks may be red-eye. It's better to do the job yourself after downloading.

>> **You may be able to copy photos to a backup drive at the same time you copy them to your main storage drive.** This feature, found on some photo downloaders, is a great timesaver, for obvious reasons. The initial download may take a bit longer because files are being written to two locations, but you don't have to take the time to select and copy photos to your backup drive later.

FILE-ORGANIZATION TIPS

TIP

When you transfer picture files to your computer, you can store them in any folder on your hard drive that you like, but it's a good idea to stick with the default location that your computer's operating system sets aside for digital pictures. The folder is named either Pictures or My Pictures, depending on your operating system (Windows 7, Windows 10, Mac OS X El Capitan, and so on). Most photo-editing programs, as well as other programs that you may use to work with your pictures, look first in the default folders when you go to transfer, edit, and save pictures. Keeping your images in those folders saves you the trouble of hunting down some custom folder every time you want to work with your photos.

After you amass a large image collection, you may want to create subfolders inside the Pictures or My Pictures folder so that you can better organize your photos. For example, you can create a Travel subfolder to hold travel photos, a Family subfolder for family images, and so on.

You might even like to rename your individual photos with filenames that let you reference them specifically. For example, if you took pictures in France in the year 2016, you might rename the files this way:

Original File Name: DSCN0223.jpg

Your New File Name: France 16-0223.jpg

That way, you can identify the picture subject and year by looking at the first part of the filename, yet by keeping the original file number, each image has a unique identifier. I also like to assign special identifiers to pictures that I've resized for online use so that I can easily distinguish it from its high-resolution original. I usually just add the tag *Web*, as in France 16-0223 Web.jpg. And if I crop a photo for a certain frame size, I use the same tactic: France 16-0223 5 x 7; France 16-0223 8 x 10, and so on.

Some photo programs offer automated file renaming tools that can make this organizational step a breeze, too. Look for a menu command named something like Batch Rename. See Chapter 9 for help on preparing files for online use and printing.

Chapter 9

Printing and Sharing Your Pictures

In the early days of digital photography, printing and online sharing of photos was rare. Cameras didn't offer enough resolution to produce good print quality at sizes much larger than a postage stamp, and because retail options for printing digital images didn't exist, you had to either invest in your own photo printer or spend a big chunk of change having the files output at a pro lab. The Internet was in its infancy, too, with slow — and I mean *slowwww* — dial-up connections that made sharing even low-resolution photos a tedious, time-consuming affair.

Of course, those limitations are gone now. Even entry-level cameras offer enough resolution to produce great prints, which you can have made at any corner drugstore or other retail outlet, whether brick-and-mortar or online. And although some people who live in rural areas still rely on dial-up Internet service, the majority of us enjoy fast connections that enable us to upload photos in seconds.

Some potential glitches still exist, however. You may be dismayed to find that colors in your prints bear no resemblance to the ones you see on your computer monitor, for example. Or your favorite social media site may reject an image file for being too large or the wrong file type. To help you avoid these and other possible problems, this chapter helps you prepare your photos for printing and online sharing and also provides advice on buying a photo printer. In addition, the first

part of the chapter explains how to convert pictures that you shoot in the Raw format to a format that's suitable for either printing or online use.

Converting Raw Files

Many digital cameras can capture images in the Camera Raw file format, or just Raw. This format stores raw picture data from the image sensor without applying any of the usual post-processing that occurs when you shoot using the JPEG format.

REMEMBER

Shooting in the Raw format offers a number of benefits, which you can explore in Chapter 4. But the downside is that if you want to have images printed at a retail lab or to share them online, you need to *process* the Raw files and then save them in a common image format. Nor can you use Raw files in a word processing, publishing, or presentation program — actually, in any program except photo software that can understand the particular Raw language spoken by your camera. (Every manufacturer has its own proprietary Raw format, and each new model from that manufacturer produces Raw files slightly differently from the previous models.)

You have a couple options for converting Raw files:

>> **Some cameras offer a built-in converter.** For example, Figure 9-1 offers a look at the converter available on some Nikon cameras. Although convenient, these tools enable you to control just a few picture attributes. Additionally, there's the issue of having to make judgments about color, exposure, and sharpness on the camera monitor — a small canvas on which to view your work when compared with a computer monitor. Still, having this option is terrific for times when you need to process a Raw file on location or when you're in a hurry.

FIGURE 9-1: Here's a look at the built-in Raw converter found on some Nikon cameras.

>> **After downloading the Raw files to your computer, you can process them using a photo program that offers a converter.** The software provided by your camera manufacturer may provide a Raw converter, and many photo-editing programs also offer this tool. Figure 9-2 offers a look at the Raw converter found in Adobe Photoshop, for example. (Pros in the photo industry refer to this tool as ACR, for *Adobe Camera Raw.*) How many picture characteristics you can tweak depends on the software, so if you're shopping for a program to handle this task, investigate this feature carefully. Some entry-level programs simply change the file format from Raw to a standard format, applying the same picture-characteristic choices that the camera would have used had you taken the photo in the JPEG format originally.

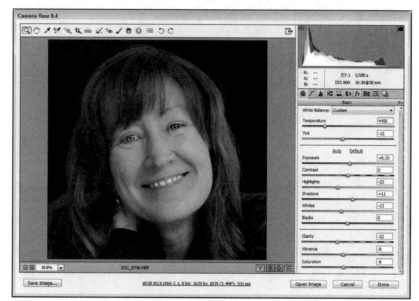

FIGURE 9-2: Adobe Photoshop offers multiple panels of image-tweaking options in its Raw converter.

For specifics on selecting conversion settings, I need to point you to your camera manual or software manual. You also can find online tutorials for Adobe Camera Raw and other major photo–editing programs that offer Raw conversion tools. But here are a few general rules to follow:

>> **Don't erase your original Raw file.** You may someday want to convert the file using different settings, and retaining the Raw file means that you always have an original image in pristine condition that you can return to, if necessary.

>> **The settings you use when making your Raw conversion stay with the Raw file, sort of like an invisible recipe card.** The next time you reopen the file in the converter, you don't have to go through all the adjustments again;

they're automatically applied as you did them the first time. But because your picture data still is technically "raw," you can apply a whole new set of adjustments without doing any damage to the picture.

>> **To retain the highest image quality in the converted file, save it in the TIFF format.** TIFF (tagged image file format) is a *non-destructive* format: It preserves as much of the Raw file's original image data as possible. That translates to the best image quality, which is why TIFF is the standard format used for professional publishing. I submit images for this book, for example, in the TIFF format. Most photo editing, word processing, and publishing programs can work with TIFF files, and most retail labs can print TIFF files as well.

Other nondestructive formats include PNG (Portable Network Graphics) and PSD, which is the Photoshop *native* format (the one created for use in that program). PNG is compatible with many publishing and graphics programs, but few programs other than those from Adobe can work with PSD files. So make your life simple and, unless someone requires you to do otherwise, stick with TIFF.

TIFF does have one downside: Pictures stored in this format are much larger than JPEG files. But that's the price you have to pay if you want to retain your image at its highest quality.

>> **If you want to use your converted file online, save a copy in the JPEG format.** TIFF files don't work online; browsers and email programs can't display them. JPEG, on the other hand, is the universal online photo format and also is fine for taking photos to retail print shops. Just know that unlike TIFF, JPEG is a *lossy* format. To reduce file sizes, JPEG tosses away some image data as the file is saved. You can read more about this issue in Chapter 3, but as far as Raw conversion goes, the best practice is to save one file in the TIFF format and then save a copy in the JPEG format for online use. (You also may want to reduce the resolution of the JPEG version, for reasons explained later in this chapter, in the section "Sizing photos for screen display.")

WARNING

>> **Before you do any Raw conversions — or any photo editing, for that matter — calibrate your monitor.** This step, explained in the later section "Getting print and monitor colors in sync," ensures that you're seeing an accurate representation of image color, contrast, and brightness.

Avoiding Printing Pitfalls

After years of helping people sort out photo-printing problems, I've learned that most printing woes can be traced to a handful of issues. The next three sections provide the information you need to avoid them.

Checking resolution: Do you have enough pixels?

For good-quality prints, you need an adequate pixel population. Chapter 4 explains the role of pixel count, or resolution, in detail, but the short story is that you should aim for the neighborhood of 200 to 300 pixels per linear inch of your print. If you want to print, say, an 11 x 14-inch photo, your image needs to contain at least 2200 x 2800 pixels, or roughly 6 megapixels. (Here's the math: 11 inches by 200 equals 2200 pixels; 14 x 200 equals 2800 pixels; and 2200 pixels x 2800 pixels equals a total resolution of 6.16 million pixels, or 6 megapixels.)

WARNING

Don't have enough pixels? Expect prints that look jagged along curved and diagonal lines and exhibit other visual defects. Also remember that even though some photo programs enable you to add pixels to an existing image, doing so never improves picture quality.

If you're printing photos at a retail or online site, the printer's order form usually indicates how large a print you can make given the image's pixel count. If you're doing your own printing, you have to be the resolution cop, though. You can find out how many pixels you have by looking at the image file properties during picture playback on the camera. (You may need to change the camera's display settings to do so.) For example, in Figure 9-3, the resolution value reports 4032 x 3024 pixels. (I dimmed everything except that value to make it easier to spot.)

Picture resolution

FIGURE 9-3:
You can usually choose a playback display mode that indicates the picture resolution.

You also can view resolution information in the photo software after you download pictures to your computer. For example, here's how to get to the resolution data in the free photo programs provided on Windows-based and Mac computers:

REMEMBER

>> **Windows:** In Windows Live Photo Gallery, click the image thumbnail, click the View tab (at the top of the image window), and click All Details, as shown in Figure 9-4. You then see the filename, the date the picture was taken, the file size (3.72MB in the figure), and the picture resolution (3697 x 2464). These instructions refer to the version of Windows Live Photo Gallery found in Windows 7; the process may be slightly different in other versions of Windows.

Note that the file size value shown here (3.72MB, or megabytes) is not the image resolution, which is stated in mega*pixels*. In this case, the megapixel count is roughly 9.1 megapixels (3697 x 2464 pixels equals about 9.1 million pixels).

>> **Mac:** After launching iPhoto or Photos, track down the image thumbnail and then choose View⇨Info or click the **i** button in Photos or the Info button in iPhoto. You then see a box showing an assortment of picture settings, including the resolution. Figure 9-5 shows the window as it appears in Photos. (In iPhoto, the Info button is at the bottom of the screen instead of at the top.)

File size Picture resolution

FIGURE 9-4:
You can check the pixel count in the Windows Live Photo Gallery.

For pictures stored on your cellphone or tablet, you may be able to pull up resolution data in whatever photo viewer the device's operating system provides. If not, many third-party photo apps enable you to get the image file to disclose its hidden metadata. Of course, if you didn't crop the photo and your phone takes pictures at only one resolution setting, you can just check the phone's camera specs to find out the image resolution.

Click to display image information

Picture resolution

FIGURE 9-5:
In the Mac Photos program, choose the Info from the View menu or click the **i** button icon to inspect the resolution information.

Getting print and monitor colors in sync

Aside from poor picture quality, the number-one printing complaint is that colors on the computer monitor don't match the ones that show up in print. When this problem occurs, most people assume that the printer is to blame, but in fact the most likely culprit is the monitor. If the monitor isn't accurately calibrated, the colors it displays aren't a true reflection of your image colors.

To ensure that the monitor is displaying photos on a neutral canvas, you can start with a software-based *calibration utility,* which is just a small program that guides you through the process of adjusting the monitor. The program displays various color swatches and other graphics and then asks you to provide feedback about what you see on the screen.

TIP

Both the Windows and Mac operating systems offer built-in calibration programs. If you use a Mac, look in the Displays section of the System Preferences dialog; the utility is called Display Calibrator Assistant. Windows 7 and 10 offer a similar tool named Display Color Calibration.

Software-based calibration isn't ideal, however, because people's eyes aren't that reliable in judging color accuracy. For a more accurate calibration, you may want to invest in a device known as a *colorimeter*, which you attach to or hang on your monitor, to accurately measure and calibrate the display. Companies such as Datacolor (`www.spyder.datacolor.com`) and X-Rite (`www.xritephoto.com`) sell this type of product along with other tools for ensuring better color matching. Figure 9-6 shows the X-Rite ColorMunki Smile, for example, which has a suggested retail price of $109. As shown in the image, some products work with both laptop and desktop monitors, and some companies even offer tools designed for calibrating tablets. (Check the product specs to ensure compatibility with your screen and your computer or tablet's operating system.)

FIGURE 9-6: For precise monitor calibration, invest in a colorimeter such as the ColorMunki Display from X-Rite.

Courtesy of X-Rite, Incorporated

TECHNICAL STUFF

Whichever route you go, the calibration process produces a monitor *profile*, which is a data file that tells your computer how to adjust the display to compensate for any monitor color casts. Your Windows or Mac operating system loads this file automatically whenever you start your computer. Your only responsibility is to perform the calibration every month or so, because monitor colors drift over time.

If your monitor *is* calibrated, color-matching problems may be caused by any of these other, secondary issues:

>> **One of the print nozzles or heads is empty or clogged.** Check the manual to find out how to perform the necessary maintenance to keep the nozzles or print heads in good shape.

>> **You chose the wrong paper setting in your printer software.** When you set up the print job, be sure to select the right setting from the paper-type option — glossy, matte, and so on. This setting affects how the printer lays down ink on the paper.

TIP

Some paper manufacturers provide *ICC profiles,* which are small data files that help your printer and computer better translate your image colors to the specific paper you're using. (ICC stands for International Color Consortium, the group that developed the universal color translator on which this system is based.) After you download and install the profiles, you should see the related paper types in the list of options in your printer settings dialog box. If you're using paper made by the printer manufacturer, though, you don't usually have to take this step; the profiles are automatically added when you install the printer software during initial setup.

» **Your printer and photo software are fighting over color-management duties.** Some photo programs offer features that enable the user to control how colors are handled as an image passes from camera to monitor to printer. Most printer software also offers color-management features. The problem is, if you enable color-management controls in both your photo software and your printer software, you can create conflicts that lead to wacky colors.

Unless you're schooled in color management, I recommend letting your printer handle things. However, it's wise to do a few test prints to see whether results are better when you hand the job to your photo software. Check your photo software and printer manuals to find out the color-management options available to you and how to turn them on and off.

REMEMBER

Even if all the aforementioned issues are resolved, however, don't expect perfect color matching between printer and monitor. Printers simply can't reproduce the entire spectrum of colors that a monitor can display. In addition, monitor colors always appear brighter because they are, after all, generated with light.

Finally, be sure to evaluate print colors and monitor colors in the same ambient light — daylight, office light, whatever — because that light source has its own influence on the colors you see. If your prints will be displayed in a gallery, you also should make sure that colors look good in whatever lighting the gallery uses. Ditto for prints you hang in your own home, of course.

Ordering Prints from a Retail Lab

Any outlet that used to offer film developing, from your local drugstore to big-box retailers such as Costco or Walmart, offers quick and easy digital photo printing. The cost varies, but depending on the number of prints you make, you can get 4 x 6-inch prints for as little as ten cents apiece and buy 8 x 10-inch prints for under $3.

You have a variety of options for ordering and picking up your prints:

TIP

>> **Request one-hour printing.** Take in your memory card, leave instructions about your print job, and go run other errands or do your shopping. Come back in an hour and pick up your prints.

If you're worried about a lab losing your memory card, by the way, you usually have the option of copying your pictures to a flash drive and taking it to the photo lab.

>> **Use instant-print kiosks.** In a hurry? You may not even need to wait an hour for those prints. Many stores have kiosks that can print pictures immediately. Again, you just put in your memory card, push a few buttons, and out come your prints. You can even do some retouching, such as cropping and eliminating red-eye, right at the kiosk.

>> **Order online; print locally.** You can send image files via the Internet to most retail photo printers and then specify the store where you want the prints made. Then pick up the prints at your convenience.

This option also makes it easy to get prints to faraway friends and relatives. Rather than have the prints made at your local lab and then mail them off, you can simply upload your files to a lab near the people who want the prints. They can then pick up the prints at that lab. You can either prepay with a credit card or have the person getting the prints pay upon picking them up.

>> **Order online; get prints by mail.** Some brick-and-mortar retailers also offer this option. In addition, you can order prints by mail from online photo-sharing sites such as Snapfish (www.snapfish.com), Shutterfly (www.shutterfly.com), and SmugMug (www.smugmug.com).

Printing Your Own Photos

Even if you have most of your prints made at a retail lab, adding a photo printer to your digital–photography system is still a good investment, for several reasons:

>> When you need only a print or two, it's more convenient to do the job yourself than to send the pictures to a lab.

>> For times when you're feeling artistic, you can print on special media, such as canvas-textured paper. You can even buy iron-on transfer paper, which enables you to add images to T-shirts, pillows, and other material.

One of my favorite printing projects is creating custom greeting cards. Although labs enable you to put your photos on greeting cards, they usually require that you print those cards in large quantities and may only offer a few templates, such as those with a holiday theme. I prefer creating my own so that I can swap out photos and text depending on the occasion. I used the photo and text shown in Figure 9-7 for a get-well card, for example. You can buy pre-folded cards and envelopes designed just for this purpose in any office-supply store.

>> Doing your own printing gives you complete control over the output, which is important to many photo enthusiasts, especially those who exhibit or sell their work.

>> Today's photo printers can produce excellent results. In fact, most people can't tell the difference between prints made at home and those made at a lab.

Hope you're back in the swing of things soon!

FIGURE 9-7:
I printed this used this photo as the basis for a custom-made get-well card.

WARNING

One caveat: Good prints require not only high-resolution photos, as outlined earlier in this chapter, but also good photo paper. You can save a few bucks by purchasing "store brand" paper, but in my experience, name-brand papers perform better. I suggest that you start with paper sold by the manufacturer of your printer because that paper is specifically engineered to work with your printer's inks. The prints you make with that paper can give you a baseline from which you can compare results on other brands.

The next several sections provide more information that will steer you toward a printer offering the features you need.

Choosing a printer type

Cruise the aisles of your favorite office–supply or electronics store, and you'll encounter a few different print technologies, each of which has its pros and cons. The next three sections explain the most common options to help you decide which makes the most sense for the kind of printing you want to do.

Inkjet printers

Inkjet printers work by forcing little drops of ink through nozzles onto the paper. You can find two basic categories of inkjet printers:

>> **General-purpose models:** These printers are engineered to do a decent job on both text and pictures but are sometimes geared more to text and document printing than photos. Today, the vast majority of these models combine a printer with a flatbed scanner (which can also be used as a document copier) and sometimes a fax machine.

>> **Photo printers:** Sometimes referred to as *photocentric* printers, these models are designed with the digital photographer in mind and usually produce better-quality photographic output than all-purpose printers. But they're sometimes not well suited to everyday text printing because the print speed can be slower than on a general-purpose machine. However, many printers do have a foot in both the general-purpose and photo printer camps, offering good results for all printing uses.

Some photo printers offer extra-wide printing capabilities, which is something that fine-art photographers need for printing work they want to exhibit. On the flip side, if you need a portable photo printer, you also can consider products such as the Canon Selphy (www.canon.com, about $100). This model can output prints as large as 4 x 6 inches, has a USB port for connecting a camera or computer, and also has an SD card slot for direct printing from a memory card.

Most inkjet printers enable you to print on plain paper or thicker photographic stock, either with a glossy or matte finish. That flexibility is great because you can print rough drafts and everyday work on plain paper and save the more costly photographic stock for final prints and important projects.

The downside? Although most inkjet printers themselves are inexpensive, *printing* is not necessarily cheap, because the inks they use can be pricey. This give-them-the-razor-sell-the-razor-blades marketing strategy may be changing, though; some manufacturers are going in the opposite direction, charging more for the printer and then making ink less costly.

Some people try to save money by using third-party inks. Although those inks are less expensive, you may notice a reduction in print quality and, worse, invalidate the printer warranty. Before going this route, do an online search to find out what other users of your printer have experienced. Also consider that printer manufacturers spend lots of time and money developing ink formulas that best mesh with their printers' ink delivery systems and with various papers, including those they manufacture and sell themselves. So it makes sense that the media offered by the manufacturer — both inks and papers — should produce optimum results.

Laser printers

TECHNICAL STUFF

Laser printers use a technology similar to that used in photocopiers. You probably don't care to know the details, so here's the general idea: The process involves a laser beam, which produces electric charges on a drum, which rolls toner — the ink, if you will — onto the paper. Heat is applied to the page to permanently affix the toner to the page.

Although laser printers once weren't capable of outputting good-looking prints, that's no longer the case. As long as you feed them high-quality photo paper, laser printers can produce excellent prints. As with inkjet models, you also can print on plain paper when needed, and most laser printers can also accept a wide range of specialty photo printers.

The biggest advantage of a laser printer over an inkjet has nothing to do with photo quality, however. Rather, a laser printer is usually the best choice for large-volume printing and mixed-use printing (prints and documents). It's faster than an inkjet, and although you may pay more up front for a laser printer than for an inkjet, you should save money over time because the price of toner is usually lower than for inkjet ink. In addition, many laser printers have features geared to business use, such as networking capabilities, large paper bins, document-collating tools, and the like.

Dye-sub printers

Dye-sub is short for *dye sublimation,* a totally different printing technology than inkjet or laser printing. With dye-sub printers, you don't install any ink or toner cartridges; instead, you install paper coated with heat-reactive dye. When you print a picture, the printer heats the paper, causing the reaction that produces your photo. (You may hear these types of printers referred to as *thermal dye* machines — *thermal* equals *heat.*) Usually, a glossy protective coating is applied to the print to help preserve its colors.

At present, this technology is used mainly in compact, carry-along models designed for outputting photo prints that are snapshot-size or smaller. These printers can be great fun at parties or, for business purposes, for printing ID photos to use on visitor badges and the like. Just keep in mind that you can't print on standard paper; you can only use the dye/paper sheets specially made for your specific printer. Expect to pay about 50 cents per print.

If you're in the market for this type of printer, be sure to find out how you send picture files to the printer for output. Depending on the printer, you may be limited to printing only from a cellphone or another smart device on which you can install the manufacturer's printing app.

Looking at other printer features

After you narrow down what type and size of printer you need, a few additional shopping tips can help you pick the right product:

>> **Don't worry too much about the specification known as *dpi*.** This abbreviation stands for *dots per inch* and refers to the number of dots of color the printer can create per linear inch. A higher dpi means a smaller printer dot, and the smaller the dot, the harder it is for the human eye to notice that the image is made up of dots. In theory, a higher dpi should mean better-looking images, but frankly, just about any printer you buy today offers enough resolution to output good prints.

Don't confuse *dip* with *ppi,* even though many printer manufacturers (and online "experts") use the two terms interchangeably. Ppi measures the resolution of the digital photo file (*ppi* stands for pixels per inch). Many printers use multiple dots to reproduce one image pixel.

>> **For inkjets, look for a model that uses four or more colors.** Most inkjets print using four colors: cyan, magenta, yellow, and black. This ink combination is known as CMYK. (See the sidebar "The separate world of CMYK," later in this chapter.) But some lower-end inkjets eliminate the black ink and combine cyan, magenta, and yellow to approximate black. *Approximate* is the key word — you don't get good, solid blacks without that black ink, so for best color quality, avoid 3-color printers.

Some high-end photo inkjets feature six or more ink colors, adding lighter shades of the primary colors or several shades of gray to the standard CMYK mix. The extra inks expand the range of colors that the printer can manufacture, resulting in more accurate color rendition, but add to the print cost.

>> **If you're a black-and-white photo fan, look into printers that offer special ink combinations designed for that purpose.** Such printers often have two or more black or gray cartridges, for example, to better render all the tones in a black-and-white image. However, before you invest in this type of printer, compare the price of the printer (and ink and paper) with the cost of having the job done at a lab. You may find that you can get better results, for less money, by having a pro lab output your black-and-white prints.

>> **Inkjets that use separate cartridges for each color save you money.** On models that have only one cartridge for all inks, you usually end up throwing away some ink because one color often becomes depleted before the others. With multiple ink cartridges, you just replace the ones that are running out.

>> **Compare print speeds if you're a frequent printer.** If you use your printer for business purposes and you print a lot of images, be sure that the printer you pick can output images at a decent speed. And be sure to find out the

per-page print speed for printing at the printer's *highest-quality* setting. Most manufacturers list print speeds for the lowest-quality or draft-mode printing. When you see claims like "Prints at speeds *up to . . . ,*" you know you're seeing the speed for the lowest-quality print setting.

≫ Computer-free printing options give you extra flexibility. Some printers can print directly from camera memory cards — no computer required. Several technologies enable this feature:

- *Built-in memory card slots:* You insert the memory card, use the printer's control panel to set up the print job, and press the Print button. Be sure that the printer offers card slots that are compatible with the type of memory card you use, though.

- *PictBridge:* This feature enables you to hook up your camera to your printer via USB cable for direct printing. (Both the camera and the printer must offer PictBridge capabilities.)

- *DPOF:* This acronym, pronounced "dee-poff," stands for *digital print order format* and enables you to select the images you want to print via your camera's user interface. The camera records your instructions on the memory card. Then, if you use a printer that has memory card slots, you put the card into a slot, and the printer reads and outputs the "print order." Again, both the camera and the printer must offer DPOF technology.

- *Wireless connections:* Manufacturers are offering a number of Wi-Fi and Bluetooth-enabled printers, too. If you use a camera or memory card that offers wireless connectivity, you can send your pictures from the camera to the printer wirelessly.

Of course, direct printing takes away your chance to edit your pictures; you may be able to use camera or printer settings to make minor changes, such as rotate the image, brighten the picture, or apply a prefab frame design, but that's all. Direct printing is great on occasions where print immediacy is more important than image perfection, however. For example, a real estate agent taking a client for a site visit can shoot pictures of the house and output prints in a flash so that the client can take pictures home that day.

≫ Research independent sources for cost-per-print information. Consumer magazines and computer publications often publish articles that compare current printer models based on cost per print. Some printers use more expensive inks than others, so if you're having trouble deciding between several similar models, this information could help you make the call. Note that some printer ads and brochures also state a cost per print, but the numbers you see are approximations at best and are calculated in a fashion designed to make the use costs appear as low as possible. As they say in the car ads, your mileage may vary.

> » **Read reviews and blog comments for other input, too.** Once again, it pays to check out reviews in magazines and online sites to find detailed reviews about print quality and other printer features. You also can get lots of good real-world information by searching out blogs and user forums where people discuss their experiences with models you're considering.

TECHNICAL STUFF

THE SEPARATE WORLD OF CMYK

Your digital camera produces *RGB* images, which are created by mixing red, green, and blue light. Scanners, monitors, and other screen devices also use RGB color technology. But professional printing presses and most, but not all, consumer printers create images by mixing four colors of ink — cyan, magenta, yellow, and black. Pictures created using these four colors are called *CMYK* images. (The *K* is used instead of *B* because black is called the *key* color in CMYK printing.)

You may be wondering why four primary colors are needed to produce colors in a printed image while only three are needed for RGB images. (Okay, you're probably not wondering that at all, but go with it, will you?) The answer is that unlike light, inks are impure. Black is needed to help ensure that black portions of an image are truly black, not a muddy gray, as well as to account for slight color variations between inks produced by different vendors.

What does all this CMYK stuff mean to you? First, if you're shopping for an inkjet printer, be aware that some models print using only three inks, leaving out the black. Color rendition is usually worse on models that omit the black ink.

Second, if you're sending an image to a commercial service bureau for professional printing, you may need to convert the image to the CMYK color mode and create *color separations.* Four color channels (digital vats of color data) comprise CMYK images — one channel each for the cyan, magenta, yellow, and black image information. Color separations are nothing more than grayscale printouts of each color channel. During the printing process, your printer combines the separations to create the full-color image. If you're not comfortable doing the CMYK conversion and color separations yourself or your image-editing software doesn't offer this capability, your service bureau or printer can do the job for you. Be sure to ask the service rep whether you should provide RGB or CMYK images, because some printers require RGB. In fact, fewer and fewer labs are tailored to CMYK these days.

Don't convert your images to CMYK for printing on your own printer, however, because consumer printers are engineered to work with RGB image data. And no matter whether you're printing your own images or having them commercially reproduced, remember

that CMYK has a smaller *gamut* than RGB, which is a fancy way of saying that you can't reproduce with inks all the colors you can create with RGB. CMYK can't handle the truly vibrant, neon colors you see on your computer monitor, for example, which is why images tend to look a little duller after conversion to CMYK and why your printed images don't always match their onscreen images.

One more note about CMYK: If you're shopping for a new inkjet printer, you may see a few models described as CcMmYK or CcMmYKk printers. Those lowercase letters indicate that the printer offers a light cyan, magenta, or black ink, respectively, in addition to the traditional cyan, magenta, and black cartridges. As mentioned earlier, the added inksets are provided to expand the range of colors that the printer can produce.

Protecting Your Prints

TIP

No matter what the type of print, you can help keep its colors bright and true by following a few storage and display guidelines:

>> **Use archival framing practices.** If you're framing the photo, mount it behind a matte to prevent the print from touching the glass. Be sure to use acidfree, archival matte board and UV-protective glass.

Also, don't adhere prints to a matte board or another surface using masking tape, Scotch tape, or other household products. Instead, use acidfree mounting materials, sold in art-supply stores and some craft stores. Don't write on the back of the print with anything except a pen made for printing on photographs.

>> **Avoid exposing the picture to strong sunlight or fluorescent light for long periods.** For greater protection, ask the picture framer to use museum-quality glass that's designed to minimize light degradation.

>> **In photo albums, slip pictures inside acidfree, archival sleeves.** If your closet holds photo albums from years gone by, get those prints into newer, archival albums ASAP. Some of your prints may already be discolored by the plastic that was once used in photo albums, but you can at least prevent further damage. Many albums from my college era (nope, not telling you the dates) used clingy plastic that actually wound up permanently stuck to the photos. Use caution when removing your prints from old albums, or else you could tear them. (Of course, we all have our old film negatives, so we could produce a new print if needed. Oh, who am I kidding? I'm a photographer and even I don't have any idea where all my negatives reside or even whether they still exist.)

PUBLISHING YOUR OWN COFFEE-TABLE BOOK

Ever seen a coffee-table–style book of photographs from a wedding? It used to be that you had to print copies of the best photos from a wedding or similar event and then insert them into a leather- or linen-bound fancy book to keep as a high-quality showpiece.

Today, you can do the same thing online by uploading your favorite photos from virtually any event or collection and have them printed in a beautiful book. You can have anywhere from a few photos to several hundred in a single book and, as an added bonus, you can even create "virtual" copies of the book for sharing online, complete with music.

Many companies offer photo printing into books of all sizes and styles, including

- **Shutterfly** (www.shutterfly.com)
- **Snapfish** (www.snapfish.com)
- **Blurb** (www.blurb.com)
- **MyPublisher** (www.mypublisher.com)

You simply create an online account, decide on a design, upload your photos, and then use the various templates and layouts provided to create your book. Many photo-editing programs also have book-building templates and links to connect you with various book printers.

>> **Limit exposure to humidity, wide temperature swings, cigarette smoke, and other airborne pollutants.** All can also contribute to image degradation. Although the refrigerator door is a popular spot to hang favorite photos, it's probably the worst location in terms of print longevity. Unless protected by a frame, the photo paper soaks up all the grease and dirt from your kitchen, not to mention jelly-smudged fingerprints and other telltale signs left when people open and close the door.

Preparing Pictures for Online Sharing

Getting your digital photos ready for online use, whether you want to use them on your own web page, post them on a social media site, or send them via email, involves two tasks. Make sure that

>> **The picture resolution is appropriate for onscreen use.** In all likelihood, your digital-camera originals are too big and need to be resized. Chapter 4 provides the technical reasons why this is so, if you're interested.

>> **The file is in the JPEG format.** It's the only one guaranteed to be compatible with all web browsers, email programs, and other screen-viewing programs and apps.

Some cameras have built-in tools for making low-resolution copies of either JPEG or Raw originals. Or, if you prefer, you can do the job after downloading photos to your computer, using whatever program you typically rely on to edit images.

I don't have room to provide you with detailed instructions for either task, because the steps vary greatly depending on which tool you use. But the next two sections offer some general guidelines.

Sizing photos for screen display

How many times have you received an email message that looks like the one in Figure 9-8? Some well-meaning friend or relative sent you a digital photo that's so large you can't view the whole thing on your monitor. (Again, Chapter 4 explains why high-resolution photos take up so much screen space.)

FIGURE 9-8:
The attached image has too many pixels to be viewed without scrolling.

Fortunately, the latest email programs have tools that automatically adjust the display of large images to make them viewable. Even so, that doesn't change the fact that sending someone a mega-resolution picture means that you're sending them a very large file, and large files mean longer downloading times and, if recipients choose to hold on to the picture, a big storage hit on their hard drives.

Sending a high-resolution photo *is* the thing to do if you want the recipient to be able to generate a good print. But for simple email sharing, I suggest limiting photos to about 800 pixels on the longest edge. This limit ensures that people who use an email program that doesn't offer the latest photo-viewing tools can see your entire picture without scrolling, as in Figure 9-9.

FIGURE 9-9:
At 720 x 480 pixels, the entire photo is visible even when the email window consumes some of the screen real estate.

The same sizing usually works well for Facebook and other social media sites, but check the site's image restrictions before you post. If the picture will be used on a business website, the web administrator or designer should be able to tell you the size guidelines to follow.

Saving files in the JPEG format

In addition to paying attention to file size, you need to be sure that your files are in the JPEG file format, which is the only format that's sure to be viewable in all web browsers and email programs.

What about PNG (pronounced "ping") and GIF, the other two online formats you may encounter? Well, PNG is a less-common image standard on the web, so I don't recommend that option. And GIF files can contain only 256 colors, so photos appear splotchy when saved to this format, as illustrated by Figure 9-10. GIF is designed for logos and other simple graphics that contain only a few colors.

People argue about whether to say "jiff," as in "jiffy," or "gif," with a hard *g*. I go with "jiff" because our research turned up evidence that the creators of the format intended that pronunciation, but it doesn't matter how you say GIF as long as you remember not to use it for your web photos.

TECHNICAL STUFF

FIGURE 9-10: For better-looking web photos, use the JPEG file format (top). GIF images can contain only 256 colors, which can leave photos looking splotchy (bottom).

To avoid some potential confusion when you take the step of saving your JPEG files, here's advice about a couple of options you may encounter:

» **Quality:** When you save a file in the JPEG format from inside a photo-editing program, you usually see an option named Quality. In some cases, you may find this feature instead provided within the overall program-preferences settings; in that case, the program uses the same setting for all files you save in the JPEG format.

Either way, the Quality option relates to the how the JPEG format achieves its smaller file sizes, which is to remove some of the original picture data from the file — a process known as *lossy compression.* A higher Quality setting results in less lossy compression, which translates to a better-looking image but a larger file size. As you lower the Quality setting, more data is tossed, the file size shrinks, and the image quality is further degraded.

The good news is that if you first reduce the resolution of your photos, taking the pixel count down to a size appropriate for online use, your files shouldn't be too large for most online uses even if you select the highest Quality setting

(least amount of compression). Remember that with onscreen images, pixel count only changes the size of the display, not the quality, whereas the amount of JPEG compression *does* affect picture quality. See Chapter 4 for more on this issue.

» **Progressive:** When you save a picture in the JPEG format inside a photo editor, you usually encounter an option that enables you to specify whether you want to create a *progressive* image. This feature determines how the picture loads on a web page. With a progressive JPEG, a faint representation of the image appears as soon as the initial image data makes its way through the viewer's modem. As more and more image data is received, the picture details are filled in bit by bit. With *nonprogressive* images, no part of the image appears until all image data is received.

Progressive images create the *perception* that the image is being loaded faster because the viewer has something to look at sooner. This type of photo also enables website visitors to decide more quickly whether the image is of interest to them and, if not, to move on before the image download is complete. However, progressive images take longer to download fully, and some web browsers don't handle them well. In addition, progressive JPEGs require more RAM (system memory) to view. For these reasons, most web design experts recommend that you don't use progressive images on web pages.

WARNING

» **File naming:** If you're saving a low-resolution copy of a JPEG original, *be sure* to give the copy a name that's different from the original. Otherwise, the full-resolution version will be overwritten by the smaller file. You may even want to save your screen-size images in a separate folder so that you can track them down more easily when it's time to upload them to their final online destination.

Viewing Photos on a TV

Want to share your photos with a group of people? You may be able to display those photos on your TV, which is a great alternative to passing around your camera or having everyone huddle around your computer monitor. You can get those photos up on the big screen in a number of ways:

» **Memory card slots:** Some TVs, DVD players, and other media hubs you may attach to your TV have slots that accept the most popular types of camera memory cards. You can then just pop the card out of the camera and into the slot. Keep in mind that most of these devices can display JPEG files only.

>> **HDMI or A/V connection:** If your camera has a video-out port, you can connect it with a cable to the video-in port on your TV (or DVD player or whatever). For example, Figure 9-11 shows a camera connected via an HDMI cable to an HDTV. After you connect the two devices and turn on the camera, you can navigate through your pictures using the camera's own playback controls. You may even be able to use your HDTV remote control to activate certain playback features. (This option requires that both the camera and remote offer a technology named HDMI-CEC.)

FIGURE 9-11: You can connect some cameras to a TV for picture playback.

REMEMBER

Most digital cameras sold in North America output video in NTSC format, which is the video format used by televisions in North America. You can't display NTSC images on televisions in Europe and other countries that use the PAL format instead of NTSC. So if you're an international business mogul needing to display your images abroad, you may not be able to do it using your camera's video-out feature. Some newer cameras do provide you with the choice of NTSC or PAL formats.

>> **USB connection:** A few TV and video devices even have a USB port. This enables you to connect your camera for picture playback or hook the TV to your computer and access pictures stored on the hard drive (or another computer storage device).

>> **Wireless or Internet connection:** If both your camera and TV offer wireless connectivity, you can link the two devices that way. As an alternative, if your TV offers Internet connectivity, you can upload your photos to an online storage site and then log in to that site on your TV. (Check the TV manual to find out what apps or other software tools you may need to use; some TVs can link to Facebook, for example, or to a certain photo-sharing site).

>> **DVD playback:** If you can't get your pictures onto the TV via any of these routes, you can always create a video DVD of your pictures; many photo programs and slide-show programs offer tools to help you do this. Then you can just pop the DVD into your DVD player for playback. (Check your DVD player's manual to find out the format of DVD recordings it accepts, and make sure that you burn the DVD using that specification.)

For all these viewing options, you need to track down the manual for your television, DVD player, or whatever device you're using to get the pictures to the screen to find specifics on how to proceed from here. You may need to set the device's input signal to a special auxiliary input mode or use certain buttons on the remote controls to initiate and control picture playback.

TIP

With some cameras, you can use the same connection for *tethered shooting*, which simply means that the big-screen TV (or monitor) serves as your camera monitor while you shoot. If the monitor is connected to a computer, you can even have your files immediately downloaded to the computer's hard drive for storage. This setup is one that many pros use in a studio because it enables them (and their clients) to get a nice, large view of each image right after it's taken and make adjustments to lighting, poses, and so on, if necessary. With some cameras, you can choose to view everything on both the camera monitor and the large-screen display.

The Part of Tens

Discover all sorts of accessories that can make your photography easier or just plain more fun, from tripods to special-effects apps for your smartphone or tablet.

Got a problem photo? Maybe one that's overexposed, out of focus, too red or too blue, or (yikes) all of the above? Look here for easy solutions to the most common picture-taking pitfalls.

Find out how to protect your camera and other gear from damage — and what to do in the event that even your best efforts in that area aren't enough.

Chapter 10

Ten Accessories to Enhance Your Photography

D o you remember your first Barbie doll or — if you're a guy who refuses to admit playing with a girl's toy — your first G.I. Joe? In and of themselves, the dolls were entertaining enough, especially if the adult who ruled your household didn't get too upset when you shaved Barbie's head and took G.I. Joe for

a spin in the garbage disposal. But Barbie and Joe were even more fun if you could talk someone into buying you some accessories, like a Ken doll or, even better, that awesome baby blue Barbie convertible.

Similarly, you can enhance your digital photography experience by adding a few of the hardware and software accessories described in this chapter. They may not bring quite the same rush as a Barbie penthouse or a G.I. Joe surface-to-air missile, but they greatly expand your creative options and make some aspects of digital photography easier.

Note: For more information on the products in this chapter, including current prices, visit the manufacturer's website. Understand that this chapter is by no means an exhaustive list of the good products in any category; browse your local camera store, your favorite photography magazine, or online forum to discover other options.

Invest In a Good Camera Bag

Perhaps the most important accessory you can buy is a camera bag to protect your equipment. Luckily, you have many good options, with manufacturers including Tenba, Lowepro, Think Tank Photo, Tamrac, and Pelican offering products designed for all types of cameras and photographers. Prices start at about $15 and go into the hundreds, depending on the size and type of bag.

With all the choices available, in fact, you can drive yourself crazy trying to find the perfect do-it-all bag. Don't. It doesn't exist. Instead, start with a bag that will work for your daily photography outings, maybe just big enough to hold your camera and a single lens. Then add to your bag collection if you invest in more gear or your needs change. Many bags offer straps or loops that enable you to attach additional equipment pouches or even a tripod so that you can build your own customized and flexible system.

The following list offers some additional shopping tips:

>> **Think about what gear you need the bag to hold.** Some bags are big enough to stow just a small point-and-shoot model, whereas others can hold two dSLR camera bodies, a couple of lenses, a flash, and other equipment. Some bags also provide stowage for a small laptop or tablet.

Don't forget to consider the noncamera gear you need to tote, though. I insist on bags that have at least one outside pocket to hold my car keys and phone, along with an inside, zippered pocket to hold my ID, a few dollars, and most

important, my health-insurance card. That way, I don't have to bring both a purse and a camera bag. Another plus is a bag that has divided compartments with inserts that you can rearrange to accommodate different equipment depending on what you need for that day's shoot.

>> **Choose a solidly constructed bag with sufficient padding.** Check the zippers, straps, and seams of the bag. Do they appear well made and durable? Is there enough cushioning to protect your equipment if you drop the bag? Is the exterior made of material that can stand up to a little rain or a spilled cup of coffee, keeping the contents of the bag dry and safe? If not, and you like other aspects of the bag, you can invest in a water-resistant bag cover. Some larger bags even have this feature built in.

If you need to ship your gear to a remote location or to check it along with your bags at the airport, you can find hard-sided, watertight cases that cushion your gear in customizable foam. (Pelican is the best known brand for this type of case.)

>> **Try several styles of bags.** You can choose from shoulder bags, waist packs, messenger bags (worn slung across your chest), and backpacks. To test out the various styles, take your equipment to the store so that you can load up a bag you're considering. You may find that one design feels less stressful on your back and shoulders than another or makes accessing your equipment easier. Give extra points to a bag that can be worn in a couple different ways. For example, some bags can be carried as either a waist pack or a shoulder bag.

>> **If you need to cart a lot of gear more than a short distance, consider a wheeled bag.** I consider a wheeled bag a must-have item for air travel — my back and neck can no longer endure the strain of carrying all my equipment and other travel necessities from terminal to terminal. But I also use my wheeled bag if I'm taking more than a camera and a flash to a classroom or studio or another destination where I know I'll need to do a bit of walking to get from my car to the shooting location.

The same shopping guidelines you use to assess a wheeled suitcase apply to wheeled camera bags. If you do a lot of air travel, make sure that your bag meets the airline's carry-on size restrictions — you don't want to have to gate-check your equipment. Also put the bag's handle and wheels through their paces, making sure that the handle rises to a comfortable height and that it and the wheels operate smoothly and seem sturdy.

>> **If you go with a backpack, choose a style that makes it difficult for thieves to steal your gear** — but easy for you to access it. When you're navigating a crowded bus or street, a skilled thief can open a pocket on the back of a backpack and snag your gear without you even knowing you're being robbed. So look for a backpack that opens on the side that faces your back or

your side. Another plus is a model that enables you to flip the pack around for quick access to your gear so that you don't have to take off the backpack every time you encounter an interesting subject.

Finally, keep in mind that you don't necessarily have to buy a bag expressly designed for photography — when I'm traveling on small regional jets, I use a tiny, wheeled backpack that I picked up for about $20 at a discount store. It's just large enough to hold my laptop and camera but still fits in a tiny overhead bin. As an added bonus, it escapes the notice of would-be thieves because it doesn't look like a camera bag. I pack an empty camera bag in my checked luggage so that I'll be able to use the bag at my destination.

Steady Your Camera with a Tripod

For nighttime shots and other photos that require long exposure times, keeping your camera steady is essential. Otherwise, you run the risk of camera shake during the exposure, which can cause blurry photos.

Here's a look at some of the devices you can use any time you want to be sure that your camera remains absolutely still:

>> **Traditional tripods:** You can spend a little or a lot on a tripod, with models available for anywhere from $20 to several hundred dollars. How much you care to spend is up to you, but be sure to check the specs of a model you're considering to find out how much weight it can support. But don't trust the specs blindly: Take your camera and largest lens with you when shopping so that you can test the tripod. Set the tripod at its maximum height, push down on the top camera platform, and try turning the tripod head as though it were a doorknob. If the tripod twists easily or the legs begin to collapse, look for a different model.

With higher-end tripods, you buy the base separately from the head (the part that attaches to the bottom of the camera). This setup gives you a little more flexibility in buying the components you like best. Other features to consider are a *quick-release plate,* which enables you to easily mount and dismount the camera, the shortest and tallest heights to which you can extend the tripod legs, the ease with which you can make those leg adjustments, and whether you can adjust the angle of each leg independently of the others. This last issue can be important when you need to set up the tripod on an uneven surface and so need one leg to be longer and at a different angle than the others.

TIP

>> **Small solutions:** A great option for times when you don't want to carry around a full-size tripod is a product like the Joby GorillaPod (www.joby.com). Made of stiff but flexible gripping legs, it can stand as a short tripod or wrap around something and hold on — such as a tree, as shown in Figure 10-1. The GorillaPod comes in a variety of sizes, shapes, and colors for all types of cameras.

FIGURE 10-1: The Joby GorillaPod lets you mount a camera nearly anywhere.

Courtesy of Joby, Inc.

>> **Monopods:** A *monopod* is a collapsible stick that lets you hold your camera steady but doesn't stand on its own. You frequently see sports photographers at football games traipsing around the sidelines with a big camera, a big lens, and a monopod. If you get tired of holding your camera, whatever its size, monopods are useful and easy to tote around. However, for nighttime photography or other instances where you want to use a slow shutter speed, a monopod doesn't offer quite the same protection against camera shake as a regular tripod.

>> **Hybrids:** Some innovative tripod/monopod hybrids exist; they look like monopods, but you can pop out three mini legs for extra stability.

Figure 10-2 gives you a look at a model from Benro (www.benrousa.com). This hybrid comes as a kit that consists of the monopod, a rotating head, and the three-leg stand. Even with the feet, though, a hybrid model isn't as stable as a standard tripod, so don't stand too far from your camera if there is a strong wind blowing.

TIP

At present, full-size tripods and monopods made of carbon fiber offer the most strength at the lightest weight. You'll pay more for carbon fiber, so you have to decide whether the difference in weight is worth the money. For me, it's a no-brainer, but I'm weary of toting around tripods and other camera equipment.

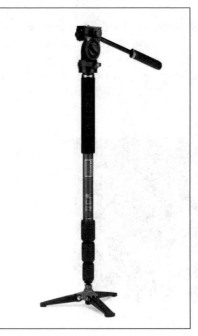

FIGURE 10-2:
Some mono-
pods have small,
pop-out feet to
provide extra
stability.

Courtesy of Benro

Find a More Comfortable Camera Strap

If you find the strap that came with your camera to be a pain in the neck — literally — take a look at some of these alternatives:

» **BlackRapid straps:** BlackRapid makes a line of straps that screw into the tripod mount on the bottom of a camera instead of attaching to the rings found on the sides of most cameras. You wear the strap like a cross-body purse or messenger bag, so that the strap crosses your chest, and the camera hangs at your hip. This design takes some of the strain off your neck. When you're ready to shoot, you can immediately bring the camera up to your eye.

» **Cotton Carrier Vest:** Slip on this vest-like contraption to carry the weight of the camera on your chest, as shown on the left in Figure 10-3. Or, if you regularly like to carry two camera bodies, the company offers a version that accommodates that need. Built-in and optional accessories enable you to carry additional gear, including a small umbrella.

» **Spider Pro Holster:** Shown on the right in Figure 10-3, this product is designed for carrying the weight of the camera on your hip, with no weight on your neck or shoulders. You can buy add-on tools that allow you to attach other bits of equipment, such as a lens pouch.

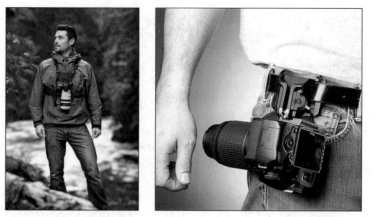

FIGURE 10-3: The Cotton Carrier (left) and Spider Pro Holster (right) offer two alternative options to the traditional camera strap.

Courtesy of Cotton Carrier, LTD

Courtesy of Shai Gear LLC

The product photos shown here feature dSLR cameras, but you can find variations of the same concepts for all sizes of cameras. Also, several manufacturers other than the ones mentioned make these types of products, so shop around.

Get a Better View of Your Monitor

No matter how good a camera's monitor, it can be difficult to see the displayed image in bright light. You can solve this problem in a couple ways: Attach a monitor shade, such as the one shown on the left in Figure 10-4, which is sold by Delkin Devices (`www.delkindevices.com`), or a product such as the HoodLoupe (`www.HoodmanUSA.com`), shown on the right. The shade featured here adheres to the back of the camera with a special mounting adhesive and offers extra monitor protection when closed. Loupe-style viewers are usually not affixed to the camera; instead, you can wear them on a lanyard around your neck until you need to view a picture.

FIGURE 10-4: To make it easier to see your monitor in bright light, consider a monitor shade or loupe.

Courtesy of Delkin Devices

Courtesy of Hoodman USA

Take Advantage of Remote Operation

Being able to trigger your camera's shutter button via remote control comes in handy for a number of purposes. Perhaps the most important benefit is eliminating the possibility of camera shake when you use a very slow shutter speed or a lens with a long focal length (telephoto lens). Even if you have your camera mounted on a tripod — which is vital for long-exposure images — the gentlest push on the shutter button can cause enough camera shake to blur the image. Triggering the shutter with the remote control eliminates this possibility.

It's also handy to have a remote shutter release when you want to include yourself in a group shot. Sure, most cameras have a self-timer mode that you can use to delay the shutter release for a few seconds after you press the shutter button, but it seems that there's never enough time to run into the frame, wedge yourself into the group, suck in your gut, and work up a smile before the shot is taken. With a remote, you can wait until you're settled to take the picture.

Your remote-control options depend on your camera. Some cameras have a jack into which you can plug a wired remote, some have sensors that pick up a signal from a wireless remote, and some models offer both options. If your camera offers Wi-Fi communication, you may also be able to use your smartphone as a remote control. You need to download the manufacturer's app to enable the device to talk to the camera. (Check your camera manual to find out where you can grab the app; usually, Apple users are directed to the App Store, and Android users, to Google Play.)

Consider a Few Lens Filters

Lens filters screw onto the camera lens or can be attached via an adapter. To find out whether your lens can accommodate a filter — and to find out what diameter filter to buy — check the camera or lens manual. With most lenses, the diameter is usually printed somewhere on the lens. (The size is stated in millimeters.)

Some filters create special effects and so aren't everyday tools, but the following filters can come in handy on a more regular basis:

>> **Ultraviolet (UV) filter:** A UV filter is a clear filter designed to block UV light rays, which can cause a blue tint to photos. With digital cameras, automatic white balancing usually takes care of that problem, so the main reason to attach a UV filter to your digital model is to protect the lens from breaking if you happen to knock it into something.

However, a cheap UV filter can lower image quality, and it makes little sense to spend a lot of money on a good lens and then slap a poorly made piece of glass on top of it. If you do put on a UV filter, make sure that it's of high quality.

» **Polarizing filter:** A polarizing filter cuts glare from light rays that bounce off reflective objects, such as water and glass. It's sort of like putting a pair of polarized sunglasses on the lens. With landscape shots, polarizers can also produce bluer, more dramatic skies and reduce haze. You can see an example of a picture taken with and without a polarizer in Figure 10-5.

Without polarizing filter

With polarizing filter

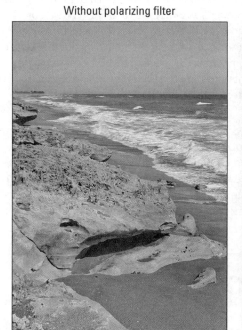 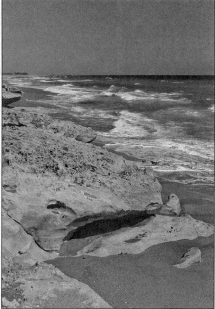

FIGURE 10-5:
A polarizing filter cuts glare from light rays bouncing off water and other reflective surfaces.

It's important to understand, though, that in order to achieve the polarizing effect, you must have the sun at one shoulder, and your subject must be at a 90-degree angle to the lens. At other angles, you won't see any difference except a slight reduction in the amount of light coming through the lens. Neither should you use a polarizer if you like the look of specular highlights dancing on water — the polarizer will eliminate them. Keep in mind, too, that the filter cuts the amount of light coming through the lens, so you have to use a slower shutter speed, larger aperture, or higher ISO to expose the photo. (Chapter 5 explains these exposure terms.)

The other thing to know is to look for a *circular* polarizing filter. (Most filters today are circular.) With this type of filter, you turn a ring on the filter to vary the polarizing effect.

>> **Neutral density (ND) filter:** This filter is designed to cut light coming through the lens without affecting picture colors — essentially, it's a gray (neutral) piece of glass. An ND filter is helpful for shooting outside on a very bright day, because it enables you to use a slow shutter speed (to blur a moving object, such as a waterfall) or wide-open aperture (for a blurry background) without overexposing the picture.

>> **Graduated ND filter:** A graduated ND filter is one that is clear on one side. The idea is to enable you to cut the light from a portion of the scene but catch all the light from the rest, as when you're taking a picture of a bright sunset at the beach. Without the filter, you have to expose for the sunset, leaving the beach dark, or expose for the beach, blowing out the sunset. Underwater photographers sometimes use graduated ND filters to balance the exposure of over/under shots — where the top of the image is above water; the lower portion below water.

TIP

For any filter that cuts light, the manufacturer provides information about how many stops of exposure shift you need to make to compensate for that reduced light. A *stop* refers to a change in exposure settings that results in twice as much light hitting the image sensor. (You can also speak of stops in terms of cutting the light in half, but in the case of filters, you need to go the other direction because the filter is eliminating some light.) Again, see Chapter 5 for more about exposure issues.

Download Some Cool Apps

Many cameras offer at least a few built-in tools for making small adjustments to your photos, such as cropping or adding a couple of special effects. But if you have a smartphone or tablet, you can explore a much bigger universe of effects and retouching tools by downloading a few apps. Or a dozen. Or heck, hundreds.

These apps aren't just for playing with pictures you take on your cellphone or tablet, though; you can use them on photos that you take with a standard camera, too. You just have to transfer the image files to your phone or tablet. If your device can accept a memory-card reader, you can transfer files that way. You also can copy files via a wireless NFC connection, assuming that both the camera and your device offer NFC. (See Chapter 8 for information about this technology.) As another option, you can download photos to your computer, upload them to an online storage site, and then download them from the site to your device.

Although I usually do serious photo editing on my desktop computer, I admit to having a lot of fun fooling around with special-effects apps on my phone. (It's a great way to pass the time while waiting at the airport or doctor's office.) Those effects serve a practical purpose, too: Adding a texture or another effect disguises the fact that my cellphone's camera doesn't take the sharpest images.

As an example, the left image in Figure 10-6 shows a photo as it appeared with no adjustment except for some extreme cropping — I couldn't get close to the steeple, so the original included a lot of the church building below. The right side of the figure shows the image after I applied several special-effects filters. The result not only creates a moody scene but also makes the steeple details sharper. (Don't ask me which apps I used or which filters I applied; I just experiment with different apps and filters until I find a look I like, and I don't pay much attention to anything but the final result.)

FIGURE 10-6: My original cellphone photo wasn't that sharp or interesting (left); applying a few special-effects filters added some drama and even made the letters of the clock more readable (right).

If you haven't yet filled your device with apps (don't forget to leave some storage space for photos), here are a few to try. All sell for under $5 — a few are even free — and are available for both Apple iOS and Android devices. Some have versions that work with tablets as well as with phones. Be sure to check the app specification so that it will run under the operating system used by your device.

>> **Instagram:** Most people who haven't lived on a deserted island for the past five years have at least heard of Instagram, a popular site for sharing selfies and other snaps that let people know what you're doing at the moment. But you may not be aware that the free Instagram app makes it easy to snap a photo in the classic square aspect ratio that was once the hallmark of

Instagram photos. You also can do a bit of retouching, add some filter effects, and then post the result to the Instagram site as well as to Facebook and other photo-sharing sites.

>> **Snapseed (Google):** Another great free app, Snapseed enables you to adjust color, exposure, sharpness, and other basic photo characteristics with a surprising amount of precision. You can alter a specific portion of an image by simply tapping it, for example. It also has some effects and borders you can apply.

>> **Handy Photo (ADVA-Soft):** I also like this tool for its useful array of retouching and effects filters. Like Snapseed, it provides ways to select the area you want to retouch. You can even select and move or rotate objects in the photo.

>> **Photoshop Express (Adobe):** If you're an Adobe Photoshop, Photoshop Express, or Lightroom user, you'll be immediately comfortable with the photo-retouching tools found in this app, which offers simplified versions of those tools plus a few effects filters. And you can't beat the price — like Snapseed, this one is free.

>> **Lightroom (Adobe):** A mobile-friendly version of the full-featured Lightroom program, this free app offers its own set of retouching and effects tools. But if you use Lightroom on your main computer, you'll also appreciate tools that enable you to sync your files, so that changes you make on your mobile device can be transferred to your desktop or laptop computer, and vice versa.

>> **Facetune (Lighttricks):** Enhance your skin tones and do other portrait retouching to make yourself look better in your selfies. You can even cover bald spots with digital hair and reshape your face, assuming that you don't plan to meet the people who see your photo in person. On a more practical note, the app also enables you to blur everything but your face, making distracting background objects less intrusive.

Catch Great Light with a Reflector

One of the least expensive but most helpful tools for portrait shooting is a *reflector*, which, as the name implies, you use to throw reflected light onto your subject. And why, you ask, would you want to do *that?* Well, one common reason is to shoot an indoor portrait without using flash, which often produces harsh, unflattering light and red eye. For a softer light, have your subject sit next to a large window so that one side of the face is lit by daylight coming through the window. Then have a friend hold the reflector so that the window light bounces off the reflector and onto the side of the face that's turned away from the window, as illustrated in Figure 10-7. Figure 10-8 shows the final portrait (left) compared with one taken using a built-in flash (right).

FIGURE 10-7:
By using reflected window light, you can shoot a flash-free indoor portrait.

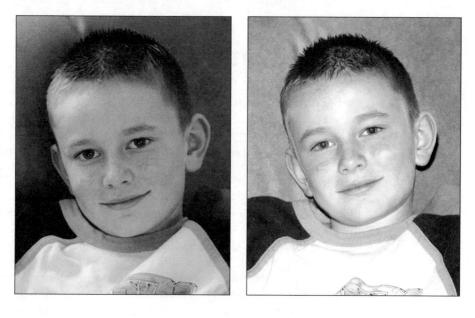

FIGURE 10-8:
I shot the left portrait using window light and a reflector, eliminating the harsh shadows and red-eye caused by shooting with flash (right image).

Reflectors come in many shapes and sizes; the one in Figure 10-7 is a 32-inch, round version that has two sides. One side of this reflector is gold, which adds a nice warm touch to the reflected light; the other side is white for times when you want the bounced light to be the same color as your main light source. You can also find reflectors with a silver panel, which produce a cool (bluish) light, or a black panel, which is handy for creating instant shade when you're shooting in bright sunlight. Most reflectors fold into small carrying cases, making them easy to transport.

TIP

Reflectors aren't just for portrait shooting, though. I also carry a much smaller reflector than the one shown in the figure when I photograph flowers, for example. By placing the reflector at the base of the flower, I can throw a bit of light onto the underside of the petals.

If you have a flash head that rotates, you also can use reflectors with flash light to good effect. Rather than aim the flash at your subject, have someone hold a reflector to one side of the person's face. Then aim the flash at the reflector so that your subject is illuminated by a nice, soft bounced light.

Among the companies known for making good reflectors are Photoflex, Westcott, and Lastolite. Prices range from about $15 to $70, depending on the size of the reflector and how many different reflective surfaces it offers. Some reflectors are of the two-sided variety shown in Figure 10-7, but you also can buy kits that consist of a white reflector and an assortment of covers that change the color and strength (strong or subtle) of the reflected light.

Dive In with a Waterproof Housing

Some cameras, especially point-and-shoot models marketed as "rugged," can survive a quick dunk in a pool or ocean without any ill effect. But if you want to enjoy underwater photography without risking your camera's life, you can buy a waterproof housing designed just for that purpose. Many manufacturers offer housings custom-made for specific camera models, but you can find good third-party solutions as well.

TIP

Be sure that the housing you choose enables you to easily operate the camera — the best products in this category allow you to access all the camera's external controls, not just the shutter button. If you do a lot of underwater photography, you may want to look for a housing that enables you to attach a light (or two) so that you can illuminate your surroundings. Such housings (and the accessory lights) aren't cheap, though; expect to pay hundreds of dollars, at the least. If you're not into underwater photography in a big way, you may want to rent a housing instead. (Two good online rental options are www.BorrowLenses.com and www.LensRentals.com.)

Treat Your Wrist to a Graphics Tablet

A tablet enables you to edit photos using a *stylus* (it resembles a pen without ink) instead of a mouse. If you do a good deal of intricate touch-up work on your pictures or you enjoy digital painting or drawing, you'll wonder what you ever did without a tablet. Wacom, the industry leader in the tablet arena, offers a basic tablet, called the Intuos Photo Pen and Touch, shown in Figure 10-9, which sells for about $100. It comes with a stylus, but you can also simply use your finger on the tablet as you do with a touchpad on a laptop computer. You also get a nice assortment of photo-editing software thrown in for the price.

FIGURE 10-9: Intricate photo-editing tasks become easier when you set aside the mouse in favor of a drawing tablet and stylus like this Wacom model.

Courtesy of Wacom Technology

If you own a touch-enabled tablet or computer, however, you may not need a separate graphics tablet. Instead, you can buy a stylus that provides a similar experience. Some devices, in fact, come with a stylus. However, be aware that not all similar devices have enough computing power to run a serious photo-editing program, and not all programs and apps respond to every type of stylus.

Chapter 11

Ten Fixes for Common Photo Flaws

When you return from a photo outing, don't be discouraged if you like only a handful of images out of the dozens of frames you shot. First, understand that a 100 percent good-to-garbage ratio is unrealistic, especially when you're photographing kids, wildlife, or other unpredictable subjects. Second, most photo-editing programs offer tools you can use to eliminate certain photo flaws — your camera may even have some of those tools built in. This chapter offers help on both counts, providing tips to help you avoid the most common picture problems and explaining how to apply a few basic retouching tools to cover up mistakes after the fact.

Correcting Exposure Problems

When you photograph a subject that's set against a very bright background, you may get a result similar to the one shown on the left in Figure 11-1, where the background looks fine but the subject is underexposed. On the flip side, if the background is much darker than the subject, the subject may be overexposed.

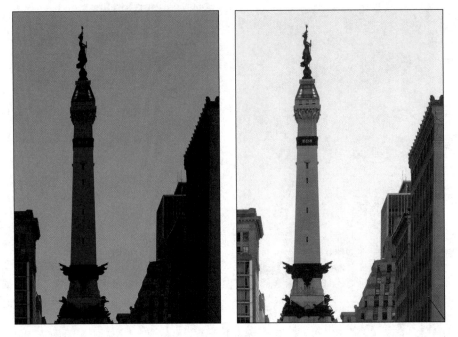

FIGURE 11-1:
For a brighter picture, raise the Exposure Compensation value.

Chapter 5 explains a variety of ways to correct exposure problems, but here are two solutions that are available on most cameras and are easy to implement:

» **Apply Exposure Compensation for an all-over exposure change.** This feature tells the camera's autoexposure system that you want a brighter or darker result on your next shot. Look for a button, menu option, or touchscreen icon that looks like the plus/minus sign in the margin — it's the universal symbol for Exposure Compensation. The default setting is EV 0.0, which applies no adjustment. (EV stands for *exposure value*.) Raise the value for a brighter exposure. I set the value to EV +1.3 to brighten the foreground buildings for the second shot in the figure. Lower the value for a darker exposure.

The drawback to using this feature is that you can't limit the exposure change to only part of the frame. When you apply positive Exposure Compensation in a landscape, the skies may go from a lovely blue to a very pale blue, as in the figure. Some cameras have special shooting modes designed to work around

this problem, such as automatic HDR (high dynamic range) mode, which merges multiple frames in a way that brings too-dark subjects out of the shadows without destroying highlight details. But if your camera doesn't provide such features, don't worry about it. If your subject is well-exposed, that's the best you can do.

>> **To brighten only your subject, try adding flash.** Check the camera manual for details on how to enable flash in bright light; by default, most cameras are set to fire the flash only in dim lighting. Keep in mind that a built-in flash has a pretty limited range — usually about 10 to 15 feet from the camera. A flash will do you no good when shooting a scene like the one in the figure, because the buildings are too far away.

Fixing Focus Flubs

A blurry photograph can be caused by several different problems, each of which requires a different solution. Chapter 6 provides details, but here's a quick recap (or introduction, depending on the order in which you're reading this book):

>> **Mount the camera on a tripod to avoid all-over blurring.** An image that's blurry throughout the whole frame is due to *camera shake* (movement of the camera during the time the picture is being exposed). If you don't have a tripod handy, try raising the shutter speed. A shorter exposure time increases the odds of a shake-free handheld shot because you don't have to hold the camera still as long. Also enable image stabilization, if your camera or lens offers that feature, which is designed to compensate for a little camera shake.

>> **When using autofocusing, specify which part of the frame you want the camera to consider when it sets the focusing distance.** Otherwise, most cameras focus on the object closest to the lens. If your camera doesn't allow you to choose a different focus location, see Chapter 6 for some workaround ideas.

>> **Use a fast shutter speed and continuous autofocusing to capture moving subjects without blur.** How high you need to raise the shutter speed depends on how fast your subject is moving, so experiment to find the right setting. (If you can't control shutter speed on your camera, see whether it offers a Sports scene mode, which is designed to use the fastest shutter speed possible.) Continuous autofocusing tracks moving subjects and adjusts focus as necessary until you take the shot. Check your camera's user manual for help with this option; the specifics on putting it to work vary, depending on the camera.

>> **To make a slightly soft picture look a little more in focus, apply a *sharpening filter* in your photo editor.** This tool creates the illusion of sharper focus by increasing contrast along picture *edges* — that is, the boundaries between light and dark objects. Figure 11-2 shows before-and-after examples of this adjustment.

Some photo-editing programs also have a Clarity filter, which applies the contrast increase only to *midtones* (areas of medium brightness). With either filter, don't go too far or else you'll give the picture a rough texture.

FIGURE 11-2: A slightly soft image (left) can be improved by applying a sharpening filter in your photo editor (right).

Eliminating Distractions

At first glance, the left photo in Figure 11-3 looks like a winner. The exposure is fine, focus is sharp, and my subjects appear happy and relaxed. But on closer inspection, the astute portrait photographer notices two problematic issues: A tree appears to be growing out of the head of the male subject; and the black bag on the woman's shoulder draws the eye away from her face.

In this case, the fix was easy. Before taking the second shot, I asked my friend to put down her bag, and then I moved the pair a few feet to the right of the tree. Sometimes, though, you need to work a little harder to eliminate distracting elements. Look for a camera angle that doesn't include nearby objects, for example. Another option is to shoot with a telephoto lens, which includes less background than a wide-angle lens.

FIGURE 11-3: The tree directly behind the head of my male subject, along with the bag on the woman's shoulder, marred the left portrait; eliminating those distractions produced the better image on the right.

Sometimes, the element that distracts from your subject is not an object per se, but rather the intensity of its color. Such was the case for a color portrait of my nephew and his daughter, taken by my niece-in-law and shown in Figure 11-4. My nephew's bright red shirt draws the eye first, leading attention away from the eyes and smiles of father and baby. Converting the image to black-and-white removes that scene-stealer and makes the faces more prominent, as shown in Figure 11-5.

FIGURE 11-4: In this image, the bright red shirt draws the eye first, spoiling an otherwise gorgeous portrait of father and daughter.

Courtesy of Mandy Holmes

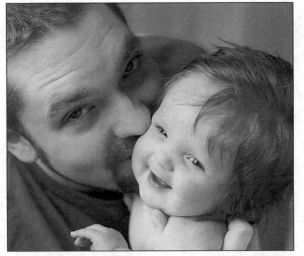

FIGURE 11-5:
A black-and-white rendition of the portrait restores emphasis to the subjects' eyes and smiles.

Courtesy of Mandy Holmes

REMEMBER

Even if you want the final image to be in black-and-white, shooting it in full color is a good idea. The black-and-white shooting modes found on most cameras tend to produce flat, low-contrast images, and you often can get better results by doing your color to black-and-white conversions in a photo editor that enables you to control which areas are emphasized in the black-and-white version.

Softening the Impact of a Busy Background

If you can't eliminate intrusive background objects, you can diminish their impact by using settings that throw the background out of focus — or, in photo terms, settings that produce a *shallow depth of field.* This tactic works because the eye is drawn more strongly to objects that are in focus than to those that are blurry.

The scene shown in Figure 11-6 offers an example. I wanted to photograph the paella pan because I thought the dish so colorful and interesting that it deserved at least a few frames. But with other dinner guests eager to dig in, I didn't have time to completely arrange the background objects to my liking. So, I used the shallowest possible depth of field to blur everything except the pan and its contents. The bread bowl and other dishes add some interest to the background, but because they're blurry, they don't compete with the star of the show.

FIGURE 11-6:
A shallow
depth of field
blurs back-
ground objects,
making them
less visually
intrusive.

You can reduce depth of field in one of three ways:

>> **Select a lower f-stop (aperture) setting.** For example, an aperture setting of f/4 blurs the background more than f/11. If your camera doesn't offer control over aperture, find out whether it provides Portrait mode; that mode automatically chooses a low f-stop value.

>> **Use a longer focal-length lens.** A lens with a focal length of 100mm delivers a shallower depth of field than, say, a 50mm lens. So, if your camera offers a zoom lens, zoom to the longest focal length to achieve the shortest possible depth of field. If you don't have a zoom lens or an interchangeable lens camera, this method of manipulating depth of field is obviously not an option.

>> **Get closer to your subject.** As you decrease the distance between the subject and the lens, depth of field is reduced. But note that every lens has a close-focusing limit; if you get too close, the camera can't focus.

Also remember that the farther you place your subject from the background, the more background blurring you can achieve when putting any of these three strategies to work. See Chapter 6 for more help with manipulating depth of field.

Getting Rid of Lens Distortion

When you photograph buildings and other tall structures, you may discover that vertical structures appear to lean inward or outward from the left and right edges of the frame. You also may notice that structures seem to be leaning toward or falling away from the camera. The left image in Figure 11-7 offers an illustration. The fault here lies not with the photographer, but with the lens. With the exception of very expensive lenses designed for architectural photography, most lenses produce this type of result.

FIGURE 11-7: If your architectural shots display distortion (left), you can straighten things out using a photo editor or in-camera tool.

Courtesy of Kristen E. Holmes

In addition, some lenses create *barrel* distortion, which makes the object at the center of the frame appear larger and closer to the lens than it really is — imagine a face wrapped around the front of a barrel, and you get the idea. The opposite problem, known as *pincushion distortion,* pinches everything toward the center of the frame so that your subject appears smaller and farther from the lens.

When you shop for a new lens, read reviews carefully to find the lens that produces the least amount of distortion in your price range. (Less distortion usually means a higher-priced lens.) In the meantime, try these two inexpensive (and maybe even free) solutions to correct distortion:

>> **Check your camera's menus to find out whether you can enable automatic distortion correction.** Usually, this feature is found only on intermediate and advanced cameras and works best with the camera manufacturer's own lenses.

>> **Look for a lens-correction option in your photo-editing software.** Figure 11-8 shows the process of using the tools found in Adobe Photoshop Lightroom, for example. Understand, though, that these tools work their magic by distorting the original image, tugging the corners this way and that to get structures into proper alignment. The result is a nonrectangular image, with some pixels shifted outside the boundaries of the frame and some

pushed toward the middle of the frame, leaving the edges empty, as in the figure. After you correct the distortion, you can crop the photo to eliminate those empty white borders. For an alternative, you may be able to *scale* the image (enlarge it) so that the new arrangement of pixels fills the frame.

FIGURE 11-8:
Adobe Photoshop Lightroom is one program that enables you to improve a photo that suffers from lens distortion.

WARNING

Both solutions result in the loss of some original image area, although the in-camera lens-distortion filters rarely result in as drastic a change as what you see in Figure 11-8. When shooting this type of image, always include a large margin of background all around the edges of the frame. That way, when you do the distortion correction, critical parts of the subject don't get lost in the process.

Straightening a Tilting Horizon

For reasons I have given up trying to understand, I can never seem to keep my camera level when handholding shots like the one in Figure 11-9. In this case, the horizon line tilts noticeably downward to the right.

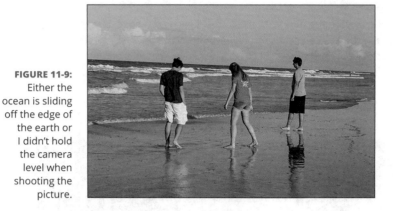

FIGURE 11-9:
Either the
ocean is sliding
off the edge of
the earth or
I didn't hold
the camera
level when
shooting the
picture.

A fail-safe solution is to mount the camera on a tripod that has a built-in level. But here are two other options:

>> **Enable a viewfinder or monitor alignment grid, if available on your camera.** For example, Figure 11-10 offers a look at a viewfinder grid. Check your camera manual to find out whether you have this feature and, if so, how to enable it.

>> **Apply a straighten tool in your photo-editing program.** Even most free programs offer this type of tool. In Windows Live Photo Gallery, shown in Figure 11-11, you simply click the Straighten button, for example, and the program automatically rotates the horizon to a level position. In other programs, you drag the mouse across a line that should be horizontal (or vertical), and the software rotates the image as needed based on that input.

TIP

Cameras that have built-in retouching tools sometimes offer a leveling tool as well. The adjustment is made to *a copy* of the original image so that the original is still available if you don't like the result of the correction.

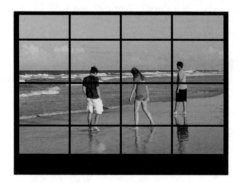

FIGURE 11-10:
Some cameras
enable you to
display a grid
in the view-
finder to help
you frame your
scene so that
the horizon
line is level.

Straighten tool

FIGURE 11-11:
Windows
Live Photo
Gallery offers
a one-click
straightening
tool.

Figure 11-12 shows the corrected seaside scene. Notice that the resulting image contains slightly less image area than the original, which is a necessary outcome of the leveling process, as it is with the distortion corrections described in the preceding section. So again, framing the image a little loosely is a good idea when taking a shot in which the horizon line is prominent.

FIGURE 11-12:
The straight-
ened image
contains
slightly less
image area
than the origi-
nal, which is an
unavoidable
result of the
correction.

Cropping Away Excess Background

To *crop* an image simply means to trim away some of the perimeter of the photo. You may find cropping necessary when you can't get close enough to your subject to fill the frame, for example, or to produce a image that fits a particular frame size.

Some cameras have built-in tools that make a cropped copy of the original photo so that the original is left intact. If your camera doesn't have a crop tool, any photo editor should offer one. You can even find crop tools in most photo apps for phones and tablets. Figure 11-13, for example, shows the crop tool found in Photos, the photo-editing tool found on some iPhones, iPads, and other Mac devices. (Devices running older versions of the Mac operating system instead offer iPhoto, which also has a crop tool.)

Notice the crop tool symbol labeled in the figure; this shape has become the standard crop-tool icon. It's designed to look like the mechanical cropping tools used in film-printing darkrooms, in case you're wondering.

In the digital world, all crop tools operate pretty much the same way: Either the software displays an initial cropping frame, as shown in Figure 11-13, or you drag from one side of the image to the other to create the frame. You then can drag the edges or corners of the frame to adjust the size of the box. You may be able to limit the frame to a particular aspect ratio (4 x 6, 5 x 7, square, and so on). When you execute the crop, all the areas outside the box are clipped away.

Crop tool icon Crop boundary

FIGURE 11-13:
After selecting the crop tool, adjust the boundaries of the crop box to control how much background to eliminate.

WARNING

If you're using an app or a photo editor, save the cropped version of the photo under a new name, to avoid overwriting the original. If the photo also needs correction of lens distortion or a tilting horizon line, make those changes *before* you crop. You want to have all the original pixels available to make both corrections because they result in the loss of some image area.

Quieting Noise

Noise is a digital defect that has the appearance of small grains of sand, as shown in Figure 11-14. Noise can occur for two reasons: A high ISO (light sensitivity) setting and a long exposure time (slow shutter speed).

FIGURE 11-14:
Here's a look at image noise, which can be caused by a high ISO setting, long exposure time, or both.

To lessen the chances of noise, then, shoot with the lowest ISO setting and the fastest shutter speed that enable you to expose the picture given the lighting conditions and the aperture (f-stop setting) you want to use. Of course, sometimes you need a long exposure in order to create motion blur effects — for example, to make the water in a waterfall appear misty. (Chapter 5 explains the fundamentals you need to know to understand ISO, aperture, and shutter speed.)

If you notice a problematic level of noise in your pictures, find out whether your camera offers built-in noise removal filters. Most intermediate and advanced cameras offer one filter aimed at softening the type of noise attributed to a high ISO setting and another geared to reducing long-exposure noise. You also can find noise-reducing filters in many photo-editing programs.

Be aware, too, that with some new cameras designed to provide noise-free, high ISO shooting — an awesome development for photographers who need to shoot in dimly lit environments — noise actually occurs more at the low end of the ISO scale. If you're in the market for a camera that specializes in low-light photography, read reviews to find out how it performs at both high and low ISO settings.

Solving Color Miscues

When image colors are off base, the most common cause is an incorrect White Balance setting. If your camera is set to the Auto White Balance (AWB) setting, try changing to one of the other options. You usually can choose from a variety of settings that are geared to specific light sources — incandescent, sunlight, cloudy, flash, or fluorescent, for example. (With fluorescent, you may even be able

to specify which type of bulb in the lights.) Choose the setting that matches the most prominent light source.

It's best to check the White Balance setting before every shoot. Otherwise, you may wind up with extremely out-of-whack hues. If the camera is set to the Incandescent White Balance setting, for example, and you shoot a picture in bright sunlight, the result is a strong blue tint, as shown on the left in Figure 11-15. The blue tint occurs because the camera adds some blue to compensate for the warm light that incandescent bulbs emit, but midday sun is actually fairly neutral in color. For this image, changing the setting to the Sunny setting fixed things, as shown on the right.

FIGURE 11-15:
The strong blue cast is an indication of an incorrect White Balance setting (left); switching the camera to Auto mode (AWB) solved the problem (right).

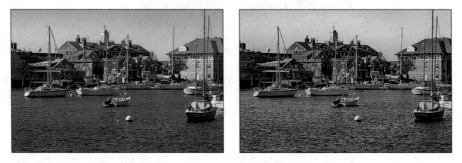

With many cameras, the Auto setting works quite well except when your subject is lit by multiple light sources, each adding its own color cast to the scene. But the reliability of automatic white-balancing systems varies from camera to camera, so take some test shots to find out how well your camera performs this function. You may find that you can leave the camera in AWB mode much of the time, or you may decide that you need to step in and provide an assist by selecting a specific setting. See Chapter 6 for more information about White Balance features and other color-related matters. Chapter 9 provides some tips to help you get the colors you see on your computer monitor to better match those in your photo prints.

Avoiding Weird Halos

Figure 11-16 displays a defect that I see more and more these days: Large halos of white along the borders between light and dark areas of the photo —in this case, the areas where the palm fronds meet the sky.

FIGURE 11-16:
The white halos around the palm branches are the result of applying an excessive amount of shadow recovery to the photo.

These halos sometimes occur when you use *shadow recovery* tools, which lighten the darkest areas of your photos without also making highlights brighter. Haloing can also be a side-effect of applying HDR (high dynamic range) tools, which try to capture a larger-than-normal range of brightness values, giving you more detail in both shadows and highlights. With HDR, you may see dark halos as well as light ones.

Some cameras have these tools built in; you also can find similar tools in many photo-editing programs. Either way, you usually can specify how much shadow recovery or HDR adjustment you want the camera or software to apply. Experiment with different settings to find the point at which the solution becomes worse than the problem.

As for the blurred edges of the palm fronds in the sample photo, that issue is partly due to the haloing defect and partly due to the fact that my shutter speed (1/200 second) was too slow. There was just enough of a breeze blowing that morning to blur the waving palm fronds at that shutter speed.

See Chapter 5 for more information on these and other exposure topics.

Chapter 12

Top Ten Maintenance and Emergency Care Tips

Nothing is more frustrating to a photographer than missing a shot because of an equipment malfunction. To help you avoid that disappointment, this chapter discusses critical maintenance steps and offers tips for dealing with unexpected emergencies.

Conserve Battery Power

Your camera won't even turn on, let alone take a picture, without adequate battery power. So check the user guide to find out where to locate battery-status information; usually, it's indicated by a symbol similar to the one shown in Figure 12-1. A full battery symbol like the one in the figure means the battery is charged; bars inside the icon disappear as the battery drains.

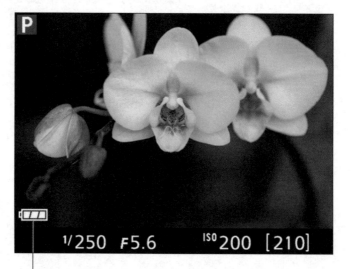

FIGURE 12-1:
Check the battery-status symbol frequently to make sure you don't run out of power during a shoot.

Battery-status icon

When the battery level approaches the danger zone, use these strategies to make the most of the remaining power:

>> **Disable or limit the use of energy-hogging features.** Two big energy consumers are the monitor and the flash, assuming that the latter is of the built-in variety. (External flash heads usually run on separate batteries.) Electronic viewfinders, too, can be a major energy suck, although the extent to which an EVF drains the battery varies from model to model.

Another feature that requires lots of battery juice is the autofocusing system, especially when you use continuous autofocusing. But if your camera doesn't offer manual focusing or your subject is moving too quickly to make manual focusing practical, you don't really have the option to go without autofocusing.

Turning off image stabilization — a feature designed to compensate for small amounts of camera shake — can lighten the load on the battery in some cases. Check your camera or lens manual to find out whether this is the case for your equipment. If not, leave this feature turned on to ensure sharper shots when you're handholding the camera.

Finally, if your camera offers GPS and Wi-Fi, shut down those features as well unless they're absolutely necessary.

>> **Turn on the autosleep function.** Most cameras offer a feature that saves power by automatically disabling the monitor and other power-hungry features (including the exposure meter and autofocus systems) after a period of inactivity. You may even be able to reduce the wait time that must pass before the shutdown occurs. Look for this option on your camera's basic-setup menu.

>> **Take off the chill.** Batteries deplete faster when cold, so when you're not shooting, do what you can to keep your camera warm.

Of course, the best plan is to always carry a spare battery — or two, or three. With larger dSLR models, you may want to invest in the optional battery packs that attach to the bottom of the camera and enable you to keep shooting when the camera's primary battery runs out of juice.

REMEMBER

Spare, loose batteries can short-circuit if their electrical contacts connect (both touching the same piece of aluminum foil, for example). Most batteries come with little caps that cover the contacts to avoid this pitfall; you also can store the batteries in separate containers.

Safeguard Camera Memory Cards

Take the following precautions to keep memory cards in good working order and ensure the safety of the pictures they hold:

>> **Avoid touching the contact areas of the card.** On an SD card, the little gold strips are the no-touch zone, as shown in Figure 12-2. On CF and CFast cards, make sure that the openings on the edge of the cards aren't obstructed by dirt or other debris.

>> **Turn off the camera before inserting or removing a card.** Also, if you just took a picture, don't power down the camera until it has time to write the picture data to the card. Many cameras display a tiny light while the picture is being recorded. When that light turns off, you can safely remove the memory card.

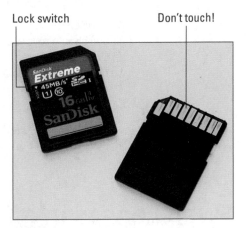

Lock switch Don't touch!

FIGURE 12-2:
Avoid touching the contact areas of the memory card.

>> **Use special care when inserting CompactFlash cards.** Be sure to position the card in the card slot at the proper angle, and don't try to force the card if it doesn't slip in with a gentle push. If the card is slightly misaligned, you can easily bend the connection pins in the card slot, and getting them fixed is expensive.

>> **Beware of environmental hazards.** Try not to expose memory cards to excessive heat or cold, humidity, static electricity, or strong electrical noise. You don't need to be overly paranoid, but use some common sense.

You can, however, ignore rumors about airport security scanners destroying data on memory cards. Although scanners can damage film, they do no harm to digital media, whether the cards travel in checked or carry-on bags.

If your card gets dirty, wipe it clean with a soft, dry cloth. Dirt and grime can affect the performance of memory cards.

>> **Store extra cards properly.** Place them in their original cases or in a memory-card storage wallet, which has pockets to hold multiple cards safely. Some wallets can also hold spare batteries and can be attached to your camera bag or belt loop for easy access.

>> **Check the lock switch (SD cards and some CFast cards):** SD cards have a tiny lock switch, labeled earlier, in Figure 12-2, that enables you to prevent any changes to data stored on the card. Unlock the card before installing it in your camera, or else you can't take any new photos or erase any existing ones on the card. If you insert a locked card into a memory-card reader attached to your computer or another device, you can view your pictures and movies but cannot delete or alter the files. Some CFast cards also provide a lock switch.

>> **Format the card.** When you insert a card into your camera for the first time, you should to *format* the card so that it's prepared to accept digital images. Usually, the camera's Setup menu contains the command that initiates card formatting. It's also a good idea to format cards after you erase the pictures they hold. Some data remains on the card after you delete files; formatting takes care of the final cleanup work.

WARNING

Do *not* format a card that already contains pictures or any other data that you want to retain. Formatting erases all the data on a card.

Swap Lenses in a Protected Environment

If you own an interchangeable lens camera, be careful when changing lenses, because that's a prime occasion for dirt to sneak into the camera. Try to point the camera slightly downward when you attach the lens; doing so can help prevent dust from being sucked into the camera by gravity.

When shooting outdoors, your camera is even more at risk during this operation, so try to find a way to shelter the camera while making the lens exchange. You can

use a jacket or T-shirt as a sort of protective tent or, if your camera bag is large enough, perform the lens swap inside it.

Finally, be especially mindful of the end of the lens that sports the electronic contacts (the end that you attach to the camera). Avoid touching the contacts, and attach the cap made to cover that end of the lens as quickly as possible.

Clean with Care

Dust, sea spray, flecks of dirt, and raindrops are just some of the substances that can spoil your images when they land on the front of the lens. Camera monitors also get gunked up pretty easily; mine has nose prints after I take just one or two shots. And with cameras that offer touchscreen controls, fingerprints are inevitable.

Cleaning both components is safe and easy *if* you use the right tools and techniques. Start by using a manually operated, bulb-style air blower or soft brush, commonly available in camera stores, to remove any large particles of dust or dirt. Then wipe the lens or monitor surface gently with a clean microfiber cloth or another material designed for camera use.

WARNING

Do *not* use any of the following materials:

>> **The same microfiber cloth you use for your glasses:** It may contain facial oil that will transfer to the lens or monitor.

>> **Facial tissue, newspaper, napkins, or toilet paper:** These are made from wood products and can scratch glass and plastic and can harm a lens coating.

>> **Household cleaning products:** Examples are window cleaner, detergent, toothpaste, and the like.

>> **Compressed air:** These cans contain a chemical propellant that can coat the lens or LCD with a permanent residue. Even more scary, compressed air can actually crack the monitor.

>> **Synthetic materials** (like polyester): They usually don't clean well, anyway.

>> **The hem of your t-shirt (or other piece of clothing):** Even if your shirt is made from soft cotton, it may contain residue from fabric softeners, detergent, or even a little mustard you didn't know you spilled at lunch.

Update Camera Firmware

Just when you thought software and hardware were confusing enough, along comes another techno-term to deal with: *firmware.* This special software lives permanently on your camera, telling it how to operate and function — in essence, it's your camera's gray matter.

Every now and then, camera manufacturers update firmware to fix problems and bugs, enhance features, and generally do housekeeping that makes your camera operate better. Sometimes these changes are minor, but occasionally they fix pretty serious problems and errors.

TIP

To benefit from these updates, you have to download the new firmware files from your camera manufacturer's website and install them on your camera. If you signed up for manufacturer email updates when you registered your camera (you *did* do that, right?), the company should inform you of updates when they occur. But it's a good idea to also simply check the manufacturer's camera support page every three months or so to make sure that you don't miss an important firmware update. You will find instructions on how to install the firmware at the website.

Go from Hot to Cold (and Vice Versa) Slowly

A digital camera is pretty much a computer with a lens, and like any electronic device, it isn't designed to cope with weather extremes. So take these safety steps:

» **Don't let your camera catch a cold.** Extreme cold can cause various mechanical functions in your camera to freeze; it can stop the lens from zooming or the shutter release button from operating. The LCD may stop functioning as well, and the battery power may drop so much that your camera won't even turn on. If you must take your camera into the cold, keep it in a camera case under your jacket until you're ready to use it.

» **Don't let it get heat stroke, either.** Extreme heat can damage your camera as well and can be especially hard on your LCD screen, which can "go dark" if it gets too hot. If this happens, simply get your camera to a cooler place. Typically, it will return to a normal viewing state. Although heat generally doesn't cause as many problems as cold, leaving your camera in direct sunlight for a long time isn't a good idea.

>> **Avoid rapid changes in temperature.** Changing temperature extremes, such as from an air-conditioned office into the heat of a summer day, is bad for your camera. Condensation forms on the camera parts and lens elements, which can (at best) obstruct your ability to take good photos and (at worst) cause permanent moisture damage. To minimize this issue, invest in a well-insulated camera bag. When you arrive at your destination, leave the camera in the bag for a while so that it can acclimate to the change in temperature.

Keep It Dry

Water — especially salt water — can short out important camera circuitry and corrode metal parts. A few raindrops probably won't cause any big problems, but exposure to enough water can result in a death sentence for a camera. Even models designed expressly to be water resistant have their limits.

TIP

If you accidentally leave your camera on the picnic table during a downpour or drop it in the swimming pool, all may not be lost, however. First, use a soft cloth to dry the outside of the camera. Then remove the batteries and memory card — try not to push any camera buttons in the process — and set the camera in a warm place where it can dry out as quickly as possible. With luck, the camera will come back to life after the water has had time to evaporate. If not, it's off to the repair shop to see whether anything more can be done.

What about the commonly heard advice to put a wet device inside a bag of rice, on the theory that the rice will absorb the water? Although this practice won't harm your camera, studies show that the rice actually absorbs very little water. (Ditto for cat litter and oatmeal, which are two other suggested options.) A better method is to place the device in a bag with silica gel packets. But testers found that even this trick didn't produce significantly better results than simply leaving the camera in the open air.

Clean the Image Sensor

The *image sensor* is the part of your camera that absorbs light and converts it into a digital image. If dust, hair, or dirt gets on the sensor, it can show up as small spots on your photos. Image–sensor spots are often most visible in the sky or in bright, clear areas of an image, but can be seen just about anywhere. Figure 12-3 shows an image marred by such a defect. Typically, the spot appears in every frame, sometimes even in the same area in every frame.

Sensor dust

FIGURE 12-3:
This spot was caused by dust or dirt on the image sensor.

Most cameras have an internal cleaning system designed to remove any stray flotsam and jetsam from the sensor. Usually, the camera is set up at the factory to complete a cleaning cycle every time you turn the camera on or off, or both. You may also be able to initiate a cleaning cycle at other times by choosing a menu option.

If the camera's internal cleaning mechanisms don't do the trick, take your camera to a repair shop to have the sensor cleaned manually. For cameras that have removable lenses, you can find products designed to help you do this job yourself, but it's a delicate operation, and you can easily damage the sensor if you're not careful. I suggest that you call your local camera store to find out the best place in town to have the cleaning done. (Some camera stores offer free cleaning for cameras purchased from them.)

Recording Proof of Ownership

When you get a new camera, lens, or other expensive equipment, fill out and submit the warranty information requested by the manufacturer. Although this step isn't technically required to obtain warranty service in most cases, it enables the manufacturer to alert you to any recalls or firmware updates. These days, you usually can send your information over the Internet, but some manufacturers still provide mail-in registration cards.

Also take a couple of pictures of each piece of equipment, including close-ups of the product serial and model numbers (usually found on the bottom of cameras). Print those photos and keep them with your purchase receipt. That way, if your equipment is stolen and later recovered by law enforcement, you can prove that it belongs to you and not to one of the other 20 people who reported that they had the same type of gear lifted. Of course, this information is also helpful in getting an insurance claim paid in the event of fire, flood, or other damage that ruins in your equipment.

Use Image Recovery Software
to Rescue Lost Photos

It happens to everyone sooner or later: You accidentally erase an important picture — or worse, an entire folder full of images. Don't panic yet — you may be able to get those pictures back.

WARNING

The first step: *Stop shooting.* If you take another picture, you may not be able to rescue the deleted files. If you must keep shooting and you have another memory card, replace the one that has the accidental erasure with the other card. You can work with the problem card later.

When you're ready to try recovering your images, install a file-recovery program. You can find several good programs available online, and some memory cards even come with an image-recovery program on the card. (Be sure to install that card before you format it for first use in your camera.)

For recovery programs to work, your computer must be able to access the camera's memory card as if the card were a regular drive on the system. If your camera doesn't show up as a drive when you connect it to the computer, you need to buy a card reader.

TIP

If you erased pictures on the computer, you may not need special software. In Windows, deleted files go to the Recycle Bin and stay there until you empty the Bin. Assuming that you haven't taken that step, just use Windows Explorer to open the Bin, click an erased file, and then choose File⇨Restore to "unerase" the picture. On a Mac, deleted files linger in the Trash folder until you choose the Empty Trash command. Until you do, you can open the Trash folder and move the deleted file to another folder on your hard drive. Already emptied the Recycle Bin or Trash? You also can buy programs to recover files that were dumped in the process. Again, head online to search for a recovery program designed for your computer's operating system.

Appendix
Glossary

Can't remember the difference between a pixel and a bit? Resolution and resampling? Turn here for a quick refresher on that digital photography term that's stuck somewhere in the dark recesses of your brain and refuses to come out and play. Note that some terms you find here are *only* discussed here; even though I don't talk about them in the book, I've included them in the glossary in case you encounter them when perusing digital photography magazines and websites.

24-bit image: An image containing approximately 16.7 million colors.

Adobe RGB: A color space option available on some cameras. (The color space determines how many colors a camera can capture.) Adobe RGB includes more colors than the default option, sRGB, but also involves some complications that make it a better choice for advanced photographers than for beginners.

AEB: *Auto Exposure Bracketing,* a feature that automatically records three exposures: one at the selected exposure settings, one using settings that produce a darker image, and one using settings that produce a brighter image. It's a useful tool for ensuring that at least one exposure is good when you shoot in tricky lighting.

AE lock: A way to prevent the camera's autoexposure (AE) system from changing the current exposure settings if you reframe the picture or the lighting changes before the image is recorded.

aperture: One of three critical exposure controls; an opening made by an adjustable diaphragm, which permits light to enter through the camera lens and reach the image sensor. The size of the opening is measured in f-stops (f/2.8, f/8, and so on, with a smaller number resulting in a larger opening). Aperture also affects depth of field, or the distance over which sharp focus is maintained. A higher f-stop number produces a greater depth of field than a smaller number.

aperture-priority autoexposure: A semiautomatic exposure mode; the photographer sets the aperture, and the camera selects the appropriate shutter speed to produce a good exposure at that aperture and the current ISO (light sensitivity) setting.

aspect ratio: The proportions of an image. A 35mm-film photo has an aspect ratio of 3:2; the standard digital camera image has an aspect ratio of either 3:2 or 4:3.

autoexposure (AE): A feature that puts the camera in control of choosing the proper exposure settings. ***See also**** aperture-priority autoexposure and shutter-priority autoexposure.

backlight: Bright light coming from behind your subject.

bit: Stands for *binary digit;* the basic unit of digital information. Eight bits equals one *byte.*

bit depth: Refers to the number of bits available to store color information. A standard digital camera image has a bit depth of 24 bits. Images with more than 24 bits are called *high-bit images.*

bulb mode: A shutter-speed setting that keeps the shutter open as long as you hold down the shutter button. Available only on some cameras and only in the M (manual) shooting mode.

burst mode: A setting that records several images in rapid succession with one press of the shutter button. Also called *continuous shutter-release* mode.

byte: Eight bits. *See also* bit.

Camera Raw: A file format offered by some digital cameras; records the photo without applying any of the in-camera processing or lossy file compression that is done in the other standard format, JPEG. Also known as *Raw.*

camera shake: Any movement of the camera during the image exposure. Can lead to allover blurring of the photo.

card reader: A device used to transfer images from a camera's memory card to your computer or another device.

catchlight: The bright, small reflective spots seen in a subject's eyes in a photo that can come from a flash or natural light.

CCD: Short for *charge-coupled device.* A type of image sensor.

CFast card: A type of memory card used by some high-end cameras; designed for shooting video and high-speed, high-resolution action shots, both of which benefit cards that offer ultrafast data recording.

chromatic aberration: A defect produced by some lenses; looks like small halos of color along object edges. Some cameras have built-in filters to reduce the defect; some photo-editing programs offer similar tools.

CIE Lab: A color model developed by the Commission Internationale de l'Eclairage. Used mostly by digital-imaging professionals.

CMOS: Pronounced "see-moss." A much easier way to say *complementary metal-oxide semiconductor.* A type of imaging sensor used in some digital cameras.

color model: A way of defining colors. In the RGB color model, for example, all colors are created by blending red, green, and blue light. In the CMYK model, colors are produced by mixing cyan, magenta, yellow, and black ink. (Black is the *key* color, thus the K in CMYK.)

color temperature: Refers to the color cast emitted by a light source; measured on the Kelvin scale.

CompactFlash: A type of removable memory card used in some digital cameras; about the size and thickness of a matchbook.

compositing: Combining two or more images in a photo-editing program.

continuous autofocus: An autofocus feature on some digital cameras, in which the camera continuously adjusts focus as needed to keep a moving subject in focus.

contrast: The amount of difference between the brightest and darkest values in an image. High-contrast images contain both very dark and very bright areas.

crop: To trim away unwanted areas around the perimeter of a photo

depth of field: The distance over which focus appears sharp in a photograph. With shallow depth of field, the subject is sharp, but distant foreground and background objects are not. With large depth of field, both the subject and distant objects appear acceptably sharp. Manipulated by adjusting the aperture, focal length, or camera-to-subject distance.

digital zoom: A feature offered on some digital cameras; crops the perimeter of the image and then enlarges the area at the center. Results in reduced image quality.

diopter: An adjustment on a camera viewfinder to accommodate your eyesight.

downloading: Transferring data from your camera to a computer or from one computer device to another.

downsampling: Eliminating excess pixels from a digital photo. Often done to create a web-friendly version of a high-resolution image.

dpi: Short for *dots per inch.* A measurement of how many dots of color a printer can create per linear inch. Higher dpi means better print quality on some types of printers, but on other printers, dpi is not as crucial.

DPOF: Stands for *digital print order format.* A feature offered by some digital cameras that enables you to add print instructions to the image file; some photo printers can read that information when printing your pictures directly from a memory card.

driver: Software that enables a computer to interact with a digital camera, a printer, or another device.

dSLR: Stands for *digital single-lens reflex;* one type of digital camera that accepts interchangeable lenses.

dye-sub: Short for *dye-sublimation.* A type of photo printer.

dynamic range: The overall range of brightness values in a photo, from black to white. Also refers to the range of brightness values that a camera, a scanner, or another digital device can record or reproduce.

edges: Areas where neighboring image pixels are significantly different in color; in other words, areas of high contrast.

EV compensation: A control that slightly increases or decreases the exposure chosen by the camera's autoexposure mechanism. EV stands for *exposure value;* EV settings typically appear as EV 1.0, EV 0.0, EV –1.0, and so on.

EXIF metadata: *See* metadata.

exposure: The overall brightness and contrast of a photograph, determined mainly by three settings: aperture, shutter speed, and ISO.

exposure compensation: Another name for EV compensation.

file compression: A process that reduces the size of the image file by eliminating certain image data.

file format: A way of storing image data in a digital file. Popular digital-camera formats include Raw, JPEG, and TIFF.

fill flash: Using a flash to fill in darker areas of an image, such as shadows cast on subjects' faces by bright overhead sunlight or backlighting.

firmware: The internal software that runs the camera's "brain."

flash exposure (EV) compensation: A feature that enables the photographer to adjust the strength of the camera flash.

f-number, f-stop: Refers to the size of the camera aperture. A higher number indicates a smaller aperture. Written as f/2, f/8, and so on. Affects both exposure and depth of field.

formatting: An in-camera process that wipes all data off the memory card and prepares the card for storing pictures.

frame rate: In a movie, the number of frames recorded per second (fps). For still photos, the number of frames per second that the camera can capture when the continuous shutter-release mode is used.

gamut: Say "gamm-ut." The range of colors that a monitor, a printer, or another device can produce. Colors that a device can't create are said to be "out of gamut."

GIF: Short for *Graphics Interchange Format.* A file format often used for web graphics; not suitable for photos because it can't handle more than 256 colors.

gigabyte: Approximately 1,000 megabytes, or 1 billion bytes. In other words, a really big collection of bytes. Abbreviated as GB.

grayscale: An image consisting solely of shades of gray, from white to black. Often referred to generically as a *black-and-white image* (although in the truest sense, a black-and-white image contains only black and white, with no grays).

HDR: Stands for *high dynamic range* and refers to a picture that's created by merging multiple exposures of the subject into one image. The resulting picture contains a greater range of brightness values — a greater dynamic range — than can be captured in a single shot.

histogram: A graph that maps out shadow, midtone, and highlight brightness values in a digital image; an exposure-monitoring tool that can be displayed on some cameras. Also found inside some of the exposure-correction filter dialog boxes displayed in photo-editing programs.

hot shoe: The connection on top of the camera where you attach an auxiliary flash.

image sensor: The component in a digital camera that senses light and converts it into digital information.

ISO: Traditionally, a measure of film speed; the higher the number, the faster the film. On a digital camera, it means how sensitive the image sensor is to light. Raising the ISO allows faster shutter speed, smaller aperture, or both, but also can result in a noisy (grainy) image. Stands for *International Organization for Standardization,* the group that set the standards for this sensor characteristic.

jaggies: Refers to the jagged, stair-stepped appearance of curved and diagonal lines in low-resolution photos that are printed at large sizes.

JPEG: Pronounced "jay-peg." The primary file format used by digital cameras; also the leading format for online and web pictures. Uses *lossy compression,* which eliminates certain data in order to produce smaller files. A small amount of compression does little discernible damage, but a high amount destroys picture quality. Stands for *Joint Photographic Experts Group,* the group that developed the format.

JPEG artifact: A defect caused by too much JPEG compression.

Kelvin: A scale for measuring the color temperature of light. Sometimes abbreviated as *K,* as in 5000K. (But in computerland, the initial *K* more often refers to kilobytes, as described next.)

kilobyte: One thousand bytes. Abbreviated as *K,* as in 64K.

LCD: Stands for *liquid crystal display*, a type of display technology used by digital camera monitors.

Live View: Found on most cameras that offer viewfinders; enables you to use the camera monitor instead of the viewfinder to compose shots.

lossless compression: A file-compression scheme that doesn't sacrifice any vital image data in the compression process, used by file formats such as TIFF. Lossless compression tosses only redundant data, so image quality is unaffected.

lossy compression: A compression scheme that eliminates important image data in the name of achieving smaller file sizes, used by file formats such as JPEG. High amounts of lossy compression reduce image quality.

manual exposure: An exposure mode that enables you to control aperture, shutter speed, and ISO. Usually represented by the letter M on the camera's exposure mode dial or menu option.

manual focus: A setting that turns off autofocus and instead enables you to set focus by twisting a ring on the lens barrel or by specifying a specific focusing distance through camera menus.

megabyte: One million bytes. Abbreviated as MB. ***See also*** bit.

megapixel: One million pixels; used to describe the resolution offered by a digital camera.

metadata: Extra data that gets stored along with the primary image data in an image file. It includes information such as aperture, shutter speed, and EV compensation setting used to capture the picture, and can be viewed during playback on some cameras or in a photo editing program. Often referred to as *EXIF metadata;* EXIF stands for *Exchangeable Image File Format.*

metering mode: Refers to the way a camera's autoexposure mechanism reads the light in a scene. Common modes include *spot metering,* which bases exposure on light in the center of the frame only; *center-weighted metering,* which reads the entire scene but gives more emphasis to the subject in the center of the frame; and *matrix, evaluative, pattern,* or *multizone metering,* which calculates exposure based on the entire frame.

mirror lockup: A feature that ensures that the movement of the camera's internal mirror is completed long before the shutter is released; used for long-exposure shots to ensure that the mirror movement doesn't blur the image.

monopod: A telescoping, single-legged pole on which you can mount a camera and lens in order to hold it more stably while shooting.

noise: Graininess in an image, caused by a very long exposure, a high ISO setting, or both.

NTSC: A video format used by televisions, DVD players, and VCRs in North America and some parts of Asia (such as Japan, Taiwan, South Korea, and the Philippines). Many digital cameras can send picture signals to a TV, DVD player, or VCR in this format.

optical zoom: A traditional zoom lens; has the effect of bringing the subject closer and shortening depth of field.

PAL: The video format common in Europe, China, Australia, Brazil, and several other countries in Asia, South America, and Africa. Some digital cameras sold in North America can output pictures in this video format. ***See also*** NTSC.

PictBridge: A universal standard that allows digital cameras and photo printers to connect directly by USB cable, without the computer serving as a middleman. Any PictBridge camera can connect to any PictBridge printer, regardless of whether both are made by the same manufacturer.

pixel: Short for *picture element.* The basic building block of every image.

pixelation: A defect that occurs when an image has too few pixels for the size at which it is printed; pixels become so large that the image takes on a mosaic-like or stair-stepped appearance.

plug-in: A small program or utility that runs within another, larger program. Many special-effects filters operate as plug-ins to major photo-editing programs such as Adobe Photoshop.

ppi: Stands for *pixels per inch*. Used to state image resolution as it applies to printed photos. Measured in terms of the number of pixels per linear inch of the print. A higher ppi usually translates to better-looking printed images.

Raw: *See* Camera Raw.

Raw converter: A software utility that translates Camera Raw files into a standard image format such as JPEG or TIFF.

red-eye: Light from a flash being reflected from a subject's retina, causing the pupil to appear red in photographs.

resampling: Adding or deleting image pixels.

resolution: A term used to describe the number of pixels in a digital image. Also a specification describing the rendering capabilities of scanners, printers, and monitors; means different things depending on the device.

RGB: The standard color model for digital images; all colors are created by mixing red, green, and blue light.

SD card: A type of memory card used in many digital cameras; stands for *Secure Digital.*

SDHC card: A high-capacity form of the SD card; requires a camera and card reader that specifically supports the format. Stands for *Secure Digital High Capacity* and refers to cards with capacities ranging from 4MB to 32MB.

SDXC card: *Secure Digital Extended Capacity;* used to indicate an SD memory card with a capacity greater than 32MB.

sharpening: Applying an image-correction filter inside a photo editor to create the appearance of sharper focus.

shutter: An exposure control that determines the length of the image exposure.

shutter-priority autoexposure: A semiautomatic exposure mode in which the photographer sets the shutter speed, and the camera selects the appropriate aperture.

shutter speed: The duration of the image exposure. Typically measured in fractions of a second, as in 1/60 or 1/250 second.

slow-sync flash: A special flash setting that allows (or forces) a slower shutter speed than is typical for the normal flash setting. Results in a brighter background than normal flash.

sRGB: Stands for *standard RGB,* the default color space setting on your camera (and the one recommended for most users). It was developed to create a standard color spectrum that (theoretically) all devices could capture or reproduce.

TIFF: Pronounced "tiff," as in a little quarrel; stands for *tagged image file format,* a popular image format supported by most Macintosh and Windows programs. It is *lossless,* so it retains image data in a way that maintains maximum image quality. Often used to save Raw files after processing and all pictures after editing.

tripod: Used to mount and stabilize a camera, preventing camera shake that can blur an image; characterized by three telescoping legs.

UHS-1, UHS-2, UHS-3: Classifications assigned to certain SD memory cards; stands for *Ultra High Speed.* The higher the accompanying number, the faster the card.

unsharp masking: The process of using the Unsharp Mask filter, found in many image-editing programs, to create the appearance of a more focused image. The same thing as *sharpening* an image, only more impressive sounding.

upsampling: Adding pixels to a digital photo in a photo-editing program. Usually degrades picture quality.

USB: Stands for *Universal Serial Bus,* a type of port found on most computers. Some digital cameras come with a USB cable for connecting the camera to this port.

white balance: Adjusting the camera to compensate for the color temperature of the lighting. Ensures accurate rendition of colors in digital photographs.

XQD: A type of memory card developed for pro cameras. Delivers fast data-recording speeds needed for demanding functions such as video recording and fast-action still photography.

Index

organizing, 220

preserving, 211–214

protecting, 201–202

ratings, 201

recovering, 287

size, 95, 239–240

storing, 211–214

fill flash, 135, 189

film grain, 114

filters, lens

described, 254

graduated neutral density (ND), 256

neutral density (ND), 256

polarizing filter, 255–256

ultraviolet (UV), 254–255

fireworks, shooting, 191–192

firmware, updating, 284

fixed-lens cameras

cellphone cameras, 16

point-and-shoot models, 16

tablet cameras, 16

flash. *See also* lighting

button, 134

commander mode, 33, 141

control over whether the flash fires, 32–33

described, 133–134

disabling, 134

enabling, 134

exposure compensation, 33, 141–142

external, 33, 139–140

fill, 135

force, 135

high-speed, 33, 136

master, 141

modes, 135

outdoor, 136

in portraits, 175–176

power, adjusting, 141–142

rear-curtain sync, 139

red-eye reduction, 137–138

remote, 141

slave, 141

slow-sync, 138–139

flash drives, 212

Flash Off mode, 135

Flash On mode, 135

flash sync cord, 33

fluorescent light, 237

f-numbers. *See* f-stop

focal length

angle of view and, 23

defined, 23, 156

effect on depth of field, 23, 56, 156–157, 269

in portraits, 174

focus. *See also* autofocus; depth of field; manual focusing

autofocus, 147–151

editing, 265–266

macro, 151

manual, 152–153

problems, diagnosing, 144–146

problems, fixing, 265–266

focus points, 29

focus zone, 158

focusing options, 29–30

force flash, 135

four-thirds camera, 87

frame rate

Continuous High, 85

Continuous Low, 85

settings, 38

frame size, 38

framing, 237

freezing motion, 113–114

f-stop. *See also* aperture

adjusting, 119–120, 154

defined, 26, 110–111

depth of field and, 56, 154–155, 158

full frame sensors, 19

Full HD, 38

G

galleries, online photo. *See* online sharing

gamuts, 166

general-purpose printers, 232

GIF (Graphics Interchange Format), 240

glass, shooting through, 190–191

golden hours, 60

golden triangle, 47

Google Play, 254

Google Snapseed, 258

Gorillapod, 251

GPS (Global Positioning System)

tagging, 42

turning off, 280

graduated neutral density (ND) filter, 256

graphics cards, 205–206

graphics tablet, 261

gray card, 165

gray market goods, 43. *See also* shopping pitfalls, avoiding

grayscale images, 161. *See also* black-and-white images

H

halos, avoiding, 276–277

Handy Photo, 258

hard drives, 205, 211–212

hardware-based stabilization, 31

HDMI connection, 243

HDMI-CEC, 243

HDR (high dynamic range) imaging

described, 130–132

exposure compensation, 264

haloing effects, 177

white balance
 bracketing, 165
 defined, 34
 effects, 165–168
 gray card, 165
 in portraits, 179
 settings, 164, 275–276
 shift, 164–165
whole-frame metering, 124
wide angle lens, 23
Wi-Fi connectivity
 camera/computer
 connection, 244
 image transfer and, 216–217
 printing and, 235
 turning off, 280
Windows Live Photo Gallery,
 209, 226, 272–273
Windows operating
 system, 206
wireless connectivity, 42
wireless printing, 235
wireless transfer
 of images, 216

X

XQD card, 39
X-Rite, 228

Z

zone autofocusing, 149
zoom lens, 26
zooming in, 174, 189

About the Author

Julie Adair King has been teaching and writing about digital photography for more than two decades. Along with this best-selling book, her other titles include a series of *For Dummies* guides to Nikon, Canon, and Olympus cameras. Other works include *Digital Photography Before & After Makeovers, Digital Photo Projects For Dummies,* and *Julie King's Everyday Photoshop For Photographers.* When not writing, King teaches digital photography at such locations as the Palm Beach Photographic Centre. A native of Ohio and graduate of Purdue University, she resides in West Palm Beach, Florida.

Author's Acknowledgments

Even though I make my living as a writer, I find it difficult to put into words how lucky I feel that have been teamed up with the outstanding group of editors who contributed to this book. Kim Darosett, Becky Whitney, Theano Nikitas, Mary Corder, and Steve Hayes, I can only say thank you from the bottom of my heart — nay, from the soles of my feet! — for everything you did to make this book *so* much better than it otherwise would have been. Of course, I am also blessed to have on my side the talented design, marketing, and other professionals at Wiley Publishing who helped make this book possible. Finally, to my friends and family, thanks for putting up with yours truly, which, I suspect, is not an easy task. Love and gratitude to you all.

Publisher's Acknowledgments

Executive Editor: Steven Hayes

Project Editor: Kim Darosett

Technical Editor: Theano Nikitas

Editorial Assistant: Kayla Hoffman

Sr. Editorial Assistant: Cherie Case

Production Editor: Selvakumaran Rajendiran

Front Cover Image: Julie Adair King